GAUGUIN
AND
THE NABIS
PROPHETS OF MODERNISM

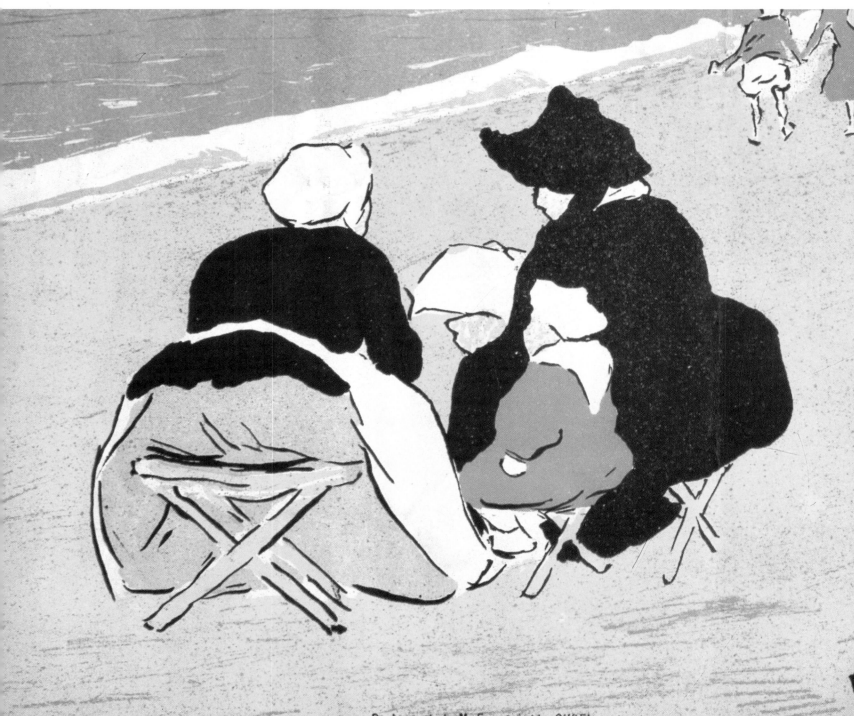

De la part de M. François de CUREL.

H. G. Ibels

GAUGUIN
AND
THE NABIS
PROPHETS OF MODERNISM

ARTHUR ELLRIDGE

TERRAIL

Cover illustrations

GEORGES LACOMBE

Blue seascape, or *Effets de Vague*

Rennes, Musée des Beaux-Arts.

PAUL GAUGUIN

Boys Wrestling

Josefowitz Collection.

Previous page

HENRI-GABRIEL IBELS

The Fossils (detail)

Josefowitz Collection.

Opposite

PIERRE BONNARD

Woman in Checkered Blouse

Paris, Musée d'Orsay.

Editors: Jean-Claude Dubost and Jean-François Gonthier
Art director: Christophe Merlin
Iconography: Claire Balladur
English adaptation: Jean-Marie Clarke
Composition: Graffic, Paris
Filmsetting: Compo Rive Gauche, Paris
Lithography: Litho Service T. Zamboni, Verona

English edition, copyright © 1995
World copyright © 1993
by
FINEST S.A./EDITIONS PIERRE TERRAIL, PARIS
A subsidiary of the Book Department
of ⓑ Bayard Presse S.A.
ISBN: 2-87939-080-X
Printed in Italy

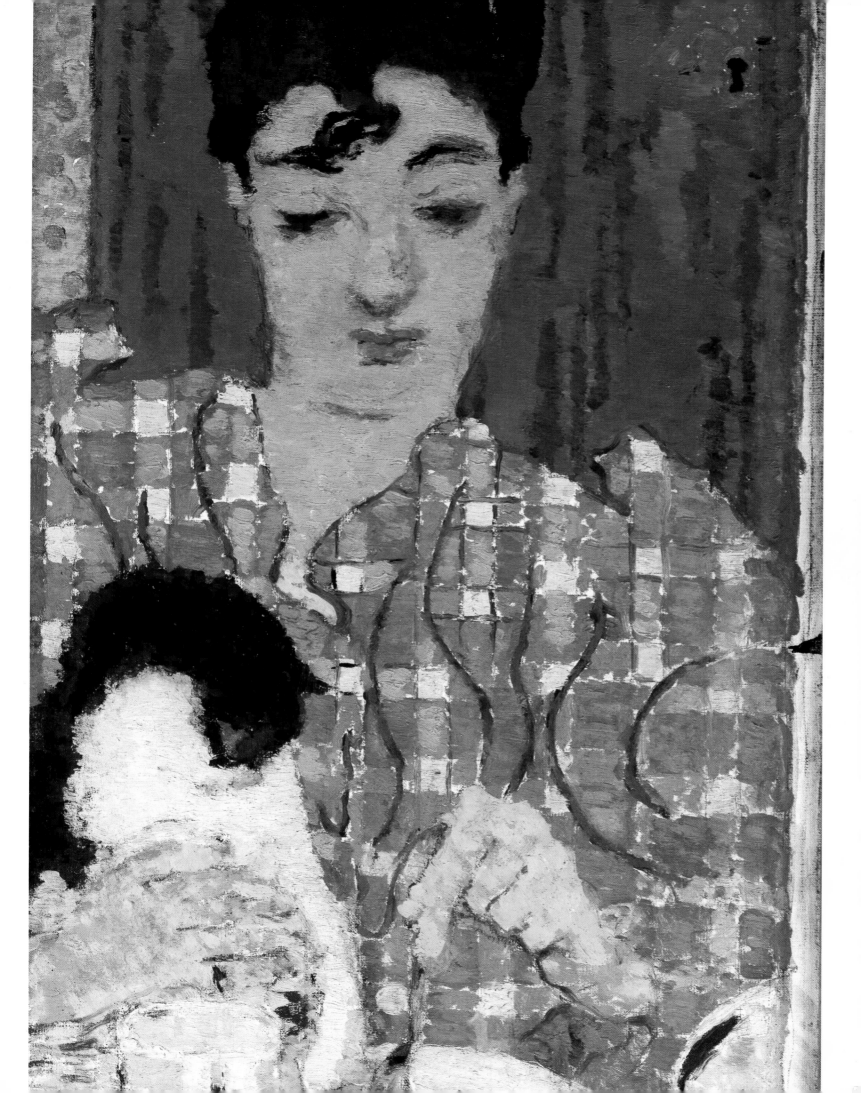

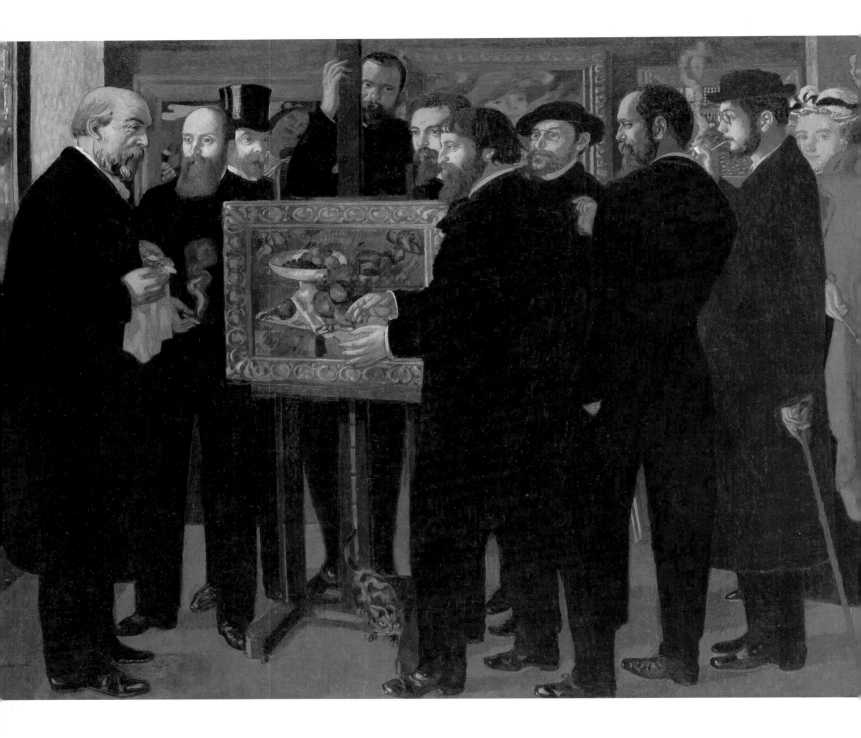

MAURICE DENIS

Homage to Cézanne

1900, oil on canvas,

180 x 240 cm. (6 x 7 1/2 ft.),

Paris, Musée d'Orsay.

1. Odilon Redon 6. Paul Sérusier

2. Edouard Vuillard 7. Paul Ranson

3. André Mellerio 8. Ker Xavier Roussel

4. Ambroise Vollard 9. Pierre Bonnard

5. Maurice Denis 10. Mrs. Denis

CONTENTS

INTRODUCTION
AN IN-BETWEEN GENERATION

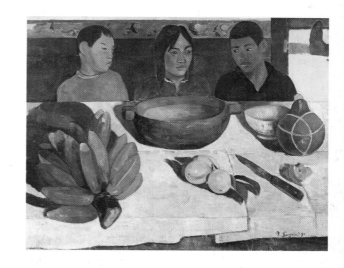

In the light of the renewed interest in figurative painting today, the Nabis may finally be seen for what they were: marvellous innovators who were able both to shake the foundations of the art of painting and, for the first time, to bring modernity down into the streets and everyday life.

In 1890, Maurice Denis was scarcely twenty when he made the prophetic declaration: "Remember that a painting – before being a war-horse, a nude or an anecdote of some kind – is basically a flat surface covered with colours disposed in a certain order." Another feature of the Nabis is that they extended their activities from easel painting to the fields of lithography, the poster, book illustration, mural painting, stained-glass, stage design and theatre programmes. They were convinced that it was both possible and necessary for the artist to come closer to his public.

With the benefit of hindsight, we can say that they had the – relative – bad luck of having been born too late, or too soon: in 1900, Bonnard was thirty-three years old, Vuillard thirty-two, and Vallotton thirty-five. As direct precursor they had the overwhelming figure of Gauguin, who had paved the way, but then blocked the view, while the new generation in their twenties, led by Picasso and Braque, was about to burst onto the Parisian art scene like a bolt out of the blue. Bonnard alluded to this dilemma when he said that the Nabis had not yet achieved the goals they had set for

themselves when they were suddenly caught off-balance by the up and coming avant-garde. With one foot in the nineteenth century and the other in the twentieth, they were fated to be an in-between generation.

However, this in no way prevented their genius from manifesting itself. Bonnard was a first-rate painter, of the same stature as Matisse, and his perennially fresh painting will surely "greet the young people of the year 2000 with butterfly wings," as he had hoped. Vuillard, who earned broad acclaim during his lifetime, but later fell into oblivion, is coming to the fore again in our own time. Ker Xavier Roussel, who fancied he saw nymphs and satyrs gambolling in the woods of the Ile-de-France, was much more than a belated Impressionist. Whether they were representing a nude or an anecdote of some kind – there were no war-horses in their pictures – the Nabis were clearly *painters* in the fullest sense of the word.

And then again, not always, and perhaps not all. Sérusier and Maurice Denis, after having had mercurial débuts, eventually became too possessed by theory and ideas, which only too rarely found their way into sensible form, as the tenets of Symbolism – another of their vehicles – required. Thus, within the group itself, there was a break which became fully apparent at the last Nabi exhibition at the Durand-Ruel Gallery in 1899. At the same time, the overall mission which they had given themselves in 1888 – to reform and perpetuate the art of painting – remained unaffected by this split.

Be that as it may, the Nabis belonged to traditional painting through their honesty, intelligence and culture, and to the avant-garde through their imagination, bold colours and simplified forms. Untouched by the *ruptures* in which too many modern artists have indulged and delved, they were the first Postmoderns, in the sense that Postmodernism abolishes the boundaries between the old and the new, the before and the after.

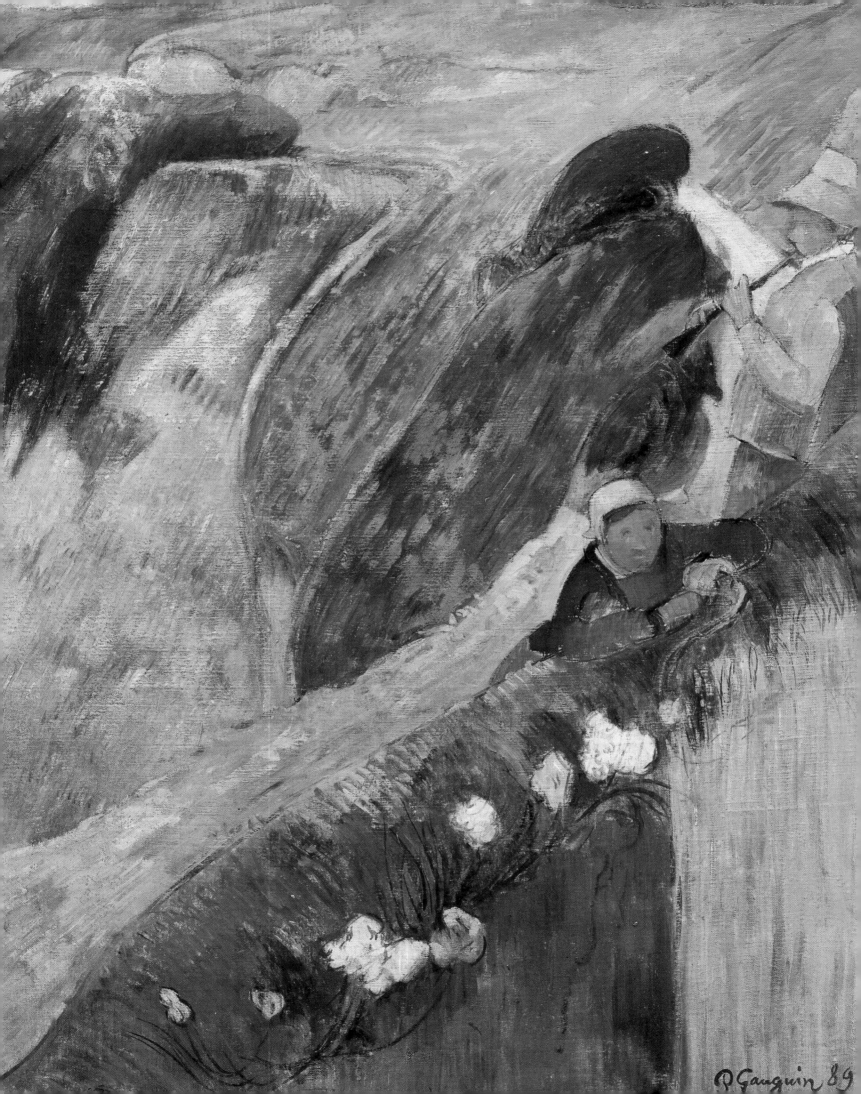

FROM LIMA
TO THE PARIS STOCK EXCHANGE

In the summer of 1889, a young man who had just failed his *baccalauréat* examination decided to spend part of his holidays hiking in Brittany. He went under a certain amount of parental surveillance: his mother followed the same itinerary and arranged to meet up with him somewhere every two or three days. The young traveller tells how he came one evening upon the village of Le Pouldu, which consisted of several cottages and two inns: "The more modest seemed the more pleasant, so I went inside, being very thirsty. A servant showed me into a room with roughcast, whitewashed walls, and left me there sitting in front of a glass of cider. The sparse furnishings and complete absence of wall-hangings made it that much easier for me to notice a fairly large number of canvases and stretchers stacked up against the wall. As soon as I was alone, I rushed over to these canvases and turned them around, contemplating each one with increasing pleasure. They seemed to show nothing more than childish daubs, but the colours were so unusually bright and gay that I had no other thought than to stay. And so I took a room and asked about the dinner service. 'Would you like to be served separately? Or will you eat in the same dining-room as these gentlemen?' the servant asked."[1]

The "gentlemen" were the painters of these singular canvases, and the young wayfarer was André Gide, the future writer, who went on to

1. André Gide, *Si le grain ne meurt*, Paris, 1924.

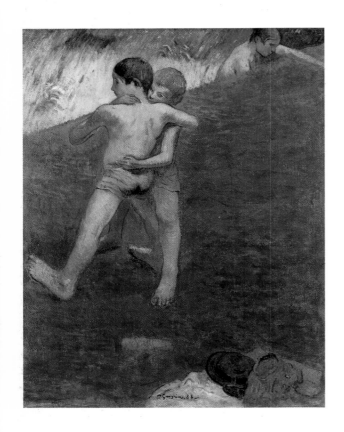

relate how they boisterously sang a song during the meal that was not by Bizet, as they thought, but by Massenet. What he had taken to be childish daubs were in fact works by Gauguin – who became one of the leading French painters of the late nineteenth century – Filiger, an undeservedly forgotten master colourist, and Sérusier, the founder of the Nabis.

Before relating the history and ideas of this group, and before retracing the careers of the artists who, from Sérusier to Bonnard and Vuillard, made it the first avant-garde movement in modern art, it is worth-while giving an account of Paul Gauguin's life up to this summer sojourn at Le Pouldu, when he was forty-one years old. To piece his story together, we will use, among other sources, his correspondence and his memoirs, which he wrote in 1903, the year of his death, and which were published only twenty years later with the title *Avant et après* (*Before and After*).

The family of Paul's father, Clovis, came from a hamlet in the Loiret called Les Gauguins. Clovis Gauguin became a political chronicler for Thier's daily, *Le National*. On his mother's side, things were not so simple. Aline Gauguin was the daughter of Flora Tristan and André Chazal. Her father, an engraver specialized in the new technique of lithography, is best known for having attempted to kill his wife in a fit of jealousy. While his reaction was somewhat extreme, it may have been well grounded, for conjugal fidelity was not one of the virtues championed by Flora Tristan y Moscoso's social philosophy. Her famous grandson later reminisced: "Proudhon says that she was not devoid of genius; not knowing for sure, I have to take Proudhon's word for it... It is more than likely that she did not know how to cook. A socialist bluestocking, an anarchist. A sympathizer of Père Enfantin and the trade guilds, they say.... I will never be able to distinguish between fable and truth in her case.... What I can say for sure, though, is that Flora Tristan was quite a lovely and noble lady.... I also know that she devoted her entire fortune to the workers' movement, travelling endlessly. In the meantime, she went to Peru to see her uncle Don Tristan di Moscoso. Her daughter – my mother – was brought up at the Pension Bascans, which was basically a Republican establishment. That is where my father made her acquaintance."

Married in 1846, Clovis left for Peru two years later with his young wife and two children, Marie (born in April 1847) and Paul (7 June 1848). His plans to found a newspaper were cut short when he succumbed to an attack of aneurysm at a port-of-call in the Straits of Magellan.

Unfortunately this is not the place to dwell on the myriad childhood memories of Gauguin, who once said, "I have a remarkable visual memory.... I can still see our little negro maid, the one who had to carry the small carpet on which we prayed in church, as was the custom." Another memory: "I was carving with my knife and sculpting... little things of my own invention, incomprehensible to the grownups, and an old woman, a friend of

the family, cried out: 'He will be a great sculptor one day.' Unfortunately, she was not a good prophet." We might differ from Gauguin on this last point.

In 1855, his mother decided to return with her two children to France, and moved in with her brother Isidore, affectionately known as "Oncle Zizi." "The year after, I was sent to a boarding school in Orleans as a day student. One teacher said of me: 'This child will be either an idiot or a genius.' He was wrong on both counts." Something, at any rate, was brewing, and Paul was already satisfying his wanderlust by playing truant.

Then came an episode truly worthy of the best Second Empire novels, related here by Gauguin in his characteristically crude and engaging manner: "So, Don Pio was no more. He was 113 years old. In memory of his beloved brother, he had created a trust fund of five thousand gold *piastres*, which amounted to more than twenty-five thousand francs. The family found a way to by-pass the old man's will, took possession of this enormous fortune and blew it all in Paris. One cousin who stayed behind in Lima is still very rich, but lives in a mummified state. You have surely heard of the mummies of Peru."

The inheritance having been liquidated, life had to go on. Aline Gauguin took on millinery work in Paris. Paul, then aged eleven, was sent to the seminary at Saint-Mesmin, near Orleans. He stayed there for three years before returning to the capital and enrolling in a preparatory school for the Navy. His mother wisely decided not to oppose the wayward adolescent's declared desire to take up the career of an "adventurer."

From there – perhaps after some unfortunate escapade – he was sent back to Orleans for a final year at the *lycée*. Graduating at the age of seventeen, he was already too old to be accepted by the Naval Academy, and so he opted for the Merchant Navy and left Le Havre in late 1865 for a pleasant crossing to Rio. "My first trip as a student officer was on the *Luzitano*.... I was very short at the time, and although I was seventeen and half years old, I looked fifteen. In spite of this, I had a woman for the first time at Le Havre before embarking and my heart was racing."

A year later, with the rank of second-mate, Gauguin embarked on a trip around the world. He learned of his mother's death at a port in India. On 14 December 1867, he was back in Le Havre. Before her son's departure, Aline had drawn up a will making Gustave Arosa, an old friend of the family, the guardian of her under-age children.

THE AROSA COLLECTION

Gustave Arosa found Paul a job in Paris working for the stockbroker Bertin, and he proved to be a very capable clerk in the liquidation department. At Bertin's he made the acquaintance of Emile Schuffenecker, an amateur painter, who faithfully and patiently helped his problematic friend during the more difficult moments in his life.

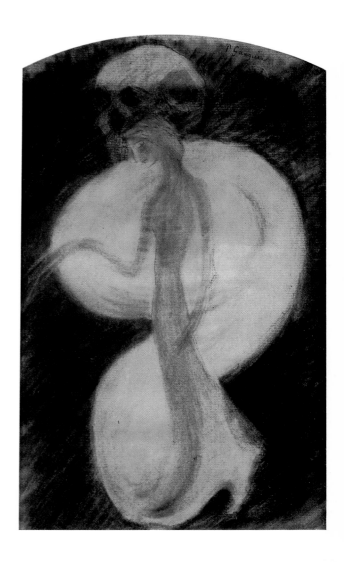

PAUL GAUGUIN

Lady Death

1891,

Paris, Musée d'Orsay.

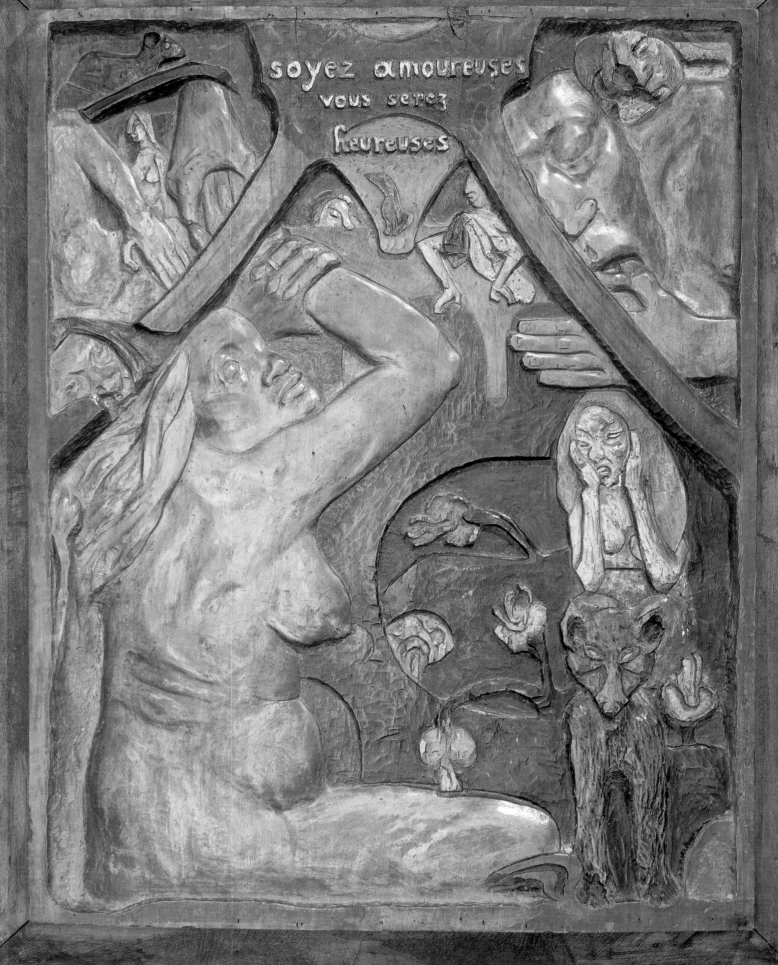

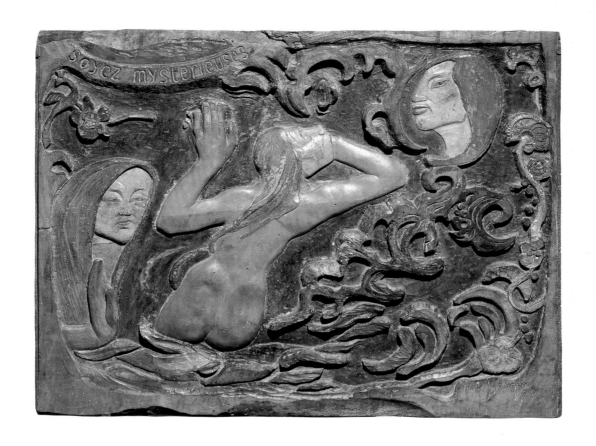

PAUL GAUGUIN

Soyez mystérieuses

1890, polychrome lime,

73 x 95 cm. (29 x 37 in.),

Paris, Musée d'Orsay.

Opposite

PAUL GAUGUIN

Soyez amoureuses,

vous serez heureuses

1889, polychrome lime,

119.3 x 96.5 cm. (4 x 3 ft.),

Boston, Museum of Fine Arts.

Arthur Tracy Cabot Fund.

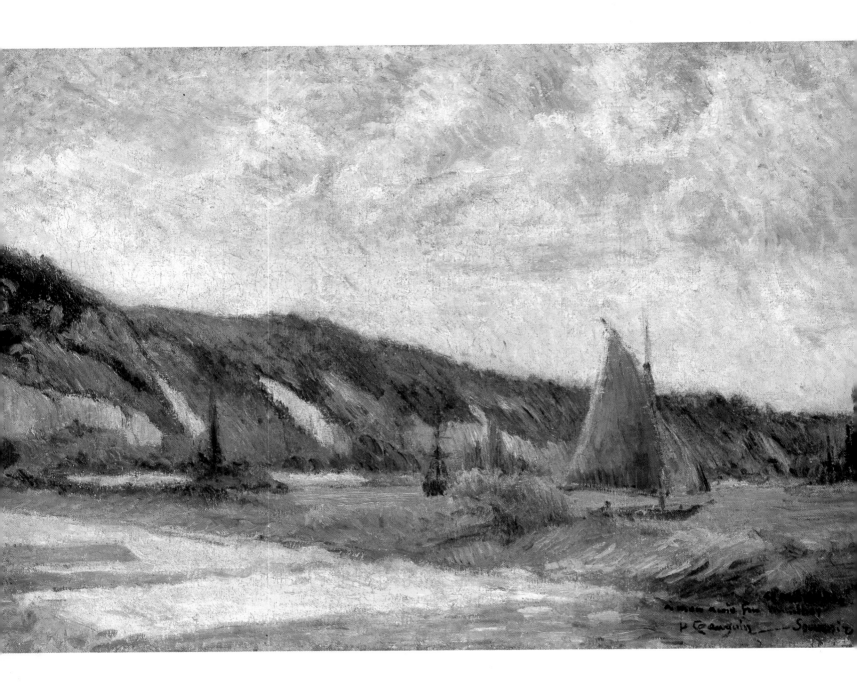

Finding a promising and lucrative position for his young ward was no small achievement, but Arosa's role in Gauguin's life did not stop there. Gustave Arosa, a wealthy dabbler in the Stock Market, was also an avid collector of paintings and objets d'art, and was especially interested in photography. He helped Gauguin (who had by then come of age) to make albums of art reproductions from all different periods and, more significantly, from all different cultures. Among the seventy-five works that constituted his own art collection, there were sixteen by Delacroix, eight Corots, five Courbets, excellent representatives of the Barbizon School, some Daumiers, Jongkinds, Boudins and Pissarros.

It was thanks to Arosa that Gauguin made the acquaintance of Pissarro, an "advanced" painter, and it is likely that he met many other artists through him, including the photographer Nadar, who put his studio at the disposal of the nascent Impressionist group for their first exhibition in 1874. From 1878, Gauguin grew closer to Pissarro, and in April of the following year, he participated in the fourth exhibition of the Impressionists. At the same time, as a successful exchange dealer, he could afford to acquire works by Manet, Cézanne and the Impressionists.

Gauguin had by then been married for several years. In 1873 he had met a young Danish woman, Mette Gad, the daughter of a judge, who was twenty-three years old and knew her own mind. After several months of a courtship conducted in the best bourgeois tradition, they were married in a Lutheran church. The Arosas and the widow of Judge Gad were rightly gratified by this union for love and fortune between a resolutely down-to-earth young woman and a former seafarer turned successful businessman. In late August, their first child, Emile, was born. Mette became somewhat worried to see how much money her husband was spending on pictures, and, worse still, the increasing amount of time he was devoting to painting them himself. But she had every reason to be happy in their conjugal nest, which was tastefully decorated with works of art by her husband who was actively engaged in securing their children's future.

A second child, Aline, was born in 1877. Gauguin was to have a lifelong attachment to his daughter. Three more boys followed. Painting was playing an increasingly important part in her husband's life and it must have become evident to Mette that he was deeply involved with the Impressionists. Did she already suspect that he himself already aspired to something more than had been achieved by these innovators who were still considered crazy by influential critics? If she did have some inkling, she must have felt that she was in no position to broach the matter with a husband who daily proved his mettle as a stockbroker.

Yet Gauguin continued to devote more and more time to painting, and he grew very close to Pissarro. He stayed with him at Pontoise in the summer of 1879, at the same time as Cézanne. In that year, and in the

PAUL GAUGUIN

Sailboats, or *The Cliffs at La Bouille*

1884, oil on canvas,

38 x 56 cm. (15 x 22 in.),

Josefowitz Collection.

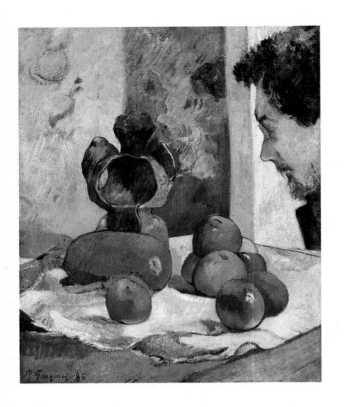

three following years, Gauguin took part in the exhibitions of the Impressionists, who by then were showing signs of increasing dissent. The *Study of a Nude* which he submitted to the sixth exhibition (1881) was noticed by J.K. Huysmans, then still a fervent advocate of naturalism, who commented on it at length in his review of the show: "I can confidently state that, among the contemporaries who have worked on the nude, none has given it so violent a note of reality as now. She is a girl of today, a girl who is not posing for the crowds, neither cloying nor lewd, but simply busily mending her garments. Every part of her body is true to life: the slightly heavy belly sagging on the thighs, the wrinkles coursing below the throat. Mr. Gauguin... has created a daring and authentic picture...."[2]

Because Mette was opposed to having professional models at home, their housemaid, Susanne, who had formerly posed for Delacroix, was pressed into service. The rumour went that Mette thought that posing in the nude was no reason to interrupt the sewing to be done. This last consideration might account for that "so violent note of reality" admired by Huysmans.

A RAGE TO PAINT

And so things went until the year 1882, which was marked by a severe economic crisis and the bankruptcies and scandals that usually accompany such phenomena. Paul Durand-Ruel, the art dealer who had championed the Impressionists, almost went out of business. Gauguin himself lost his position, without much of a fight. His decision had been made anyway: he would be a painter – only a painter, and, come what way, nothing else but a painter. Thus began a personal quest which ended twenty years later at Hiva Oa, an island in the Marquesas Group.

Shortly after the birth of Paul-Rolla (Pola) in early December 1883, the Gauguin household moved to Rouen, where life was less expensive than in Paris. Letters to the faithful Pissarro in January tell us that the family atmosphere had already seriously deteriorated. In July, Mette left for Denmark with Aline and the baby on a boat owned by a cousin.

In October 1884, Gauguin wrote to Pissarro to say that he did not have a penny to his name, and that he was leaving for Denmark as a sales representative for a prominent tarpaulin company: "I have no wages, but receive a commission on the deals negotiated up there. I hope to be able to earn my daily bread in this way, but I am still master of my time and can continue to paint up there."

"Up there" soon turned out to mean a conjugal disaster, his rejection by the Gad clan, a short, unsuccessful exhibition, and failure as a

2. J. K. Huysmans, *L'art moderne*, Paris, 1883.

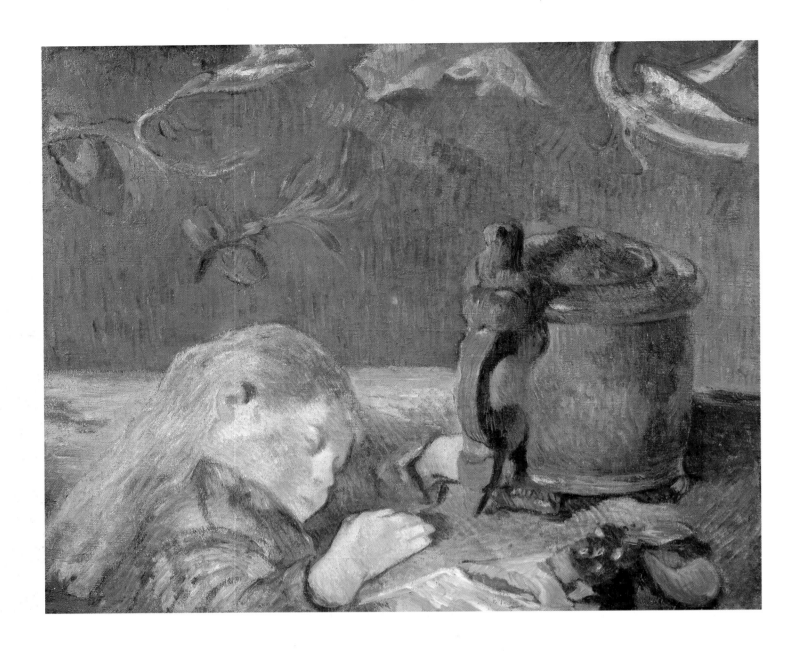

PAUL GAUGUIN

Sleeping Child

1888, oil on canvas,

47 x 55.5 cm. (18 x 22 in.),

Josefowitz Collection.

tarpaulin salesman. Yet in the midst of this turmoil, Gauguin was still able to paint, and a picture like the *Sleeping Child* (Aline?) shows that he was already tackling the problem of colour. Strangely enough, in this composition, for reasons of his own, he included a huge tankard that dwarfs the sleeping child's head. Not surprisingly, this picture was refused for exhibition in Copenhagen. The background wallpaper with plant and animal motifs shows the extent to which Gauguin was already drawn to decorative elements.

In June 1885 he returned to Paris. He continued writing fairly regularly to Mette and reported on his circumstances: "Nothing comes from nothing. I have neither money, nor house, nor furniture, and gainful employment only in the form of promises..." He stayed with Schuffenecker. In September, he spent three weeks in London. His main activity there consisted in helping Spanish conspirators – as long as his illusions lasted – and was supposed to be made worth his while. On the return trip to France he stayed at Dieppe, where artists with better social connections like Helleu, Whistler and Jacques-Emile Blanche, regularly congregated. Among them was the Norwegian painter Thaulow, who had recently divorced Mette's sister and spared no efforts in turning this elegant company against his former brother-in-law.

Degas, who was courted by all and surely no one's fool, expressed his regard for Gauguin, and always would. The latter, true to form, quarrelled with the elder master, holding him responsible for the divisions among the Impressionists. Jacques-Emile Blanche said that at the time: "He painted fine landscapes in the most moderate impressionist manner," and, speaking as the son of a psychiatrist added: "His extravagant attire and somewhat haggard mien, which my father had taught me were often the signs of megalomania, alienated me." Blanche was a valuable witness who also recalled this scene: "Helleu... would cry out when we passed him in the streets of Dieppe: 'A magus, my dear, a real cut-rate symbo-loser; just look at his hand! He has a regular *bijou d'art* on his index finger. The sight of it alone is a health hazard. Impossible for anyone in that get-up to have any talent."[3] Without having heard this summary judgement, but surely suspecting it, Gauguin made his way back to Paris. He was now living at subsistence level, and went through a very distressing period.

The following spring, he was represented in the eighth and last Impressionist exhibition with no less than nineteen pictures. His works were noticed by Félix Fénéon, who otherwise swore only by Seurat and the Pointillists (with whom Gauguin had no affinities). This perspicacious critic wrote: "Mr. Paul Gauguin's colours are close to one another, which makes for the muted harmonies in his paintings."

In a letter to Mette shortly before the end of the exhibition, he boasted: "I had a lot of success among the artists. Mr. Bracquemond, the

3. Jacques-Emile Blanche, *De Gauguin à la Revue Nègre*, Paris, 1926.

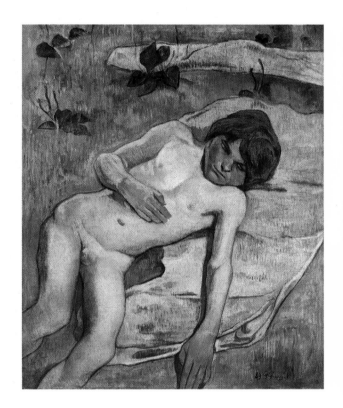

PAUL GAUGUIN

Nude Breton Boy

1889, oil on canvas,

93 x 74 cm. (37 x 29 in.),

Cologne, Wallraf-Richartz Museum.

engraver, enthusiastically bought one picture for two hundred and fifty francs and put me in touch with a ceramist who wants to make some vases. He was so taken by my sculpture that he urged me to make some works of my own invention this winter, and, if we sell them, we would split fifty-fifty. This may be a good source of money in the future."

A good source of money? A letter to Mette dated late December reports on the actual state of affairs: "I am busy making ceramic sculptures. Schuffenecker says they are masterpieces, and the ceramist too, but it is probably too artistic to sell well. However, he says that, in time... they will be the rage. May the devil heed his words! Meanwhile, all my clothes are at the pawnshop and I cannot even make any visits."

In July 1886, Gauguin borrowed some money and made a journey to the little port of Pont-Aven, not far from Quimperlé, in Brittany. The town had been frequented for the last twenty years or so by French and foreign artists who were following in the footsteps of the Barbizon painters and indifferent, for the most part, to any pictorial innovation. Soon after his arrival, he wrote to Mette: "I am working a lot here, and with good results; I am respected as the best painter in Pont-Aven; but I am not any the richer for it. Yet this could be a preparation for the future. In any case, it gives me a respectable reputation and everyone here (Americans, Swedes and French) are eager for my advice.... I am not getting any fatter with this work; I weigh less than you by now. I am as dry as a herring.... I am living here on credit. These money problems discourage me completely, and I would like to see an end to it."

Gauguin stayed at the boarding-house run by Marie-Jeanne Gloanec. Among the other guests were the painter Charles Laval, who would later play an important part in his life; Fernand de Puygaudeau, who often discreetly paid his bills, and Granchi Taylor, another former stock-broker who still appeared in a frock-coat, but wore Breton clogs (we have a portrait of him by Gauguin). In August, he met Emile Bernard, who was visiting the Auberge Gloanec for a few days. Their association really began only two years later, when the two men met again in the same spot.

In November, Gauguin returned to Paris and, as we have mentioned, worked with the ceramist Ernest Chaplet, a friend of Bracquemond's. Soon, he developed a technique of his own, shaping the clay like a sculptor, "replacing the potter's wheel with intelligent hands that can transmit the life of a figure to the vase, and give the art of ceramics a new start for the creation of new forms by hand."

These new forms were directly inspired by Pre-Columbian art, which he had known well as a child in Peru and from the collection his mother had brought back with her. He was well aware of how strange these objects would appear when he wrote to Bracquemond in early 1887: "You are going to explode when you see these monstrosities, but I am convinced they

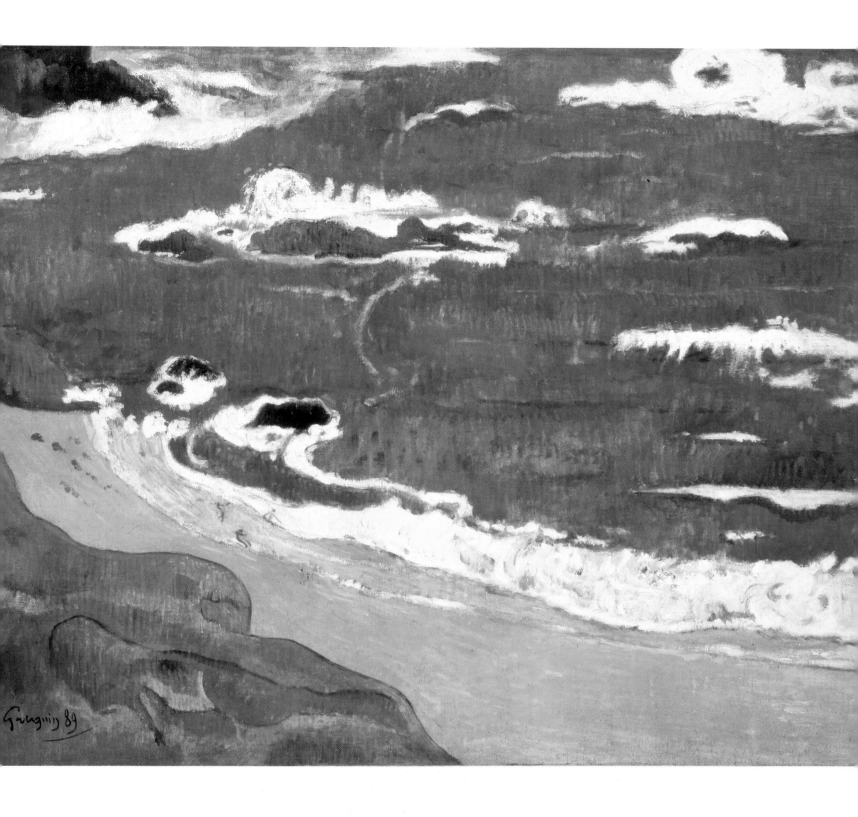

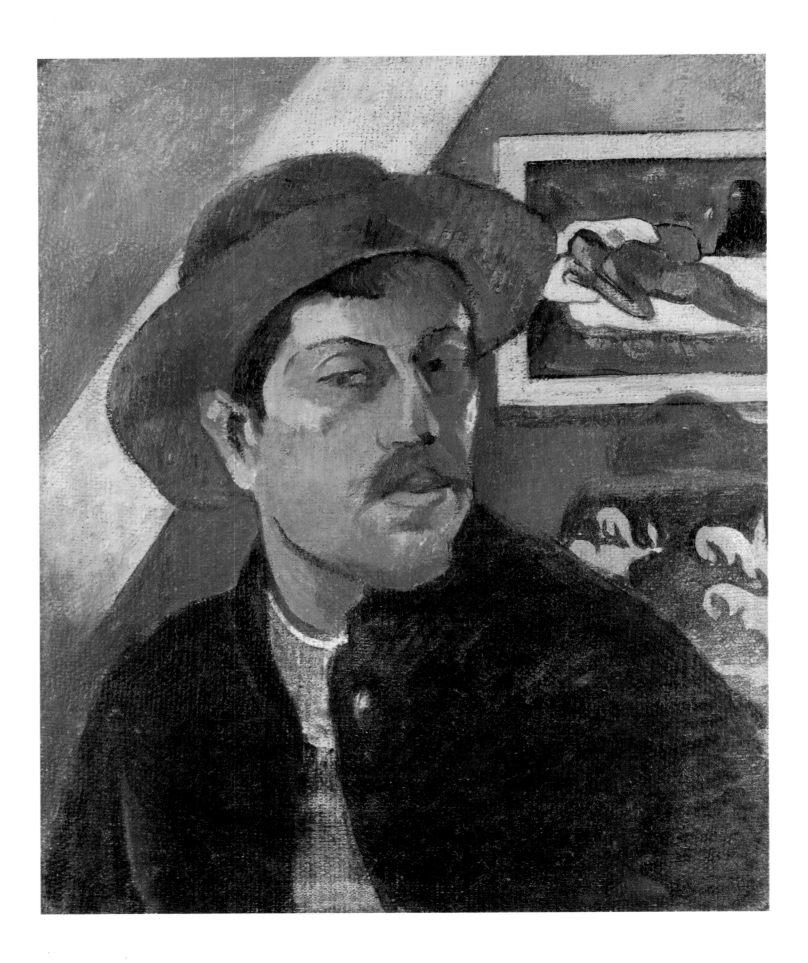

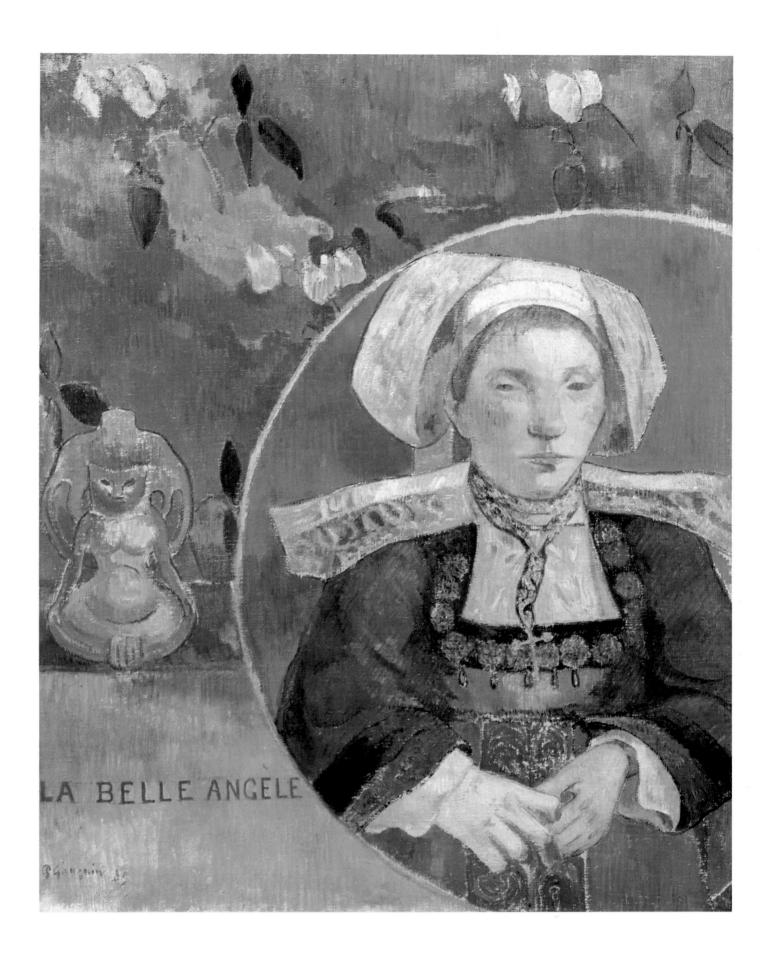

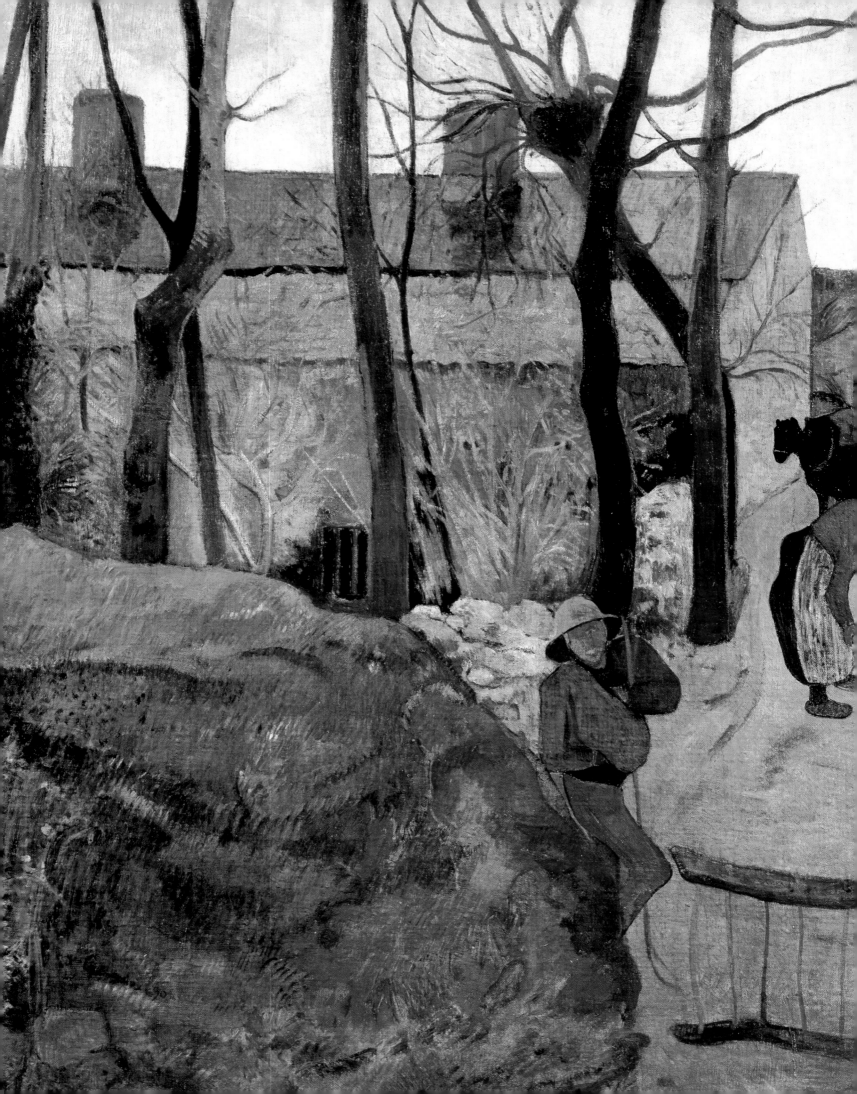

will interest you." The unusually shaped pieces were often decorated with enamel glazes. In some cases, the vases were made with strongly outlined compartments so that the different colours did not mix. This unconventional potter thus anticipated the research that led to *cloisonnisme* in painting.

"AWAY, FAR, FAR AWAY!"

For the time being, what Gauguin wanted was to get away from Paris. He gave his reasons in one of the letters (March 1887) that make up the strange correspondence between a couple that would never get together again: "What I want above all is to get away from Paris, which is a desert for a man of no means. My fame as an artist grows daily, but in the meantime, I often go three days without food; which destroys not only my health, but also my energy. I want to get it back, and so I am going to Panama to live in the wild. I know of an island in the Pacific called Taboga, which lies one league out of Panama, is almost uninhabited, free and very fertile."

On 30 April, Gauguin arrived at Colón after a short stop in Martinique. He was accompanied by Charles Laval whom he had persuaded to accompany him on his flight to a tropical Eden. As soon as they arrived the setbacks began. At the beginning of June, the two succeeded in setting off for Martinique. There, living in a modest hut, they finally found a paradise of light and colour. Gauguin stayed for five months, but under the worst possible conditions. By August, he was suffering from malaria and a severe case of dysentery which continued to plague him for a long time. He was completely destitute but succeeded in getting himself repatriated to France in November.

He brought back from his ill-fated sojourn in his Pacific Eden canvases proving that he had taken a major step forward in his art. His brushwork was still Impressionistic, but his taste for decoration and "primitivism" had begun to assert itself. Two years later, in 1890, he wrote to his friend Charles Morice: "My experience in Martinique was decisive. I felt completely myself, and those who want to know who I am should look at the works that I brought back from there, rather than those from Brittany."

Upon his arrival in Paris, he was in a deplorable state. Schuffenecker again took him in and lent him his studio. He met Daniel de Monfreid, who became his most faithful friend to the very end. There was a letter waiting for him from a pottery collector offering to commission him if he wanted to work with Chaplet. That was the good news. The bad news was that Chaplet was retiring to live on his measly pension. "Another one that got away" (letter to Mette, 24 November).

Two weeks later, another surge of hope: the Boussod-Valadon Gallery was looking for new artists, and he was one of the chosen few. In a letter dated 6 December, he mentioned his poor state of health: "If you see

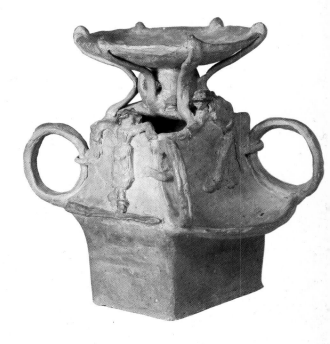

PAUL GAUGUIN

Four-handled vase. Breton Subject.
Ceramic, height: 17 cm. (7 in.),
Paris, Musée d'Orsay.

Opposite

PAUL GAUGUIN

Cottage at Le Pouldu
1890, oil on canvas,
73 x 92 cm. (29 x 36 in.),
private collection.

Previous pages

PAUL GAUGUIN

Self-Portrait with Hat
1893, oil on canvas,
46 x 38 cm. (18 x 15 in.),
Paris, Musée d'Orsay.

PAUL GAUGUIN

La Belle Angèle
1889, oil on canvas,
92 x 73 cm. (36 x 29 in.),
Paris, Musée d'Orsay.

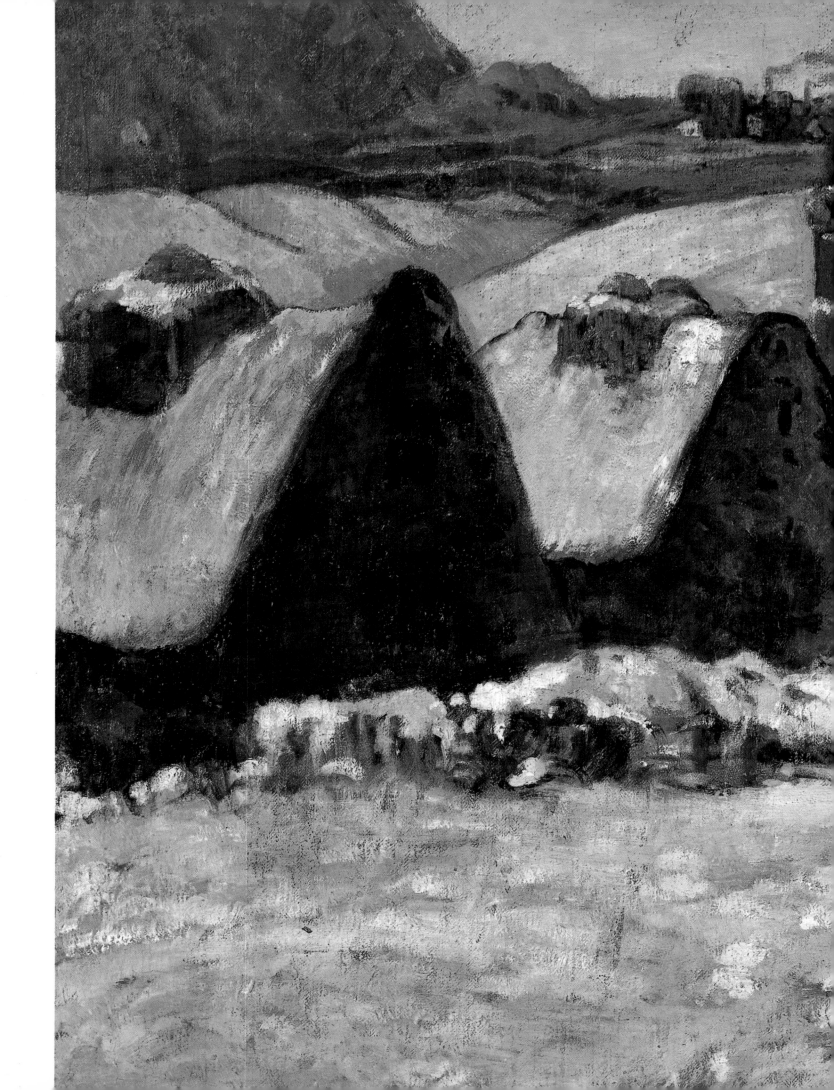

Overleaf

PAUL GAUGUIN

Breton Village in the Snow
1894, oil on canvas,
65 x 90 cm. (26 x 35 in.),
Paris, Musée d'Orsay.

PAUL GAUGUIN

Riders on the Beach
1902, oil on canvas,
66 x 76 cm. (27 x 30 in.),
Essen, Folkwang Museum.

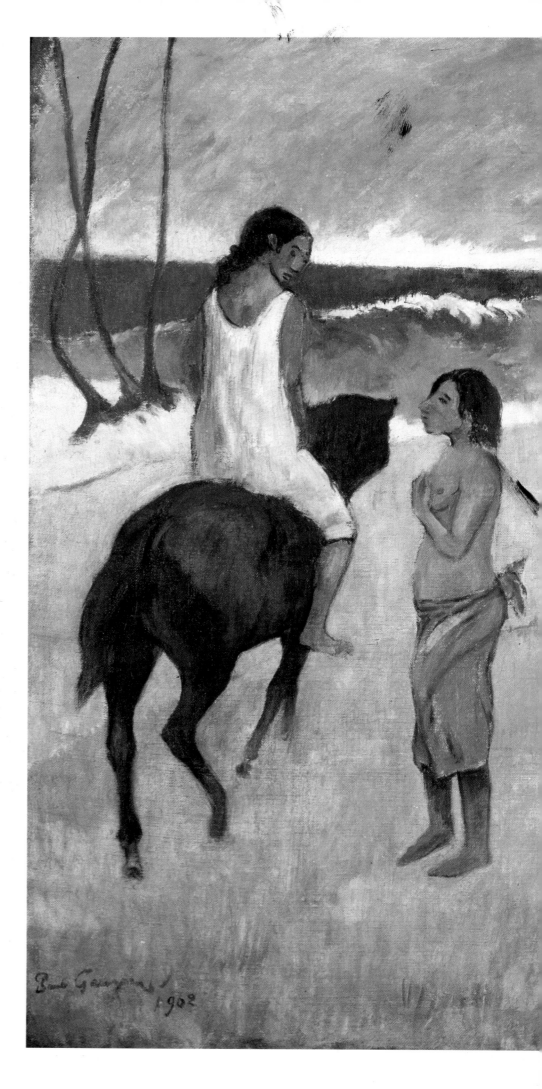

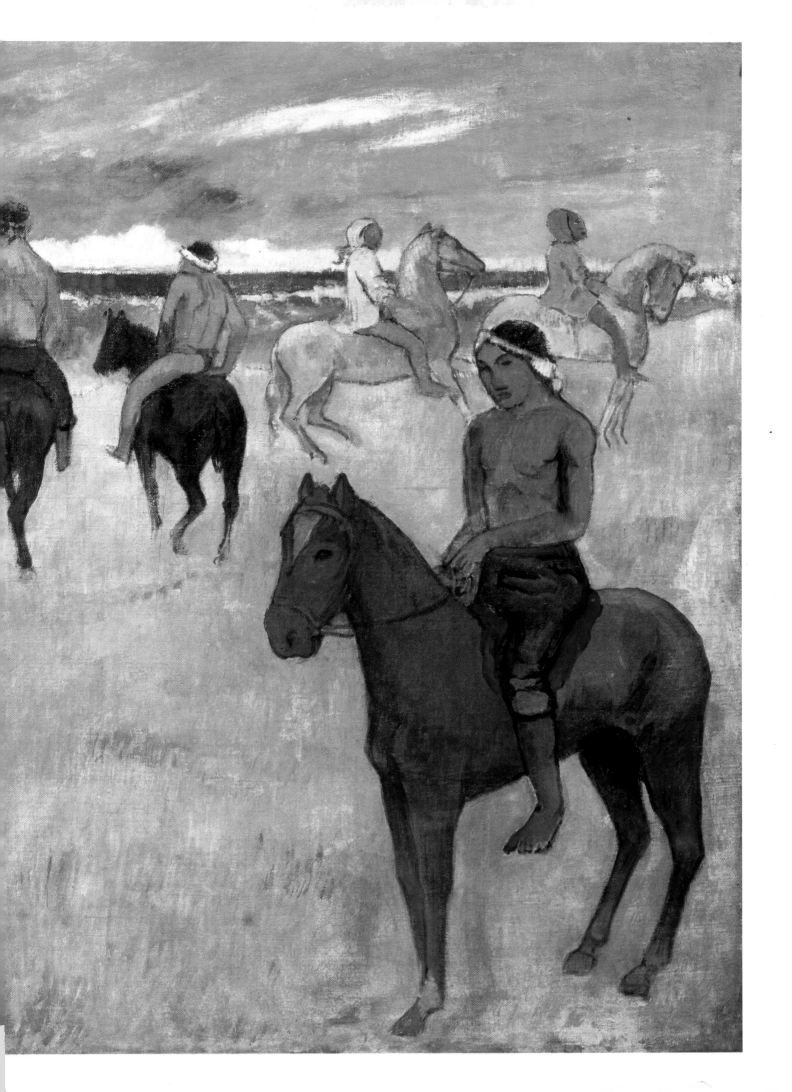

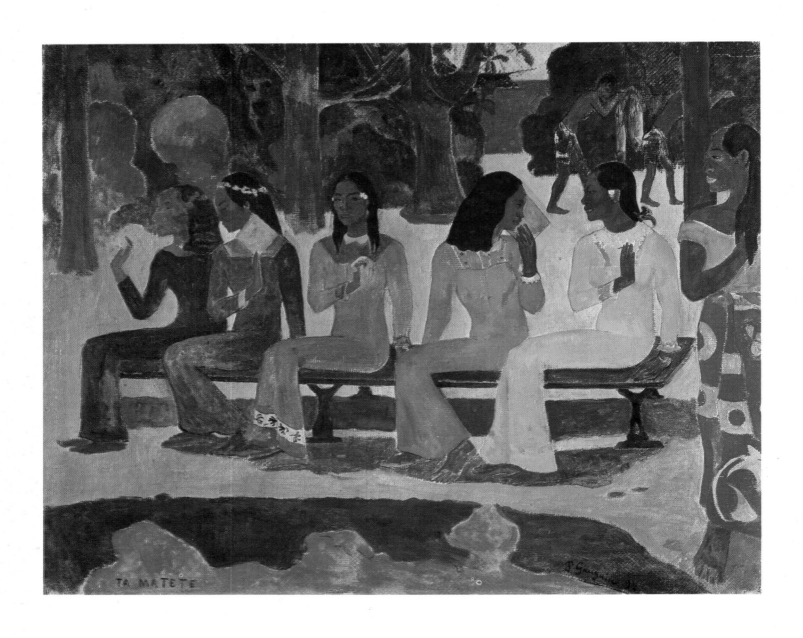

PAUL GAUGUIN

Ta Matete

1892, oil on canvas,

73 x 92 cm. (29 x 36 in.),

Basel, Kunstmuseum.

your relative the great doctor, tell him about my illness.... Since I have no money to see a doctor, tell your relative to let me know what measures I should take in the way of hygiene rather than what medicine to take."

Theo van Gogh was in charge of modern painting at Boussod-Valadon's, and it was through him that Gauguin made the acquaintance of his brother Vincent. "To get to the important part. Last Sunday I saw someone from Goupil's (Boussod-Valadon) who was very enthusiastic about my paintings and finally bought three of them for nine hundred francs, and says he will come back for more."

"My ceramic work is also to be shown to collectors. But of course I have pressing debts. And so please excuse me for not sending more at this time. Now that I am on the point of being discovered, I must make another supreme effort for my painting and am going to Brittany, to Pont-Aven, to paint for six months."

Gauguin did indeed leave for Pont-Aven, where he was joined by Charles Laval, who was just back from a trip to Martinique. Shortly after he wrote to Mette: "Since my departure, in order to preserve my mental energy, I have little by little done away with any sensitivity.... You must remember that I have two sides to my nature: the Indian and the sensitive. The sensitive side has disappeared, enabling the Indian to walk straight ahead and foursquare." We will never know what Mette herself thought of this Indian who had conquered her heart, and whose path would lead to many other beds, but never again to hers.

Be that as it may, although his sensitive side was supposed to have disappeared, he gradually expressed more and more tenderness towards Mette, and more and more often voiced his fear of being forgotten by his children. He wrote from Pont-Aven in August 1888: "I am sending you a photograph taken here by an amateur. I hope you will show it to the children, so that they will not completely forget their father."

Meanwhile, the Indian steadfastly pursued his path. The years 1888 and 1889 were decisive. In August he was joined in Brittany by Emile Bernard, accompanied this time by his mother and sister. At the time Emile Bernard was only twenty and fresh out of the Atelier Cormon, where he had met the likes of Lautrec, Anquetin and Van Gogh. He corresponded with the latter and enjoyed Cézanne's confidence. Gauguin and his junior by twenty years became good friends and spent long hours in conversation. Bernard, for his part, was familiar with the first writings of the Symbolists, whom Gauguin did not yet know. Both men had a passion for primitive art: Gauguin for that of the early civilizations and the Pacific cultures, and Bernard for that of the Late Middle Ages and the French and Italian primitives.

Maurice Denis, whose excellent memory and critical lucidity made him a valuable witness to this period, wrote that Bernard and Gauguin

"were fond of Breton Calvaries, popular imagery, and, despite their age difference, displayed the same predilection for paradoxical solutions to the problems of painting."[4]

4. Maurice Denis, *Du symbolisme et de Gauguin*, Paris, 1964.

PAUL GAUGUIN

The Teller of Tales Speaks
Noa-Noa Album, folio 67,
1894-1895, 11.5 x 22.5 cm. (5 x 9 in.),
Paris, Musée du Louvre,
Department of Drawings.

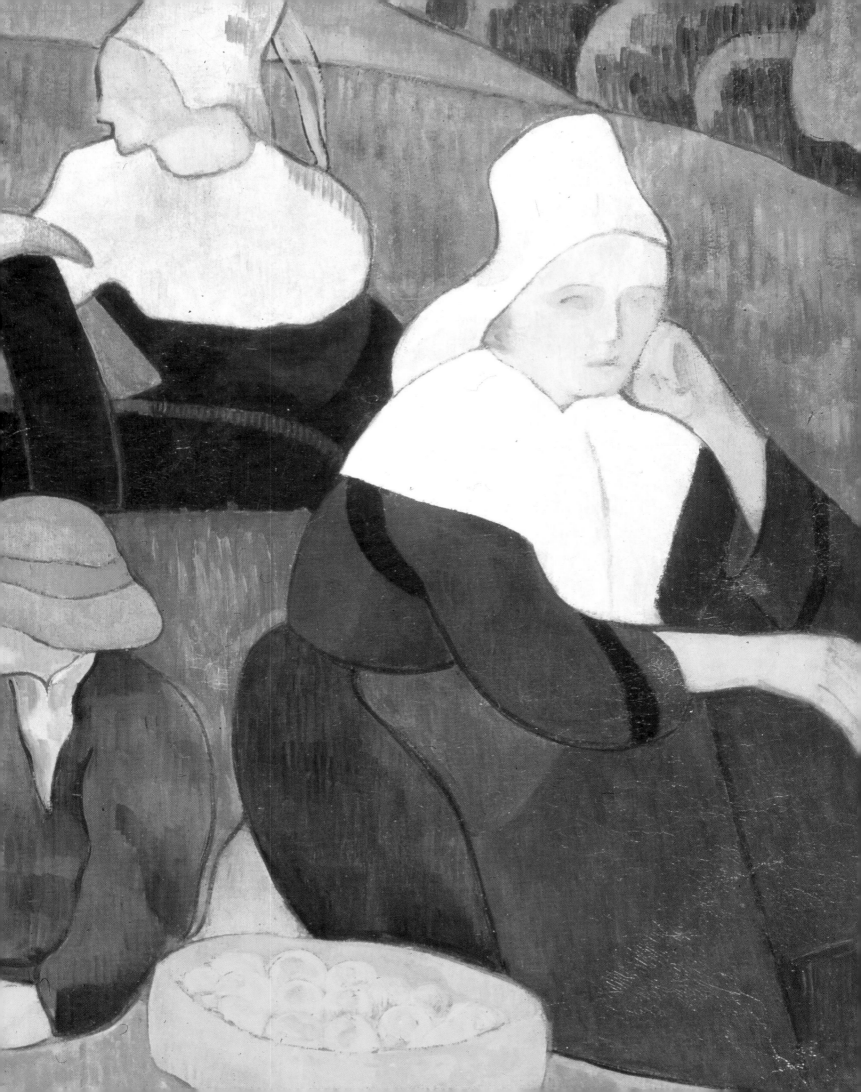

TOWARDS A NEW PAINTING

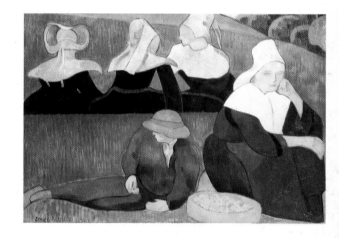

EMILE BERNARD

Bretonnerie

1892, oil on wood-mounted cardboard,

81 x 116 cm. (32 x 46 in.),

Josefowitz Collection.

A major step in this direction would be made that summer by the two painters. "Here is one who stops at nothing," Gauguin wrote, while the other guests at Madame Gloanec's would laugh at the specimens of *Cloisonnisme* ("*cloison*" is the French word for "compartment"), a style initiated by Anquetin, with whom Bernard had often discussed aesthetic matters. The Symbolist poet Edouard Dujardin, who played a key role in this period as director of *La Revue Wagnérienne*, seems to have coined the name for this new type of painting, whose invention he attributed to Anquetin: "The painter draws closed outlines to which he applies the various colours.... The painter's work is like painting in compartments analogous to cloisonné enamel, and his technique consists of a sort of *cloisonnisme*." As we can imagine, this "*cloisonnisme*" was just the sort of thing to draw Gauguin's interest after his experiments in ceramics.

A FRUSTRATED FRIENDSHIP

While working at Saint-Briac, just before moving on to Pont-Aven, Bernard met the Symbolist writer Albert Aurier, his elder by only three years. Aurier was struck by what he saw of Bernard's paintings. The two young men had long discussions in which Bernard spoke of Van Gogh and

showed his new friend the letters and sketches he had received. Bernard soon introduced all his friends to Albert Aurier, who, during his all-too-brief career, was to become the most perceptive art critic of the day, second only to Félix Fénéon.

Gauguin was completely overwhelmed by what he saw of Bernard's work. He was concerned at the time with achieving a formal synthesis to counterbalance the disintegration of forms introduced by Impressionism – and Bernard had already found it. Bernard's disquisitions on history, philosophy, aesthetics and poetry further impressed the relatively uncultured Gauguin, who was still in search of himself.

During the weeks that followed this new meeting, a close friendship developed between the forty-year-old Gauguin and the young painter who was half his age. But it was not to last: as Gauguin progressed in his experiments, he began to feel himself less and less beholden to Bernard. To Schuffenecker, he wrote: "Of course, this synthetic way is full of pitfalls, and I have only a toehold in it, but it is deep in my nature, and one must always follow one's own nature."

The mutual esteem between the two men managed to survive their respectively difficult characters. Gauguin's temperament led him to take on a dogmatic tone when he spoke on topics about which Bernard was in fact more knowledgeable, such as Japanese prints, which had such an important influence at the time. And yet, Van Gogh, writing to his brother Theo after receiving a letter from Bernard could say: "His letter is full of veneration for Gauguin's talent. He says that he considers him so great an artist that it almost frightens him." One picture of Bernard's impressed Gauguin in particular: *Breton Women in a Field*, in which their massive black dresses are counterbalanced by white head-dresses with strongly delineated contours against a flat background. Bernard, who exchanged this canvas for one of Gauguin's, was no less impressed by a picture which his friend began in September 1888.

The Vision After the Sermon, or *Jacob Wrestling with the Angel*, appeared with the impact of a pictorial manifesto. One could also speak of resonance, for Gauguin – like Delacroix and Baudelaire before him – considered "music the sister of painting," as he later wrote in *Notebook for Aline*. In a letter to André Fontainas from Tahiti (March 1899), he wrote: "Think of the musical role which colour will play in modern painting from now on. Colour is a vibration in the same sense as music, and so it can attain to what is the most general, yet most vague, in nature – its inner power."

As soon as he had finished the picture, Gauguin wrote to Van Gogh: "I have just finished a badly done religious picture, but it was interesting to do, and I like it." He then went on to list each of the colours: deep black for the costumes, red for the ground, a bright ultramarine blue for the angel and bottle green for the figure of Jacob. He concluded: "I think that I have

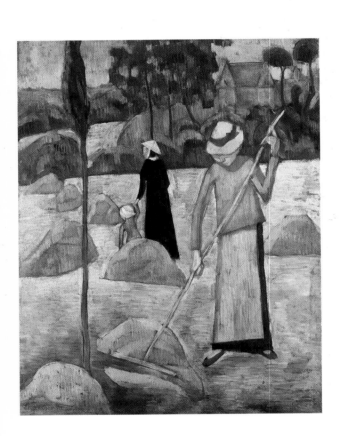

EMILE BERNARD

Woman Raking

1891, oil on canvas,

92 x 72 cm. (36 x 29 in.),

Josefowitz Collection.

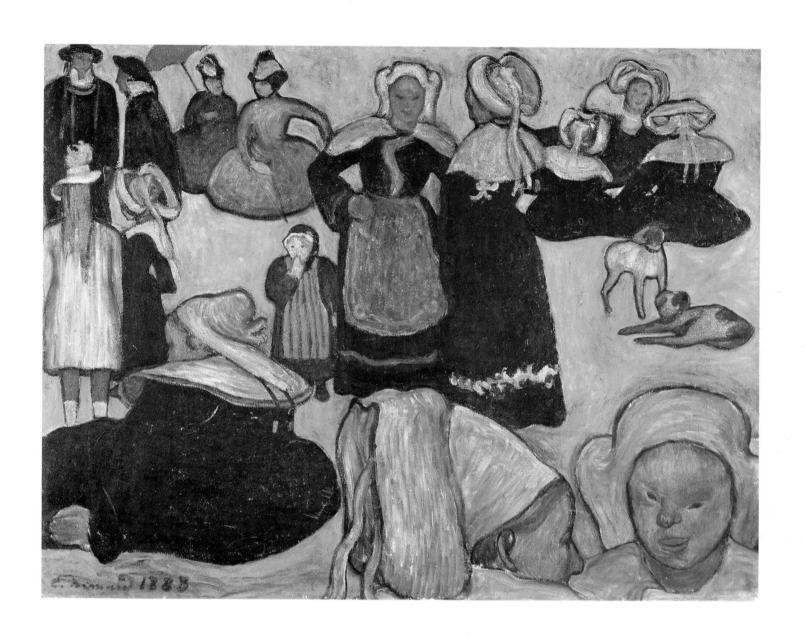

EMILE BERNARD

Breton Women in a Meadow,
or *The Pardon*
1888, oil on canvas,
74 x 92 cm. (29 x 36 in.),
private collection.

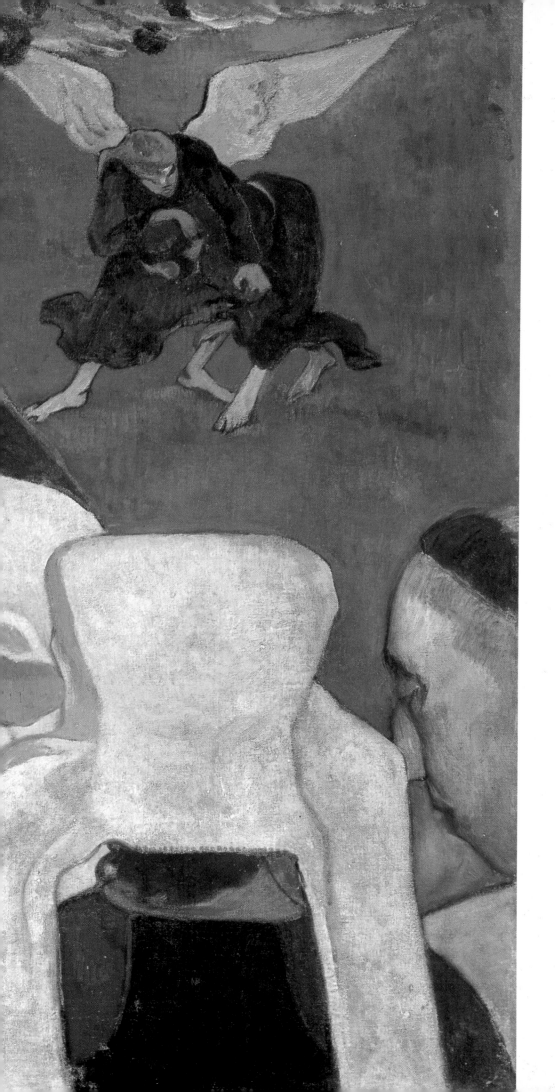

PAUL GAUGUIN

The Vision after the Sermon,
or *Jacob Wrestling with the Angel*
1888, oil on canvas,
73 x 92 cm. (29 x 36 in.),
Edinburgh, National Gallery of Scotland.

achieved great rustic and superstitious simplicity in the figures. The whole is quite severe. For me, in this painting, the landscape and the struggle exist only in the imagination of the people praying after the sermon."

Thus, what Caspar David Friedrich, the great German Romantic painter, had proclaimed at the beginning of the century had become reality by 1888: "Close your physical eyes, so that you can see the painting with the eyes of the spirit. Then bring into the light of day what you saw in your Night."

Bernard relates how he and Laval accompanied Gauguin all the way to Nizon, where there was a parish church to which he wanted to donate his *Vision After the Sermon*. The Romanesque granite church, with its primitive painted wooden statues, provided an ideal setting for the work. On the frame – which was white, as he liked his frames then – Gauguin had written in blue paint a dedication to "Don de Tristan de Moscoso." Bernard told in amusing detail how the bewildered priest refused the picture, thinking that the whole thing was a practical joke. Gauguin then sent it to Theo van Gogh, recommending that he sell it for at least six hundred francs. Schuffenecker, who had joined his friends in Brittany, was deeply impressed by the picture.

In this case, Bernard's account was good humoured and indulgent. This was not always to be the case when he spoke of this particular work: Synthetism was born, and Bernard insisted throughout his life that he was its sole inventor.

For a time still, the relationship between the two men remained cordial. Then, little by little, the tone began to sharpen. Maurice Denis wrote the most lucid analysis of the respective roles of the two painters: "Gauguin was a force of nature, a born decorator, and authentically naïve.... The other was a gifted poet and technician, with an uncommon facility of execution and assimilation, a sense of composition, and, even in his most singular inventions, an unshakeable logic." Elsewhere, Denis noted: "Perhaps he (Gauguin) did not invent Synthetism, which, after passing through the hands of the writers, became Symbolism: Emile Bernard remains adamant on this controversial point. But Gauguin was after all the Master, the unquestionable Master, the one whose words were noted, whose paradoxes were passed on from one to the other, who was admired by all for his talent, bearing, volubility, physical strength, roughness, inexhaustible imagination, resistance to alcohol, and for his romantic appearance. The mystery of his influence was that he provided us with one or two very simple ideas, of a necessary truth.... Thus, without ever having sought beauty in the classical sense, he soon had us totally preoccupied with it."[1]

It must be mentioned that, while Bernard had been a child prodigy, and a brilliant adolescent, his talent did not live up to its promise after his break with Gauguin. In 1906, Cézanne wrote: "He only draws old-

1. Maurice Denis, *Du symbolisme et de Gauguin*, Paris, 1964.

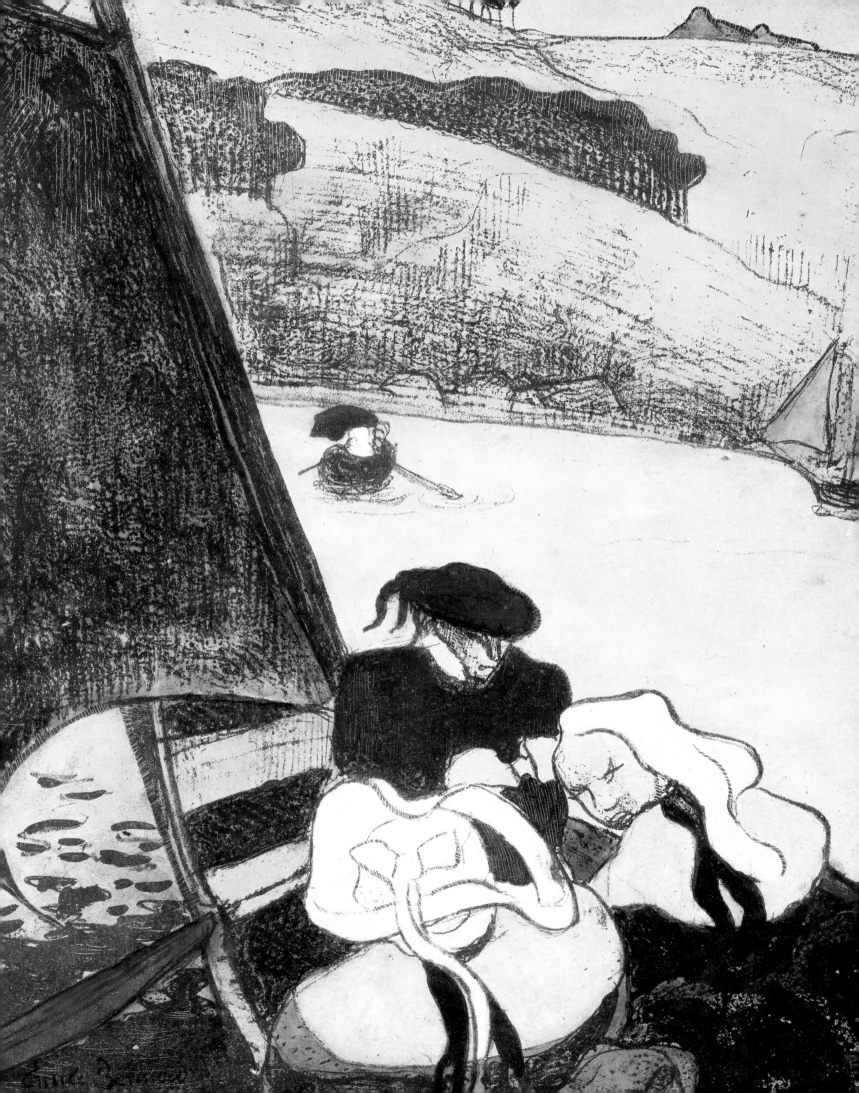

fashioned things based on his dreams of art suggested not by any emotion provoked by nature, but by what he has seen in museums, and by a philosophical spirit which he owes to his surfeit of knowledge about the masters he admires." Led astray in his quest for the "craft of the great periods of art," Bernard created nothing new before he died in 1941, at the age of seventy-two.

But fifty-three years earlier, still in that fateful year, 1888, Emile Bernard, fulfilling perfectly his role as catalyst, was responsible for bringing about a decisive encounter in the history of painting. Also at Pont-Aven that summer, was a young man who, without Bernard's repeated urging, would never have dared to approach Gauguin himself. This twenty-five-year-old painter would soon become the initiator and theoretician of a movement that was destined to have a profound effect on the art of our own time. He also became its godfather by giving it the name of the *Nabi* Movement for very personal reasons which we are about to elucidate.

THE FIRST NABI

Paul Sérusier (1863-1927) was born into a family from the North of France. His father was the director of the famous Houbigant perfume company. His brother Henri reminisced that he was raised amid the scent of roses and became such a fervent admirer of things Oriental that he studied Arabic and Hebrew at an early age. He was an excellent student, and also displayed literary and artistic gifts. Having passed his two *baccalauréats*, he began working in a stationery store, because his father did not want him to pursue a career in the arts.

Struck by Paul's gifts and conviction, a doctor who was treating him for a work accident persuaded his father to allow him to follow his artistic inclination. In 1888 he was accepted at the Académie Julian and awarded an "honourable mention" at the Salon for an extremely banal subject, *Weavers in Brittany*. He had painted it the year before at Pont-Aven, a town of several thousand inhabitants who lived from the fishing port and wheat trading, where he had spent the summer in the company of so many other painters.

Sérusier returned the following year and, it may be presumed, continued to work in the same vein, for none of his efforts has been preserved. The summer season was in full swing, with artists and other students from the Académie Julian congregating there in ever greater numbers. The prices were still low enough, but steadily rising owing to the spot's increasing popularity. Sérusier stayed at the Auberge Gloanec, and joined the group of other courtiers seeking official recognition. At that time, the prevailing mood was not kindly disposed towards Impressionism, a term then indiscriminately applied to those who had heeded the lessons of 1874

EMILE BERNARD
Still Life with Tobacco Jar
1892, oil on canvas,
33 x 54 cm. (13 x 21 in.),
Josefowitz Collection.

EMILE BERNARD
Breton Women with Kelp
1892, oil on canvas,
81 x 63.5 cm. (32 x 25 in.),
Josefowitz Collection.

(date of the first Impressionist exhibition) as well as those who had already progressed.

Several of the latter were there, but were content to keep themselves to themselves without paying much attention to their detractors. Like Gide in the following year at Le Pouldu – although with more at stake – the young Sérusier looked at their jovial company with apprehension and envy. In fact, Gauguin and his friends no longer took their meals at the same table as the "*pompiers.*" The two groups were nevertheless known to join forces and as Van Gogh (passing on information from Gauguin) wrote to Theo: "They amuse themselves discussing and battling with the virtuous Englishmen."

At the end of his stay, and at Bernard's prompting, Sérusier decided to show one of his works to Gauguin. The latter, who was still recovering from his dysentery, received him at his bedside in the company of Laval. Since the young visitor was on the point of returning to Paris, Gauguin proposed giving him a lesson the next day. The following morning, the two new friends crossed the bridge over the Aven and headed for a wood called the Bois d'Amour. Sérusier had his paints, brushes and a small wooden panel. The story, spread by Maurice Denis, is that this panel was actually the bottom of a cigar box, a base often used by Seurat. Actually, it was a standard panel measuring 27.5 x 21 cm, of the type described as "Format 3" by art suppliers at the time.

Thus equipped, Sérusier followed his companion to the Bois d'Amour, a favourite haunt of artists and lovers alike. There, he painted a landscape under Gauguin's direction: "How do you see these trees? They are yellow. Well, then, apply some yellow. That bluish shadow, paint it with pure ultramarine blue. These red leaves? Try vermilion." And in this way, a "formless landscape" came into being: "A landscape that is formless by dint of being synthetically formulated in violet, vermilion, veronese green and other pure colours, directly as they come out of the tube, with almost no white added."

Sérusier returned to the Académie Julian the same evening. Gauguin left on 21 October 1888 to meet Van Gogh in Arles.

A detailed account of the complex relationship between Van Gogh and Gauguin in Provence – before their disastrous quarrel – would be beyond the scope of this book and may be found in other publications. Briefly, they lived in a small house furnished by Van Gogh, they painted side by side, frequented the bordellos together, engaged in often highly charged discussions and drank together, something that Gauguin was far better equipped to handle than Vincent. There was talk of establishing a studio in the South of France, but Van Gogh somehow sensed that his guest was more interested in returning to the capital. Disappointed, afraid of finding himself alone again, he became more and more tense as the Christmas holidays approached.

On the evening of 23 December Van Gogh threw a glass of absinthe into his friend's face. He apologized the next day. Later that same day, as the two were crossing the town square, Van Gogh lunged at Gauguin with an open razor, but managed to restrain himself. Gauguin deemed it safer to spend the night at the hotel.

When he returned to the house early on Christmas morning there was a crowd in front of the door. He was told that, on the previous evening, Van Gogh had cut off his own ear. In fact he had only cut off an earlobe, and, once he had stopped the bleeding, he wrapped the piece of flesh and took it to the bordello he frequented and asked that it be given to a woman named Gaby.

Given permission by the police to enter the house, Gauguin had Vincent taken to the hospital, then he sent Theo a telegram urging him to come as soon as possible, and took the next train back to Paris, although according to some authors, he stayed in Arles and returned to the capital with Theo only on the 26th. Van Gogh had a violent fit of delirium and was interned in an asylum. The two men were never to see each other again.

Almost forty-seven years later, the poet Antonin Artaud (who was in the best position to know) succinctly formulated their respective quest: "I believe that Gauguin thought that the artist should seek symbols and myths, that he should raise life to the level of myth, while Van Gogh thought that he should be able to deduce myths from the lowliest things in life."

A YEAR UNLIKE OTHERS

Back in Paris, Gauguin went to Schuffenecker's again. Schuffenecker had been informed two weeks earlier of his friend's intention to leave Arles and had written back telling him that he was waiting for him "with open arms." No sooner had he settled in than Gauguin somewhat cold-bloodedly accompanied his host to witness a public execution at dawn in front of the Petite Roquette prison on 28 December. He subsequently rented a studio in the avenue Montsouris, not far from Schuffenecker's apartment in the rue Boulard.

He began a portrait of *The Schuffenecker Family*, which he reworked in May and June. This revealing portrait shows an almost caricatural Schuffenecker eyeing his wife like some obsequious inn-keeper receiving his clientele. Louise Schuffenecker dominates the centre of the composition with her two children. Her facial expression is severe, almost hostile. Nonetheless, she inspired Gauguin enough to become the subject of several works: a plaster bust made at the time she was married (1880), a vase in the form of a woman's bust (1888) and an enamelled stoneware vase with touches of gold.

Opposite and next pages

PAUL GAUGUIN

Schuffenecker's Studio,

or *The Schuffenecker Family*

1889, oil on canvas,

73 x 92 cm. (29 x 36 in.),

Paris, Musée d'Orsay.

During his first weeks back in Paris, Gauguin worked mainly on his ceramics. He continued during the course of the year, creating pieces like the stoneware *Black Venus*, which reveal the importance of ceramics and sculpture in his transition to Symbolism. At the same time, he was on the lookout for any opportunity that would contribute to his fame. As he wrote to Schuffenecker, he felt that he was benefiting from "very steady favourable winds." He was proved right when the *Groupe des XX* invited him to take part in their annual exhibition in Brussels, thus honouring him as they had regularly honoured Seurat and his Pointillist disciples.

The year 1889 was an eventful one; it was marked by the "Boulangiste" incident, the Panama scandal and a World Fair. It was also marked by a strong reaction against Naturalism. The cultural climate was at last in favour of the new aesthetic directions already explored by the masters of Pont-Aven, and primarily by Gauguin.

Also in 1889, Gauguin befriended two artists who, each in his own way, were to play an important role in his life. He had met Odilon Redon three years before at an exhibition of the *Groupe des XX* in Brussels, but the two men really became friends only when Gauguin returned from the Midi. Redon's avowed admiration must have been a valuable source of moral support for Gauguin, and it certainly contributed to his prestige in the eyes of the Symbolists. During this same period, thanks to Theo van Gogh, Gauguin also met Meyer de Haan, who was to become a faithful disciple and a very helpful friend.

In addition to all this, the year 1889 saw two even more decisive events for Gauguin's career: the creation of the Nabi Group and the exhibition at the Volpini Café.

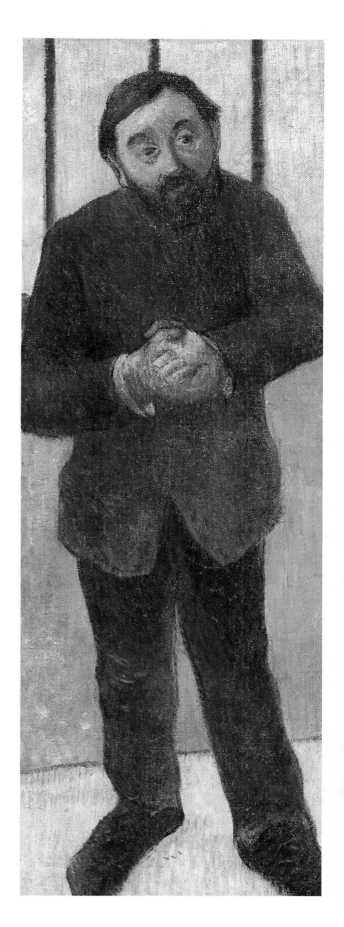

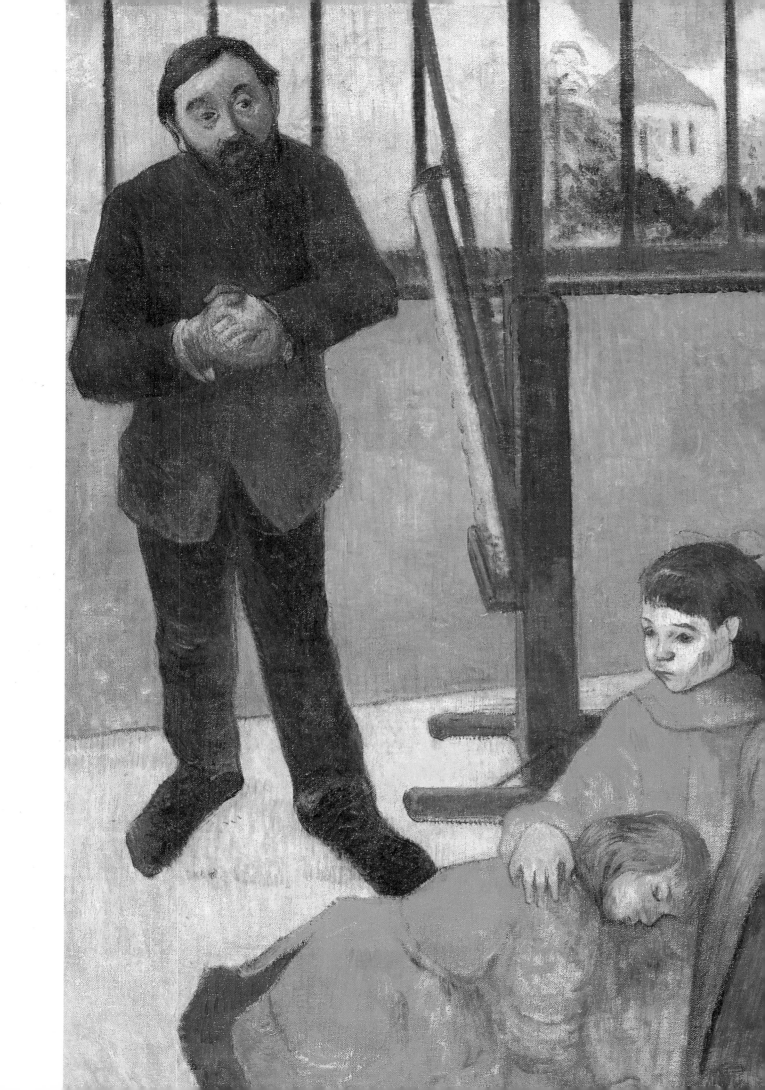

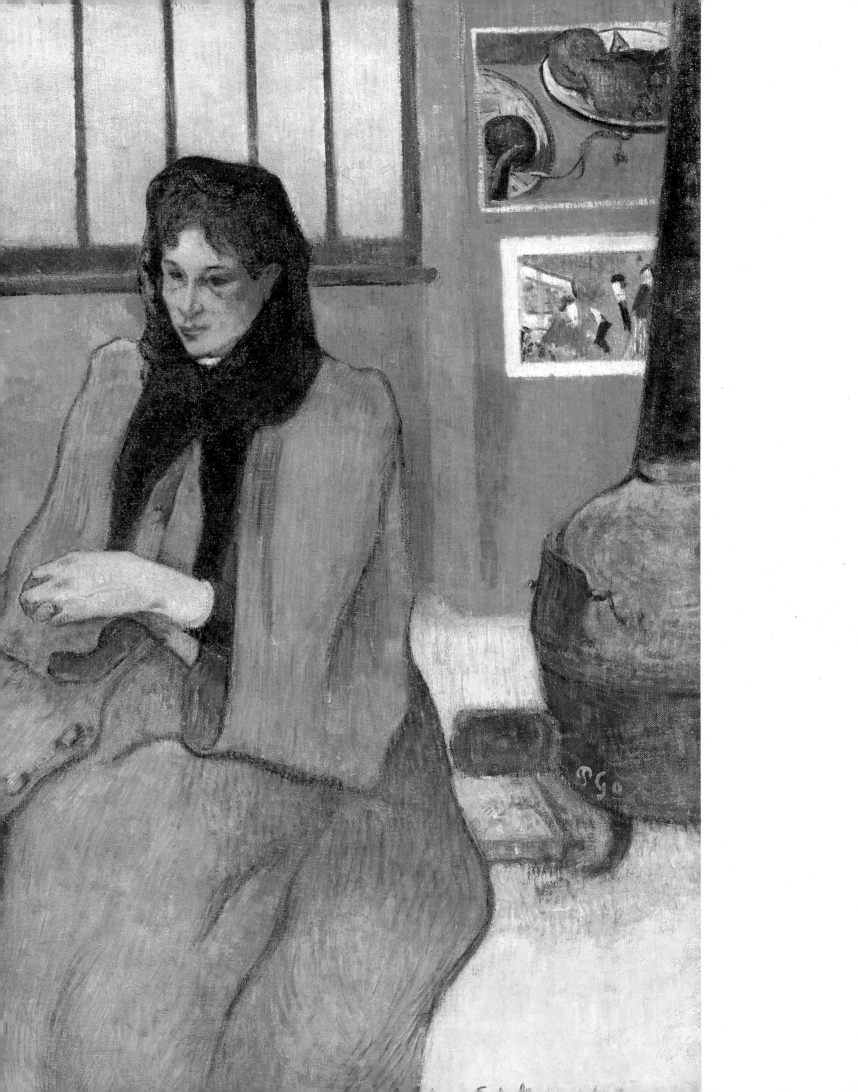

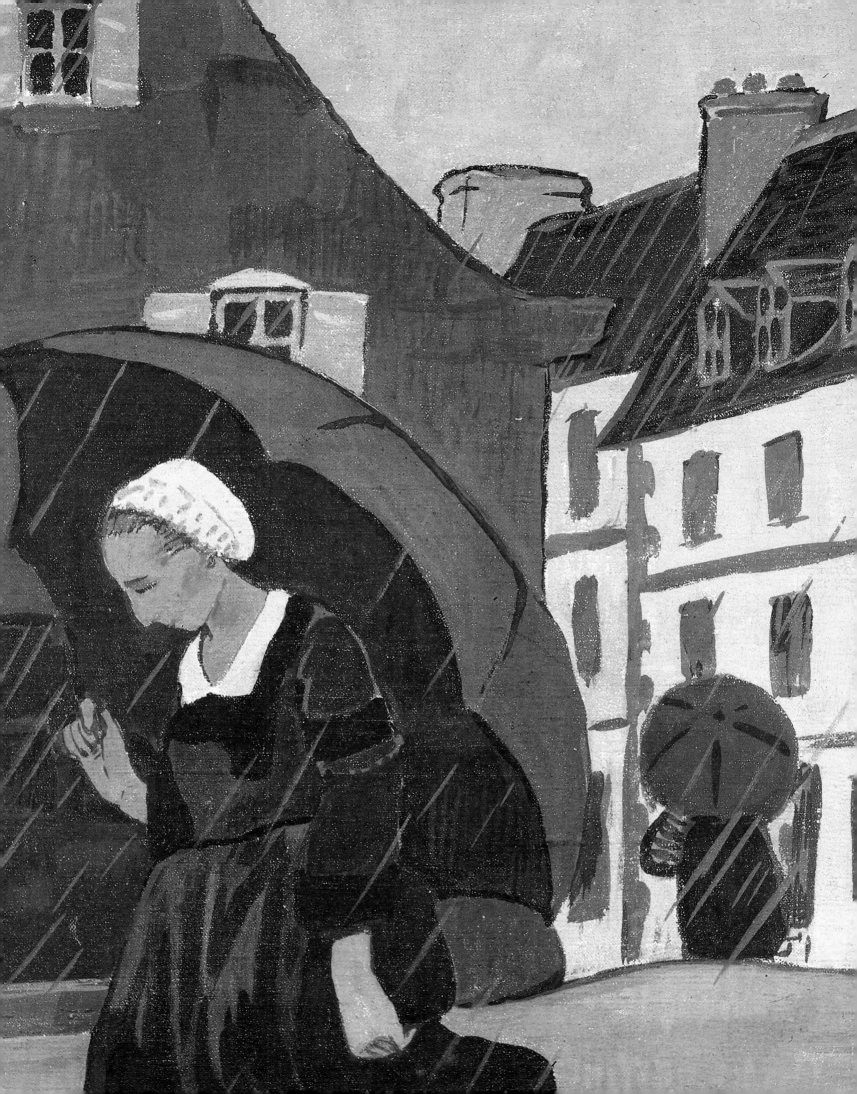

ADVENT OF THE NABIS

During his stay in Arles, Gauguin probably did not think about the small picture that Sérusier had painted under his direction. But the panel made a profound impression on a number of the students at the Académie Julian, who were preoccupied with questions to which official teaching provided no answer.

There are few movements in the history of art whose actual genesis – the who, when and where – is as precisely known as that of the Nabis. Nor has there been any other group of this kind that developed out of friendships made in high school.

The teaching establishment in question, located in the rue du Havre in Paris, not far from the Gare Saint-Lazare, was called the Lycée Condorcet. Paul Sérusier studied there up to his *baccalauréat*, as well as the younger Maurice Denis, Ker Xavier Roussel and Vuillard, who was awarded the prize for excellence in 1884 at the end of his second year. Also in that year, the same honour was conferred upon Koechlin, whose later musical work was inspired by the same spirit as that of the Nabis in painting. Other noteworthy pupils were Albert de Broglie, a future member of the Academy of Sciences, Thadée Natanson, who was to become a staunch defender of the Nabis in the pages of the *La Revue Blanche*, as well as Marcel Proust and Lugné-Poë, who

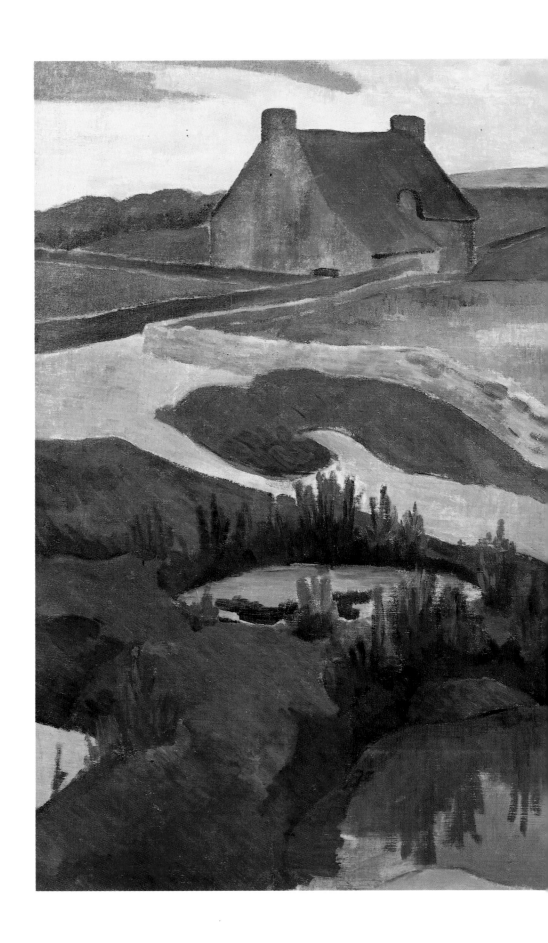

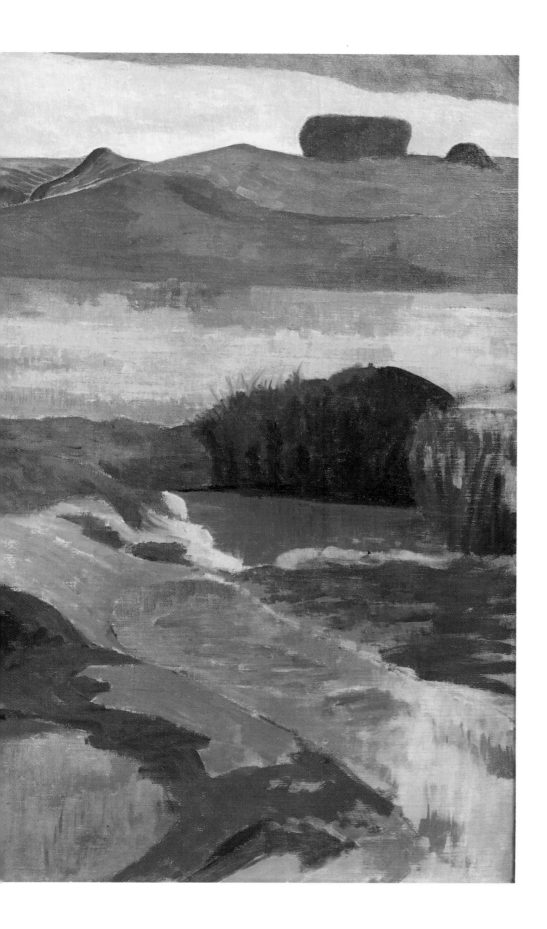

PAUL SERUSIER

Cottage with Three Ponds
1889, oil on canvas,
73 x 92 cm. (29 x 36 in.),
Josefowitz Collection.

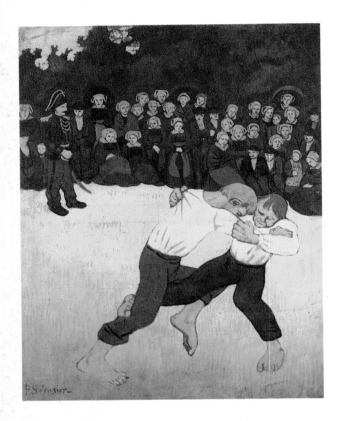

Opposite and above (detail)

PAUL SERUSIER

Breton Wrestling Match

1890, oil on canvas,

92 x 73 cm. (29 x 36 in.),

Paris, Musée d'Orsay.

Next pages

PAUL SERUSIER

The Ocean at Le Pouldu

Around 1889, oil on unprimed canvas,

55.5 x 79 cm. (22 x 31 in.),

Josefowitz Collection.

later distinguished himself as a theatre director and brought his former class-mates to apply their talents to the stage.

What made the Lycée Condorcet so special was that it was the only secondary school in Paris to admit day students. The pupils would go home for lunch and return there in the evening when their classes were finished. Mornings and evenings, many coaches (and some of the first automobiles) drove up to the school, for most of the boys came from wealthy families.

However, this was not the case for all: Vuillard's mother, for instance, had been widowed and supported her three children and mother by working as a dressmaker. But all the students, whether rich or poor, were plunged in the special atmosphere of the Lycée Condorcet, which had a high academic level that everybody pretended to take in their stride.

In 1860, when it was still called the Lycée Bonaparte, one principal described the conditions that still obtained when Proust and Vuillard studied there: "Nobody seems to be working; they spend half their time on the school-benches and the other half out in society. Yet the students are the cream of the crop, the ones who regularly pass the admissions examination to the Ecole Normale with flying colours. When the time comes, they prove to be wizards in Latin and Greek, even if, up until then, they seem only to have been concerned with excelling at billiards."

The arts were held in high esteem at Condorcet, as we can see from this portrait in verse of a typical student:

"He knows pastel and has seen the seascape
Displayed just yesterday in Goupil's showcase."

In retrospect, we can safely say that Sérusier, Roussel, Vuillard and Maurice Denis remained faithful to the spirit of the place.

THE ACADEMIE JULIAN

The Académie Julian, like the Académie Colarossi, the Grande Chaumière and the Atelier Cormon, was the kind of institution to which aspiring painters from all over the world would come to learn their craft. Craft was a very serious matter there, and the masters taught the skills required to win medals at the official Salon. As Maurice Denis recalled: "Crass realism had been replaced by the fey academicism of Ingres' last disciples, and one of our teachers, Doucet, advised us to give added interest to a sketch depicting a scene from the Passion of Christ by consulting photographs of Jerusalem." The goal of these efforts was to make a dignified showing at the Salon, where, in 1888 (fourteen years after the first exhibition of the Impressionists), one could still admire such gems as Bouguereau's *First Bereavement*, Joseph Brail's *Badinage (Light Conversation)*, Gérôme's *Thirst*, and especially Detaille's *Dream*, which was the most sought after picture at the Louvre – second only to the *Mona Lisa*!

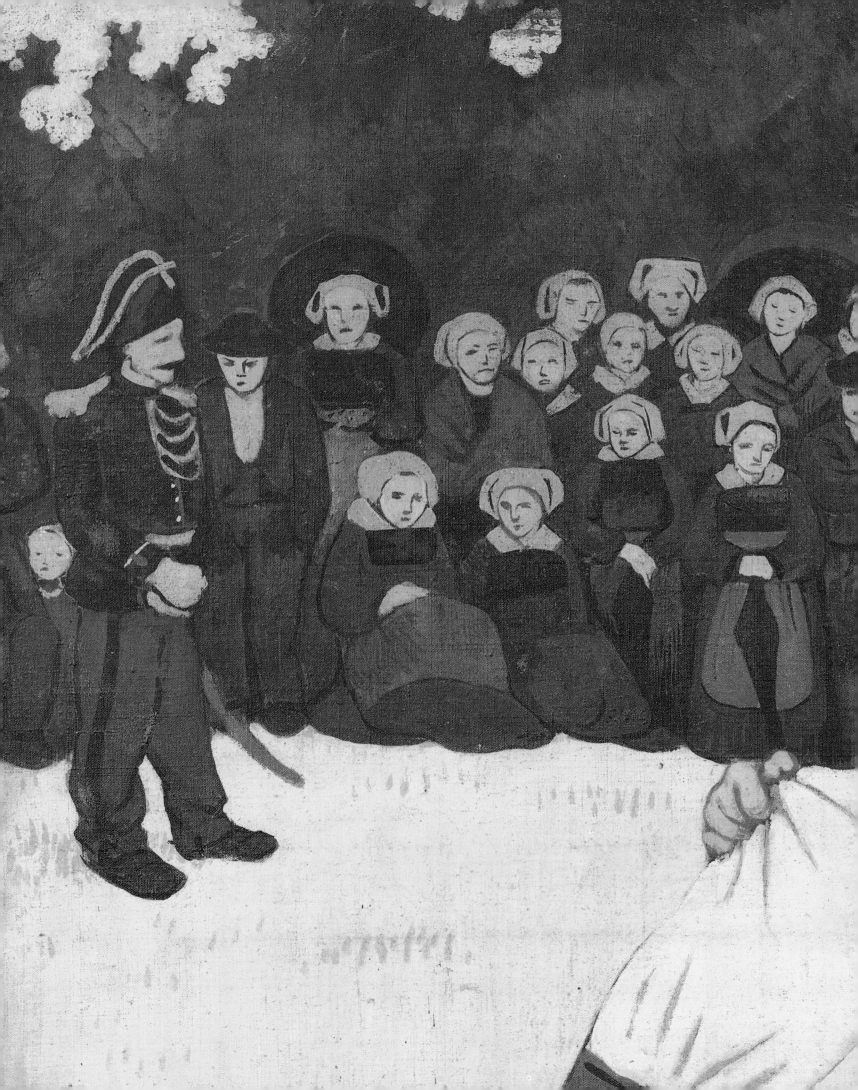

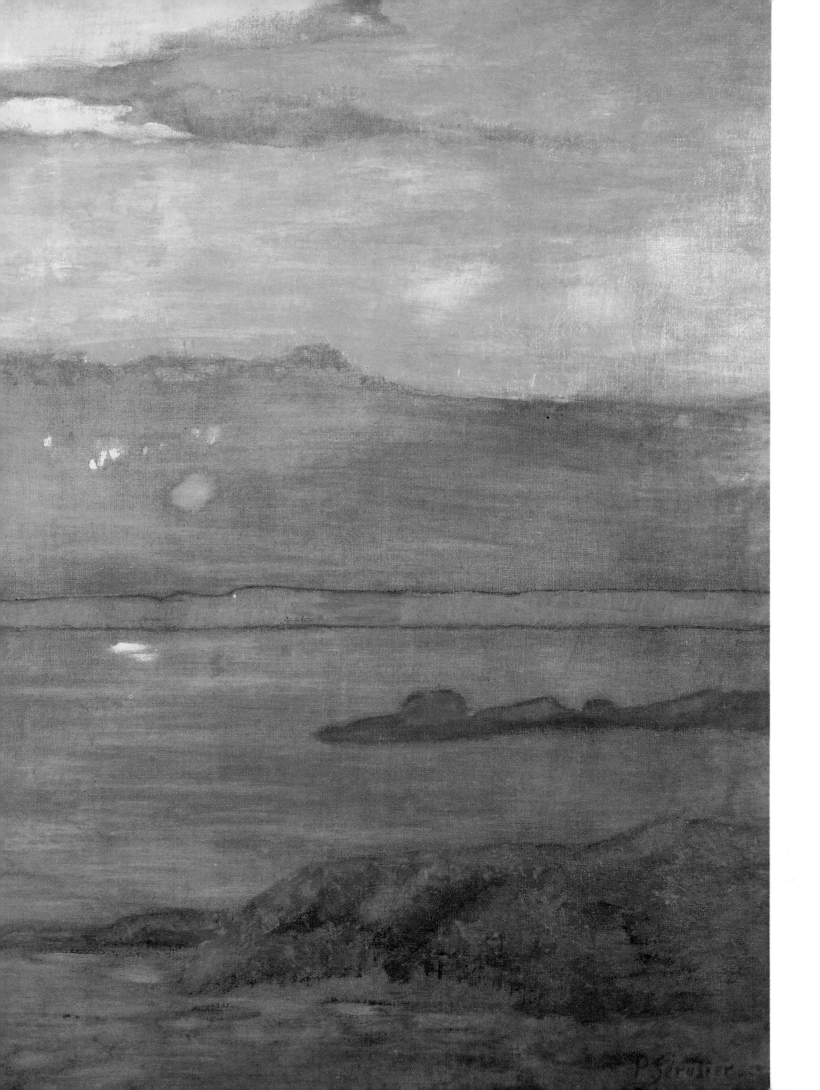

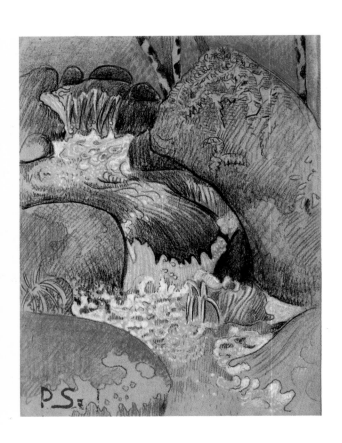

So many painters passed through the Académie Julian that we are well informed on what went on there (the accounts are sufficiently convergent to inspire confidence). Maurice Denis talks about "overly conscientious Americans applying themselves studiously and stupidly to copying, in poor lighting, the banal forms of some insignificant model." The English painter John Rothenstein, who was seventeen years old in 1888 when he attended Julian, mentions another side of these fastidious Americans, whom no one dared to attack too openly, for they were excellent boxers.

Discipline, on the whole, was non-existent and fights were a regular occurrence. Rothenstein writes: "There were so many of us crowded together that our easels touched, the air was unfit to breathe, and the noise deafening. From time to time, there would be a few minutes of silence, then, all of a sudden, someone would break out in song. The Frenchmen learned the foreign tunes amazingly fast and at least the sound, if not the sense, of the lyrics. Arguments would break out all the time, and the jokes were very cruel." Maurice Denis spoke of the inconceivable vulgarity and ignorance of the art students.

The situation was somewhat different in the studios supervised by Sérusier. Maurice Denis recalled that a great air of mystery and careful oratory preceded the unveiling to a privileged few of the painting from the Bois d'Amour which he already called *The Talisman*. To get an idea of the spiritual and emotional impact with which this word endowed the picture – in effect, Gauguin's personal missive – we must take a closer look at Sérusier, the man and the artist.

When Maurice Denis entered the Académie Julian in early 1888, he was busy preparing not only his *baccalauréat* examination in philosophy, but also the entrance exam for the *Ecole des Beaux-Arts*. One day, Sérusier found one of his textbooks and subjected him to a mock examination: "Tell me what you know about antinomies, about alexandrines.... Study Plotinus, don't neglect your Porphyrus, but above all steer away from Jamblicus."

This kind of sport was just the thing to capture the imagination of the earnest and gifted young Sérusier. When he returned from Pont-Aven that autumn, with the panel from the Bois d'Amour in his hand, he discovered in Maurice Denis the first zealous proponent of his doctrine. At the same time, Denis was to become a privileged witness to the birth of the movement that developed out of the revelation of *The Talisman*.

We have already cited the kind of advice that Doucet gave his students. However, this did not mean that he was not open to innovators like Pierre Bonnard, H.G. Ibels and Paul Ranson, who soon joined the group around Sérusier and Denis. But Doucet's indulgence became strained when the rivalry between the more academically inclined painters and those obstinately referred to as the Impressionists sharpened, due mainly to the

aggressive stance of the innovators. Maurice Denis writes that "it was in the midst of these outbursts of hostility and enthusiasm that Sérusier had the idea of meeting regularly in a bistrot in the Passage Brady, not far from the Académie Julian. It was there that the Nabis – a term coined from the Hebrew word for prophet, *Nebiim* – would convene for dinner." Sérusier had taken the term from Cazalis, who took lessons in Hebrew from Ledrain, then very much in vogue through his translations of the Bible. In this way, Denis explains, "he gave us a name which, in the context of the atelier system, made us initiates and members of a sort of mystical secret society, and proclaimed that the state of prophetic enthusiasm was a natural one for us. He was fond of using Hebrew words that had been put into circulation by Ledrain's Bible: thus, he would refer to models and other women of easy virtue as daughters *of Pelichtim* or *Quedeschim*" (the latter were excluded from the Nabis' dinners after one unfortunate experience).[1]

In those days, the term *Nebiim* applied only to the initial core of members and their activity consisted mainly in arguing with their benighted fellow-students at the Académie Julian. Before the dinners in the Passage Brady, they would first have a drink at the Crucifix (this was the actual name of a number of Parisian cafés, as well as the brand name of a popular apéritif). The dinners were held in a rather sordid restaurant located on the mezzanine of a building in the passage. These group meals were not the usual gatherings of art students but the occasion for earnest and interminable discussions of aesthetic and artistic issues. Nor did they exclude spectacular pranks, which Denis says were the speciality of Sérusier and Ranson.

During the course of 1889, the number of *Nebiim* increased and they became more assertive in their convictions. They were also greatly affected by an exhibition which, although it has since become a landmark in the history of art, went virtually unnoticed at the time.

THE VOLPINI CAFE

Preparations for the *Exposition Universelle* commemorating the centennial of the French Revolution were progressing at a feverish pace. Nevertheless, as was to be expected in this monumental sort of undertaking, delay was heaped upon delay. Among those most directly affected by this state of affairs was Volpini, the Italian owner of a well-known café on the Boulevards who had decided to open another one near the exhibition site and had called it the *Grand Café des Beaux-Arts* because it was located near the official art section.

There was no chance that Gauguin and his friends could show their work in this section, which was to include a centennial retrospective of

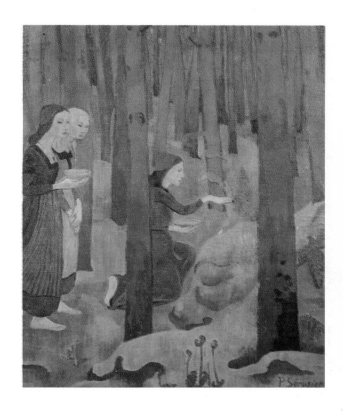

PAUL SERUSIER

The Incantation,

or *The Sacred Woods*

1891, oil on canvas,

Quimper, Musée des Beaux-Arts.

1. Maurice Denis, *in* « Sérusier », *ABC de la peinture*, Paris, 1942.

French art organized by the critic Roger Marx. The latter, an ardent supporter of the Impressionists, succeeded in exhibiting a work by Cézanne only through a subterfuge: the collector Victor Choquet, a friend of his, had agreed to a loan of his beautiful period furniture on the condition that at least one painting by the master from Aix would also be shown.

One day, Schuffenecker, like so many other visitors, was strolling through the exhibition to get an overview, when he came across a building still under construction and went to have a look at it, attracted no doubt by the name *Grand Café des Beaux-Arts*.

He engaged the owner in conversation and soon learned that he was furious because the mirror-panels ordered from Saint-Gobain to decorate the walls would not be delivered in time. Although Schuffenecker was described by some as "stupid," he had enough presence of mind to advise Volpini to cover the walls with red cloth and to hang on it pictures by young painters whom he offered to recruit for the occasion. Volpini was quite agreeable to this idea especially as it would be far less costly than the Saint-Gobain decoration.

Gauguin, then in Pont-Aven, heard the good news from Schuffenecker in a letter and replied: "Bravo! You've done it. Go and see Theo van Gogh and organize it with him until the end of my stay here. Just remember that this is not an exhibition for others. In other words, let's settle on a small group of friends and, as far as that is concerned, I want to be represented as much as possible. Do what you think is best for my interests, depending upon the space available."

Gauguin then listed ten works from Bretagne, Martinique and Arles that he wanted to show and ended with: "Imagine that we are the ones doing the inviting. I refuse to exhibit the others. Pissarro, Seurat, etc.... This is our group! I wanted to exhibit very little, but Laval told me that it is my turn and that it would be wrong for me to work for the others."

Changes were made in the initial list of guest artists that had been established. Guillaumin, an inexplicable choice on Gauguin's part, turned the offer down. Theo, not at all keen on seeing Vincent admitted to the *Exposition Universelle* through the back door, refused to lend any of his brother's works. Vincent, however, regretted this decision when he was informed of it, for he had already exhibited in cafés on two occasions.

Gauguin had originally intended to exhibit only fifty paintings, but Volpini's premises turned out to be larger than anticipated, and the exhibition eventually consisted of almost one hundred works, including paintings, drawings and watercolours.

Bernard, who quarrelled with Gauguin shortly afterwards, was the best-represented painter, with over twenty pictures and several "peintures au pétrole," which he presented under the pseudonym of Ludovic Nemo. Schuffenecker had twenty works, while Gauguin showed only

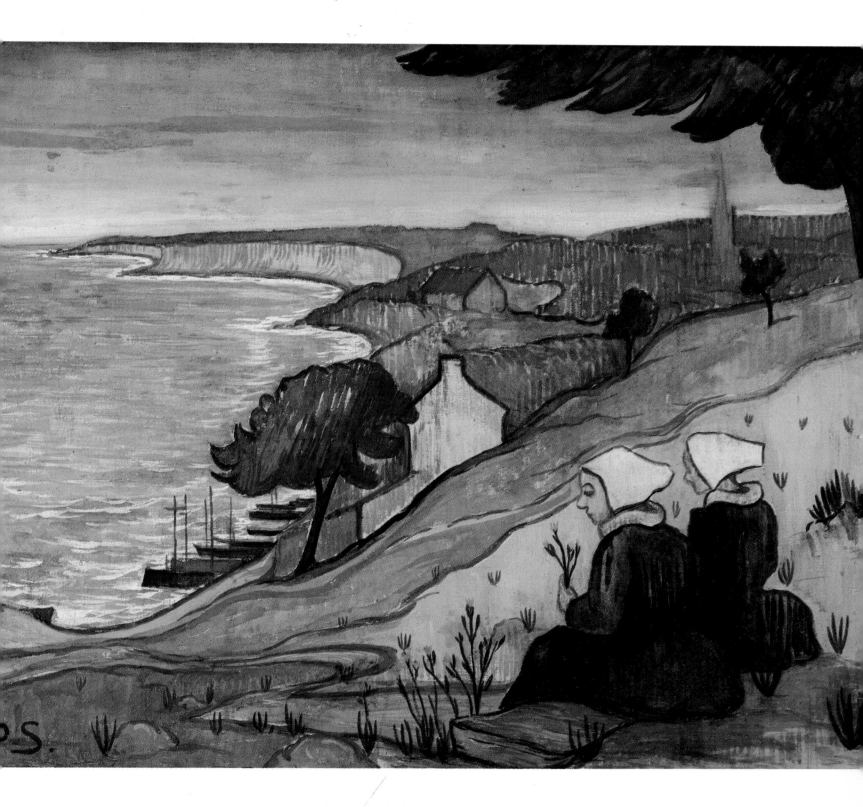

PAUL SERUSIER

Breton Women at Le Pouldu

1892, egg tempera on canvas,

57 x 70 cm. (22 x 28 in.),

Josefowitz Collection.

seventeen, Laval ten, Anquetin and Roy seven each, Fauché five and Daniel de Monfreid three.

What name could be given to such an exhibition? All the advocates of the new painting, including Gauguin and Van Gogh, were referred to as "Impressionists." Seurat and his followers clearly acknowledged their debt and difference by proclaiming themselves "Post-Impressionists," thus restricting the application of an otherwise excellent term. Gauguin chose to call the painters brought together in this unique exhibition the *Impressionist and Synthetist Group*, but did not explain the name.

Great care was taken so that the event would not pass unnoticed. Gauguin returned to Paris to make sure that everything was in good order. Standing on each others' shoulders, he and his friends put up a great number of posters in the streets – high enough to be out of reach. Sympathizers were also pressed into service: Bernard asked Albert Aurier to devote a special issue of his review, *Le Moderniste* to the exhibition. Aurier did not comply, but he did begin his review of the Centennial with several lines of praise for the painters who had been reduced to "hanging their canvases on the walls of a café." He also saw to it that a number of avant-garde periodicals printed reviews of the exhibition in the Volpini café.

Writing in *La Vogue*, the Symbolist Gustave Kahn deplored the poor conditions under which Gauguin's pictures were shown, but did not have anything good to say about the other participants. Félix Fénéon's article on the Impressionist and Synthetist Group, which appeared in the July issue of *La Cravache*, gives a good idea of the setting and its mood: "Access to these pictures is prevented by an assortment of buffets, beer faucets, tables, the corsage of Mr. Volpini's cashier and an orchestra of young Muscovites which fills the vast hall with sounds that have no bearing on the tone compositions."[2]

Gauguin paid special attention to another passage in this article, in which Fénéon said: "It is very likely that Mr. Anquetin's manner – well-defined contours, flat and saturated colours – has had an influence on Mr. Paul Gauguin: a purely formal influence, though, for there is not a hint of feeling in his intelligent, decorative pictures." Gauguin never forgave Fénéon for suggesting that he was influenced by Anquetin, whom he did not even know. However, the critic was right in pointing out that Gauguin's work presented a dimension that was entirely lacking in that of his presumed precursor.

Not a single word appeared in the daily press, and – of course – not a single picture was sold. Gauguin was deeply disappointed and lost no time in returning to Pont-Aven. His dismay was the greater because of his earlier enthusiasm for the *Exposition Universelle*; he had been especially

2. Félix Fénéon, *Œuvres plus que complètes*, Droz, Paris, 1953.

fascinated by the reconstitutions of the Temple of Angkor Wat and a Javanese village, and by the native dancers who performed there. He even took photographs of Cambodia back to Brittany with him. Some time later, having finally met Aurier through Bernard, he published an article in *Le Moderniste* in which he praised the Eiffel Tower and its "Gothic steel tracery."

Gauguin had every reason to consider the Volpini venture as a resounding fiasco. Yet it was to have some fortunate results. Sérusier often brought his friends to the café when he introduced them to Gauguin's ideas. There, they could see a representative selection of his works, and they were all equally impressed and influenced by what they saw. They soon pronounced themselves prophets of Gauguin's persuasion. Sérusier, who had hesitated at first, wrote a letter to Gauguin stating: "I am one of yours."

Other artists joined the movement. Maillol reminisced that what he had seen of Gauguin's work amounted to nothing less than a pictorial revelation. He later met him and sought his advice. More inclined to frequenting cafés than museums, Suzanne Valadon also found her way to Volpini's: fifty years later, she reported that when she discovered the technique of the Pont-Aven group, she decided to apply it to naturalistic subjects "without any trace of aestheticism."

HEYDAY OF THE AESTHETES

If Suzanne Valadon and others preferred to keep aloof from "aestheticism," there were scores of painters, artists, and writers who had no such resistance to its appeal. *Snobisme oblige*, a certain portion of the public, not necessarily fully understanding the efforts of the innovators, declared itself sympathetic to aestheticism as if it were part and parcel of the "fin-de-siècle" spirit.

The term "Aesthetics" traditionally refers to that branch of philosophical inquiry devoted to the so-called science of Beauty. But at this particular period, a new meaning had been introduced from England, at the same time as the word "aesthete." Aesthetics was the cult of Beauty, and the aesthete its worshipper.

The Symbolists and Nabis were not exempt from aestheticism, for it was in the air at the time. Art was the royal road to Beauty, according to the English Pre-Raphaelites, whose works could be seen at the 1889 Exhibition. Their influence increased over the years, and to such an extent that Degas, profoundly irritated, quipped with typical ferocity: "Taste? There is no such thing! One makes beautiful things unknowingly. But they, they plunge their heads into their hands and say: 'Let's see now, how do I find a beautiful shape for a chamber pot?'"[3]

3. François Sevin, « Degas à travers ses mots », *Gazette des Beaux-Arts*, juillet-août 1975.

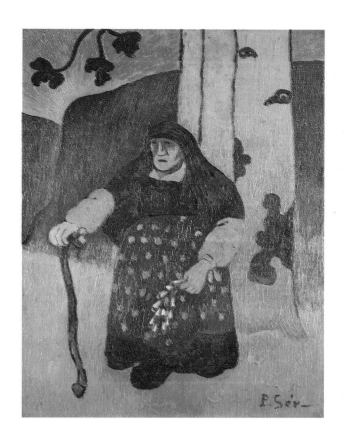

PAUL SERUSIER

Old Breton Woman under a Tree
Around 1898, oil on canvas,
54.5 x 40 cm. (14 x 16 in.),
Saint-Germain-en-Laye,
Musée Départemental du Prieuré.

Without bothering to work out who was right – Degas or the aesthetes – many women had their hair done "à la Botticelli" and appeared in Quattrocento-style dresses.

The aesthetes, decadents, Symbolists and Nabis were among the cast of characters that came to the fore at a time when rational thought was beginning to fall out of favour. The belief that Rationalism would deliver the key to all knowledge had all but dried up. The philosopher Émile Boutroux concluded that the explanations derived from the experimental sciences would always be incomplete. Brunetière declared science bankrupt, while Maurice Blondel maintained that the truths of the Christian Faith were more effective than those of the intellect.

In *Le Figaro* of 18 September 1886, Jean Papadiamantropoulos, better known by the pseudonym Jean Moréas, the most Parisian of Greek poets and self-styled cultural prophet, published the "Symbolist Manifesto," proclaiming the advent of a new artistic tendency. Basing himself on the examples of Baudelaire, Verlaine and Mallarmé, he wrote: "To retrace exactly the filiation of this new movement, one has to go back to certain poems by Alfred de Vigny, to Shakespeare, to the mystics, and even further." Weary of the industrial society, tired of Realism and Positivism, the goal of Symbolism was to "give a sensible form to ideas," Moréas explained; in other words, to materialize thoughts, intuitions and feelings in a concrete form, whether a poem or a picture.

While Pissarro condemned Symbolism as reactionary, seeing it as a bourgeois tactic to re-immerse the rising proletarian masses into obscurantism, Albert Aurier rallied to the new cause and hoped to see it applied not just to poetry, but also to painting. Symbolism was an avatar of Romanticism and shared its predilection for myth, fables and dreams; in short, the type of materials that filled that huge subterranean continent that would be called the Unconscious.

The year 1888 saw the publication of Edouard Schuré's landmark book, *Les grands initiés* (*The Great Initiates*) the main thesis of which was that Truth "was possessed by the great sages and original intitiators of humanity," and that "purely materialistic Science, which puts all religions on the same footing, cannot attain to it." It can be reached by a "*comparative esotericism* that shows the history of religions and humanity in an entirely different light." This publication, a best-seller at the time, exerted a profound influence on the Nabis.

In 1888, also, Stanilas de Guaïta, a friend of Maurice Barrès, revived the Rosicrucian Order for the purpose of transmitting to younger generations the wisdom of Eliphas Lévy, who wrote *Dogme et Rituel de la Haute Magie* (*Dogmas and Rituals of High Magie*) and claimed to have been initiated into the Orphic mysteries, in addition to being an adept of Pythagorism and Zoroastrianism.

MAURICE DENIS

Peasant Woman with Cow
1893, Oil on canvas,
20.25 x 27.25 cm. (8 x 11 in.),
Josefowitz Collection.

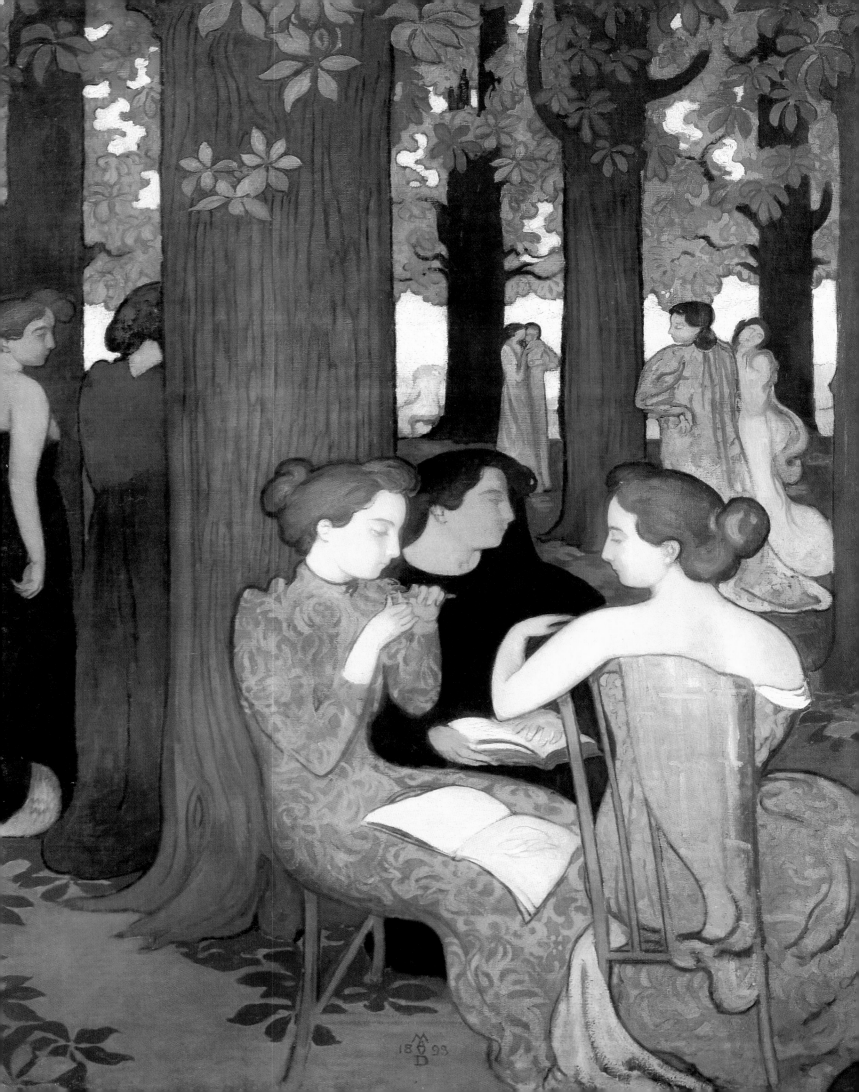

The intellectual hothouse that was turn-of-the-century Paris was agitated by the most diverse and opposite movements; they nevertheless managed to coexist peacefully because their tenants often had much in common. There were Socialists (mainly of a Jacobite tendency, Marx still being practically unknown), Libertarian Socialists, Anarchists (who perpetrated spectacular bombings), Theosophy, Catholicism, Rosicrucianism and Wagnerism.

Wagner's *Tannhäuser* had been poorly received at the Opera in 1861. Baudelaire, however, had been immediately enthusiastic, and, thanks to the combined efforts of Villiers de l'Isle Adam, Judith Gautier (the daughter of Théophile Gautier) and her husband, Catulle Mendès, who was an excellent champion of his cause on the Boulevards as well as in the aesthetic coteries, Wagner's music had finally been given its due.

In 1885, in Munich, Edouard Dujardin founded *La Revue Wagnérienne* in a socio-political context in which Gobineau's racist ideas were pushed to their extreme limits. For reasons that are too complex to go into here, France was to avoid the spread of the more sinister ideas lurking in Wagner's programme. Villers, Mendès and Schuré published articles in the first issue, and were quickly joined by Wyzewa, Elémir Bourges, Mallarmé and Morice, who was to play an important role in Gauguin's life.

There was also the conductor Lamoureux, whose Sunday concerts Mallarmé never failed to attend, sitting always in the same seat. At no time were the bonds between the arts so close as then, and the poets were called to play a seminal role.

The composer Paul Dukas, then twenty-five years old, clearly expressed the position held by poetry in this secular communion of the arts: "Verlaine, Mallarmé and Laforgue brought us new tones, new sounds..... Impressionism, Symbolism, poetic Realism, all blended together in a great concert of enthusiasm, curiosity and intellectual fervour. The painters, poets and sculptors decomposed the materials and re-assembled them according to their fancy, and were concerned above all to endow words, sounds, colours and line with new resonances and feelings."[4] As if to illustrate these lines, the twenty-year-old Bernard framed his sketches of nudes with the titles of works by Schumann or César Franck that had particularly moved him.

These poets, who were to play such an important role, began by saying they were decadents like Verlaine. Then they said they were Symbolists, a term they chose carefully. Their master, Mallarmé explained his conception of poetry in these terms: "To name an object is to eliminate three-quarters of the enjoyment of a poem, which comes from the pleasure of guessing: suggestion that is our dream. The perfect use of this mystery is what constitutes the symbol." It is clear why Gauguin was considered the master of Symbolist painting.

MAURICE DENIS

The Muses

1893, oil on canvas,

168 x 135 cm. (5 ½ x 4 ½ ft.),

Paris, Musée d'Orsay.

4. Georges Bernier, *La Revue Blanche*, Paris, 1991.

MAURICE DENIS

Young Women

1894, oil on canvas,

45.3 x 38 cm. (18 x 15 in.),

private collection.

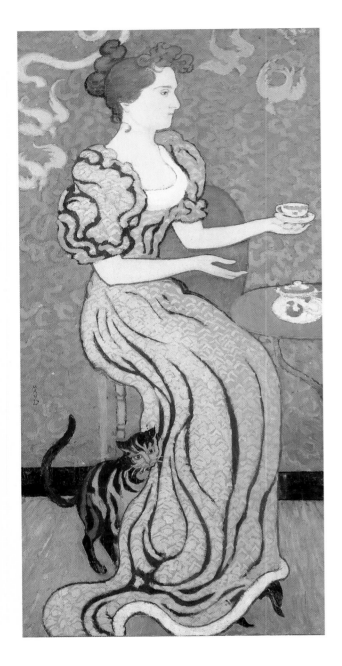

Through Lugné-Poë, another schoolfriend from Condorcet, the Nabis came into contact with the Symbolist writers. As Maurice Denis reminisced: "In 1889, 1890 and 1891, the theatre, avant-garde reviews, the brasseries of the Latin Quarter, and exhibitions at the Independents made us known to a limited, but enthusiastic public. It was a time of frenzied idealism."

Sérusier and the other Nabis were of Neo-Platonic persuasion, as were the Symbolists in general. Again according to Maurice Denis: "Writers and painters agreed that natural objects were the signs of ideas, that the visible was a manifestation of the invisible; that sounds, colours and words had a miraculously expressive value independently of representation, independently even of the literal meanings of words."

To substantiate these ideas, reference was made to sources as diverse as Hegel, Swedenborg, Poe and Baudelaire, to name but a few. They were frequently cited and, in the feverish intellectual atmosphere of the day, writers did not shrink from using – or abusing – "the bizarre metaphors, medieval clichés and obscure figures of pseudo-mystical speech."

The Nabis – or rather the *Nebiim* – were to make major contributions to this glossary. We have already mentioned the expression with which they referred to women of little virtue; instead of saying atelier or studio they preferred to speak of an *ergastery*. An 1889 letter from Sérusier to Paul Ranson gives an interesting selection of other such singular words and typical Nabi expressions:

"Day of Venus, one hour before the setting of Helios,

finished on the dominical at the same hour:

In your palm, my words and my thoughts!

Occasionally, from one Nabi to me is wafted the Word,

Not yet by any astral displacement, but, in the meanwhile, by the iron-girded rail, by means of characters traced with the quill....

To the sublime incarnation of the eternal feminine, to the one who completes with you the dreamed-of androgynate, may you present the compliments of the peregrine Nabi and take in your palm my words and my thoughts."

Short though it may be, this quotation from one letter gives a sufficiently good idea of the linguistic style of the group as a whole. Before saying more about the woman who completed the dreamed-of androgynate, and before discussing the ever-more numerous Nabis individually, let us return to Brittany and their arch-priest, Gauguin.

At the time, Gauguin made nothing of his first meeting at the Volpini exhibition with Albert Aurier and Daniel de Monfreid, who was to become his most faithful supporter. Nor did he think much of the enthusiasm of the nascent Nabi group. And so, deeply disappointed, he left with Sérusier

for Pont-Aven in mid-June. Given his state at the time, he could not but be horrified by Pont-Aven. Over the years, the Breton village had become the meeting-place for artists – real and presumed – from many different countries. The local tobacconist now sported a huge palette-shaped sign that advertised – in English – "Artists' materials."

Several days after their arrival at Pont-Aven, Gauguin and Sérusier left for Le Pouldu, which was still unspoilt. There, they were free from the "nuisance of art-students dressed in pea jackets or flannel suits, wearing wide-brimmed straw hats or berets, a pipe eternally wedged between their lips." On leaving Pont-Aven for Le Pouldu, Sérusier wrote to Maurice Denis, "I am leaving the little girls in beautiful white headdresses to contemplate the thin, strong little girls in yellow rags tending cows on great rocky cliffs, amid stacks of kelp."

Gauguin stayed at Le Pouldu until February 1890, then went back to Paris. By the end of June, he was in Brittany again and stayed there until early November. At the time, he was completely preoccupied with his plan to leave for Indochina. He wrote: "It seems to me that I will regenerate myself there. The West is rotten, and, like Antaeus, the Hercules of today can gain new strength by making contact with the ground over there."

He also spoke of Indochina to Mette and sent news: "I have been working every day with my linen trousers (the ones from five years ago are all worn). I spend one franc per day for my food and two cents for tobacco.... I am exhibiting my works at Goupil's in Paris and they are causing a sensation, but they are still hard to sell." Under the circumstances, it must have taken strong nerves to sing joyfully with Sérusier and Filiger to impress Gide.

The artists at Le Pouldu helped decorate their boarding-house. Wagnerism then being in vogue, Sérusier began by transcribing on a white-washed wall the composer's credo: "I believe in a last judgement in which horrible punishments will be inflicted upon all mortals who dared to corrupt the chaste and sublime in Art, all those who soiled and degraded it with their base sentiments, their vile envy.... I believe that the faithful disciples of Great Art will be rewarded and glorified, enveloped in a celestial shroud of light, fragrant scents and melodious chords. They will be forever immersed in the divine source of all harmony." The Nabis were easily won over to Wagner's credo and eagerly made it their own.

On 7th November, Gauguin left Le Pouldu. In his distress, he knew that only in Paris would he find the means to make his dreams of escape come true. Several weeks later, he sent the following pathetic letter to Mette: "I am completely satisfied, if not with respect to my finances, at least with regard to my self-esteem; with each passing day I see my work... grow in quantity, prepared to face the future. But if one thing makes me unhappy, it is seeing myself so isolated... cursed by my own family. Your silence during

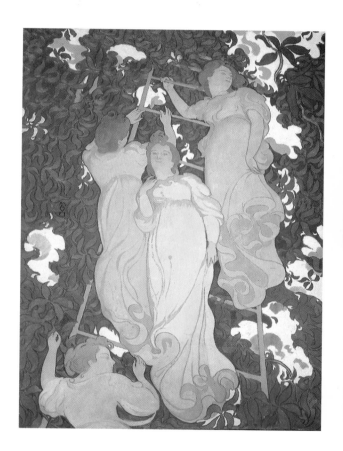

MAURICE DENIS

Ladder in Foliage
1892, ceiling decoration for Henry Lerolle,
oil on canvas mounted on cardboard,
225 x 169 cm. (7 1/2 x 5 1/2 ft.),
Saint-Germain-en-Laye,
Musée Départemental du Prieuré.

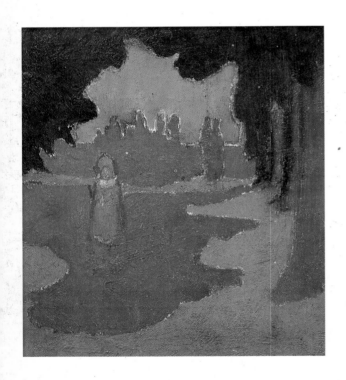

MAURICE DENIS

Patches of Sun on the Terrace

1890, oil on cardboard,

20 x 20 cm. (8 x 8 in.),

Paris, Musée d'Orsay.

the last two years, since my trip to Martinique, has caused me... more misery than my financial problems.... May the day come (perhaps soon) when I will escape into the woods on some island in Oceania, and live on ecstasy, peace and art."

And so he was back in Paris, where now he could no longer count on Schuffenecker's hospitality; his old friend, weary of Gauguin's efforts to seduce his wife, urged him (as politely as he could) to find lodgings elsewhere. This he did first at a hotel, and then he was invited to stay with Daniel de Monfreid.

NEW FRIENDS, FUTURE ADMIRERS

Gauguin did not live the life of a recluse during his stay in Paris. When he had been there in the previous January, he had explained to a group of poets and artists assembled in a restaurant near the Odéon why "Symbolism was necessary to end the abominable error of Naturalism."

Charles Morice recalled how he shocked his audience with his biting tone and his student language, describing himself as a "more colourful Baudelaire." Morice further reminisced: "In our subsequent gatherings of poets and painters, he never again took the doctrinaire, school-masterish tone that he had used that first time. He had learned his lesson."[5]

After this false start, relations were resumed the following year under better auspices. Wisely, he adopted a different attitude and seemed sympathetic enough to the others. The pontificating Moréas, who had judged him harshly at first, began to acclaim him as a great painter. Although dreaming of escape, Gauguin was anything but indifferent to the passionate discussion of ideas that thrived in this charged atmosphere. He saw his prestige growing within the intellectual chapels with even less indifference.

The Nabis were fresh out of the Académie Julian and busy with their respective "*oeuvres*," as they were fond of saying in their parlance. They also now had a "Temple" of their own – Paul Ranson's studio – which Gauguin visited on several occasions.

Before describing this sanctuary in detail, we should examine the individual figures whom the master from Le Pouldu could expect to meet there. Each of the Nabis had a nickname. Sérusier was the *Nabi with the rutilant beard* – from which we can infer that he was a red-head. Maurice Denis, an ardent Christian, was called the *Nabi of the beautiful icons*. Like his colleagues and friends, he was still under the spell of the Volpini exhibition. During Gauguin's stay in Paris, Lugné-Poë, an ex-classmate from Condorcet, asked Denis to write an article for a review called *Art et Culture*. It was in this text, entitled

5. Charles Morice, *Gauguin*, Paris, 1919.

78

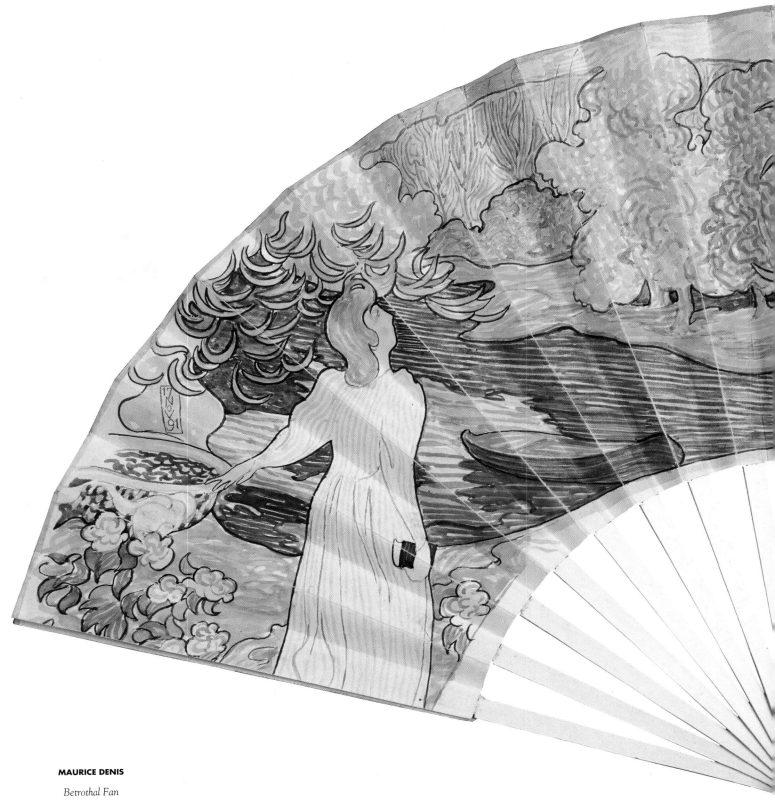

MAURICE DENIS

Betrothal Fan

1st November 1891, gouache on paper and

white-lacquered wood,

Saint-Germain-en-Laye,

Musée Départemental du Prieuré.

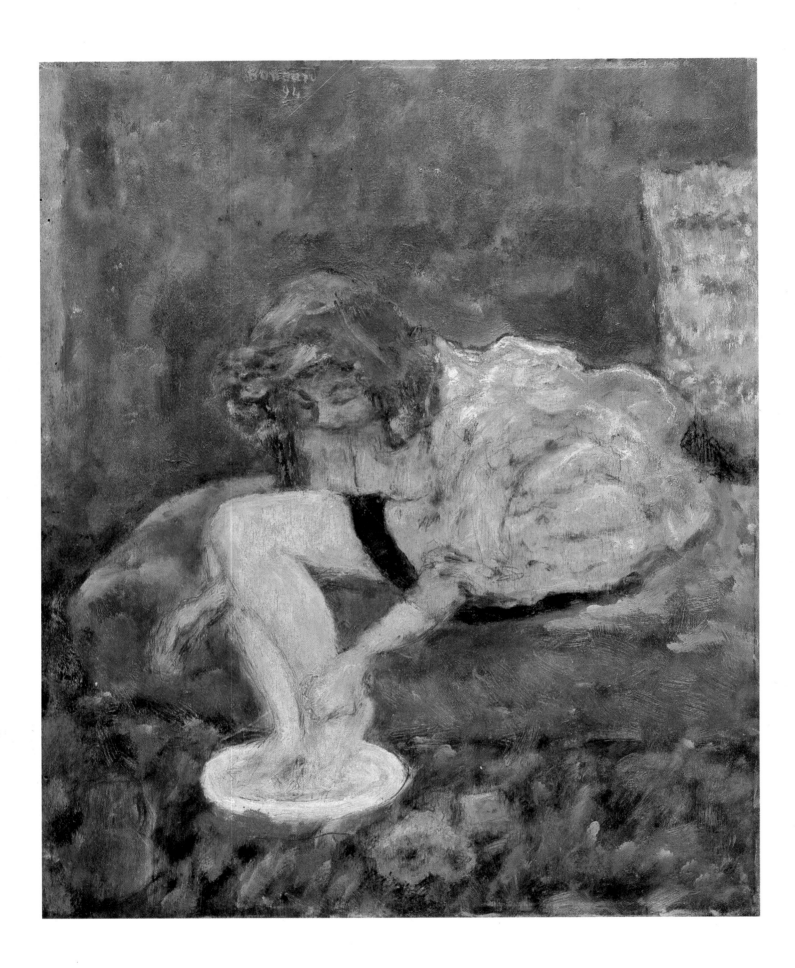

"Definition of Neo-Traditionalism," that he made the famous statement: "Remember that a picture – before being a war-horse, a nude, or an anecdotal of some kind – is essentially a plane surface covered with colours disposed in a certain order."

However important this text may be, it was not enough. Gauguin was the one best qualified to give a definition of Symbolism in painting of sufficient scope. This he did in the course of an interview with Eugène Tardieu that was printed in the *Echo de Paris* of 13 May 1895, shortly before his departure for the South Pacific.

The interview was preceded by this introduction: "Here is the most hardcore of the innovators, the most intransigent of the 'misunderstood.' Several of those who discovered him have since dropped him. For many, he is nothing but a phoney. Meanwhile he continues very seriously painting orange rivers and red dogs, aggravating with each passing day this highly personal *manner*. Built like a strongman, with curly greying hair, an energetic face with light-coloured eyes, he has a smile all his own, at once gentle, modest, and somewhat mocking."

Then began the interview:

"And so, what about your red dogs and pink skies?

– They are absolutely intentional. They are necessary, and everything in my artwork has been calculated and thought out over a long time. It is like music, if you wish. Using arrangements of colour and line, and with the pretext of a subject drawn from everyday life or nature, I can achieve harmonies that represent nothing that is absolutely real in the common sense of this word, but that should make one think in the way that music makes one think; without resorting to ideas or images, but simply through the mysterious affinities existing between our brains and such and such arrangements of colour and line."

The Nabis, Pierre Bonnard among them, were no doubt pleased with this interview, for their master expressed his views (and theirs) in the simplest of terms.

Pierre Bonnard (1867-1947), was strongly influenced by what he had seen at the exhibition of Japanese art at the Ecole des Beaux-Arts in 1890, and was called the *"very Japanesy Nabi."* His father, an official in the War Ministry, had wanted him to engage in a respected profession. He could not complain when the young Pierre successfully completed his secondary studies, then secured a law degree and went on to a promising position working for a deputy public prosecutor. At the same time, taking advantage of the leisure afforded by his job as assistant penpusher, he frequented the Académie Julian. One fine day, however, he finally decided to devote himself entirely to art. In a later interview, he explained the circumstances surrounding this decision – which did not please his father at all:

PIERRE BONNARD

The Laundry Girl

1896, colour lithograph,

30 x 19 cm. (12 x 7 in.),

Josefowitz Collection.

Opposite

PIERRE BONNARD

Woman Washing Her Feet

1894, oil on panel,

41.5 x 33.5 cm. (16 x 13 in.),

Josefowitz Collection.

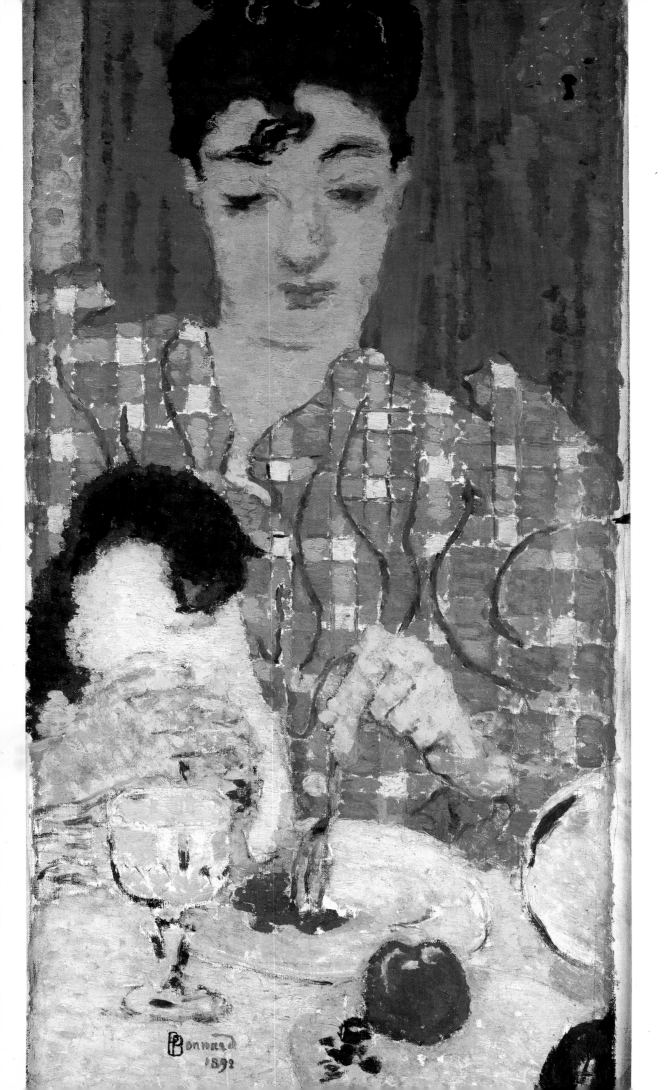

PIERRE BONNARD
Woman in Checkered Blouse
(Madame Terrasse),
1892, oil on canvas,
61 x 33 cm. (24 x 13 in.),
Paris, Musée d'Orsay.

Opposite

PIERRE BONNARD
The White Cat
Around 1894, oil on cardboard,
51 x 33 cm. (20 x 13 in.),
Paris, Musée d'Orsay.

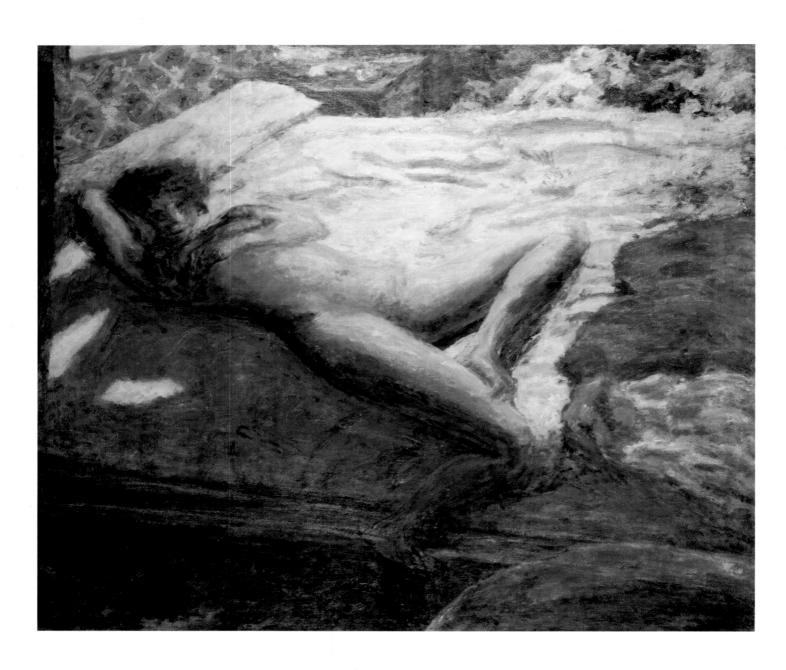

PIERRE BONNARD

Woman Lying on a Bed, or *L'Indolente*

Around 1899, oil on canvas,

92 x 108 cm. (36 x 43 in.),

Josefowitz Collection.

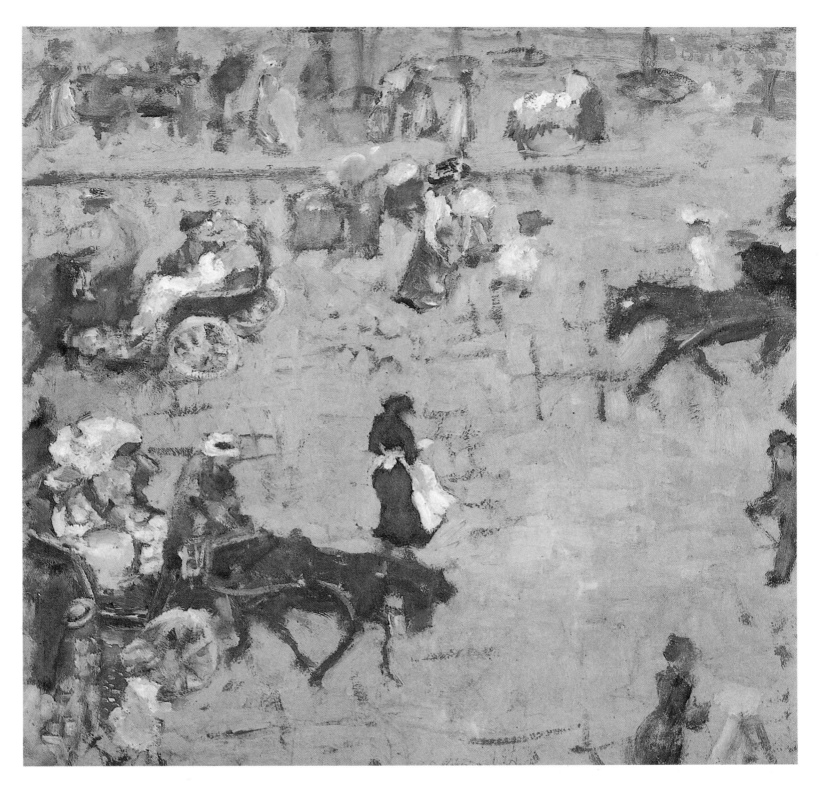

PIERRE BONNARD

Street Scene with Carriages

Around 1905, oil on panel,

47.5 x 48.5 cm. (18 x 19 in.),

private collection.

PIERRE BONNARD

Child with Sand-Patties
1894-1895, tempera on canvas,
167 x 50 cm. (5 ¹/₂ x 1 ¹/₂ ft.),
Paris, Musée d'Orsay.

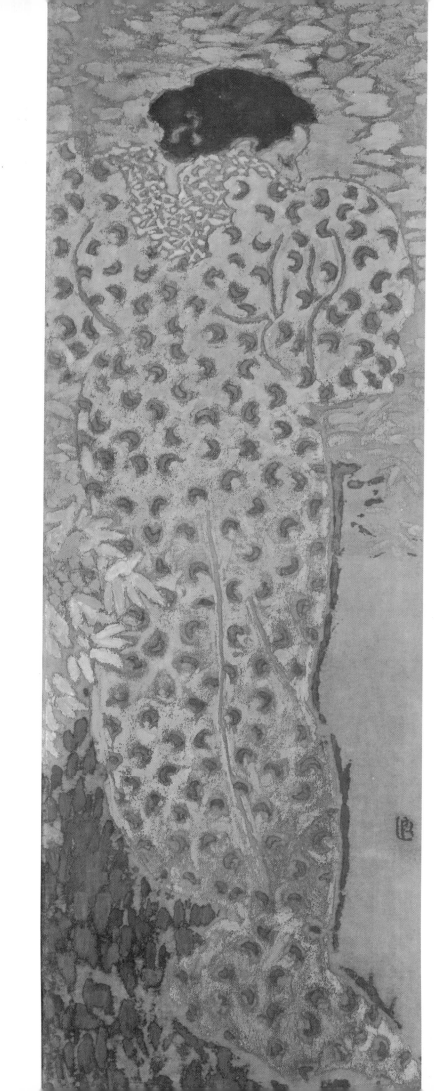

PIERRE BONNARD

The Housecoat

1892, fabric,

150 x 50 cm. (5 x 1 ¹/₂ ft.),

Paris, Musée d'Orsay.

"It seems to me that what appealed to me the most at the time was not so much art as the artist's life, with all the spontaneity and personal freedom that I imagined it to have. I had of course been attracted to painting and drawing for a long time, but they were not an irresistible passion. What I wanted above all was to avoid having a monotonous life." One of his contemporaries reminisced that if he succeeded in avoiding this stumbling block, it was in his own way: "A revolutionary in painting, but a born bourgeois, Bonnard led his bohemian existence in a bourgeois way, moving from place to place, going from barely furnished apartment to empty studio and hotel room, year in, year out."[6]

Be that as it may, the young man who was not possessed of an "irresistible passion for painting" achieved swift recognition. In 1889, he earned one hundred francs for his sketch for a *France-Champagne* poster and so was able to finance a studio in the Batignolles area.

This particular commercial success had further repercussions. When the poster was finally printed – some two years later – Toulouse-Lautrec, who had heard a lot of good about Bonnard, took him into the streets to find examples of it, for not many had been put up. When they finally found themselves in front of one, Lautrec was so enthusiastic that he decided to design posters too. He asked his young friend to tell him where he had had the lithograph printed, and from then on had all of his posters made by the same printer.

Bonnard stayed at the Batignolles studio for less than a year. In 1890, he rented another studio with Vuillard and Denis. In the same year, his sister married the composer Claude Terrasse, who participated in the great Ubu adventure by composing the musical score for *Ubu roi* in 1896; Bonnard and Sérusier designed the stage sets.

Jean-Edouard Vuillard (1868-1940) was known as the *Nabi zouave*, and, like Denis and most of the other students there, had enrolled at the Académie Julian to prepare the entrance exam to the Ecole des Beaux-Arts. He was duly admitted and followed the courses there, which were free. He remained in close contact with his Nabi friends, but resisted their anti-naturalistic stance. To their amazement, he had his sights set on the official Salon, and in 1888 (the year of *The Talisman*), he tendered for the decoration of the Marriage Room at the Town Hall of the 15th arrondissement.

Only two years later, however, he rallied completely to their cause. Denis was particularly delighted because he had recognized his friend's great talent early on. He also knew of the still-lifes that Vuillard had recently painted, extremely sensitive works that had something of Chardin, while remaining very personal. They were anything but the standard fare of the Salon, and, not suprisingly, his 1890 submission was refused.

6. Annette Vaillant, « Livret de famille », *L'Œil*, n° 24, décembre 1956.

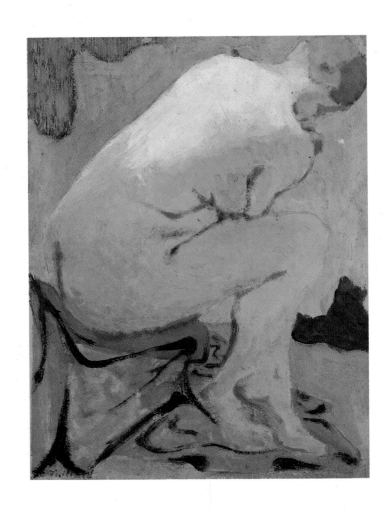

JEAN-EDOUARD VUILLARD

Seated Nude

1890-1891, oil on panel,

29.5 x 22 cm. (11 x 9 in.),

Josefowitz Collection.

Opposite

JEAN-EDOUARD VUILLARD

Two Women at the Linen Closet

Around 1892, oil on cardboard,

30.5 x 22 cm. (12 x 9 in.),

. Josefowitz Collection.

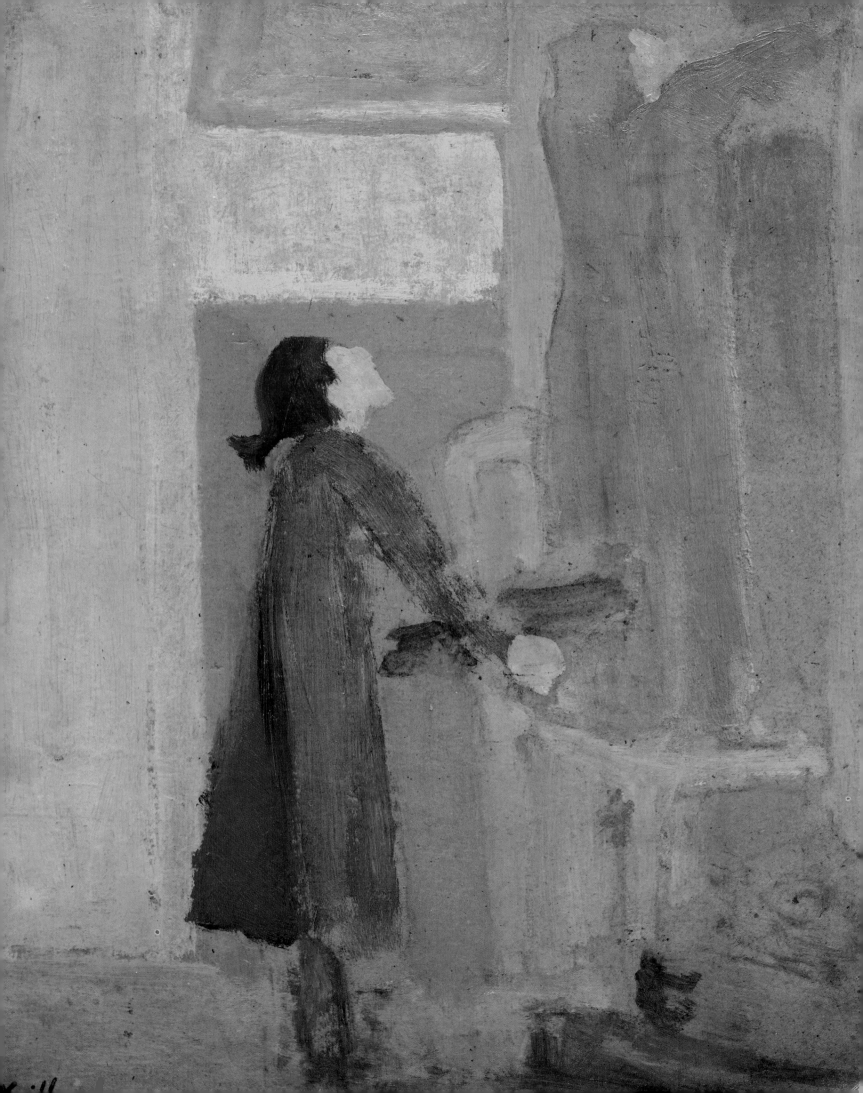

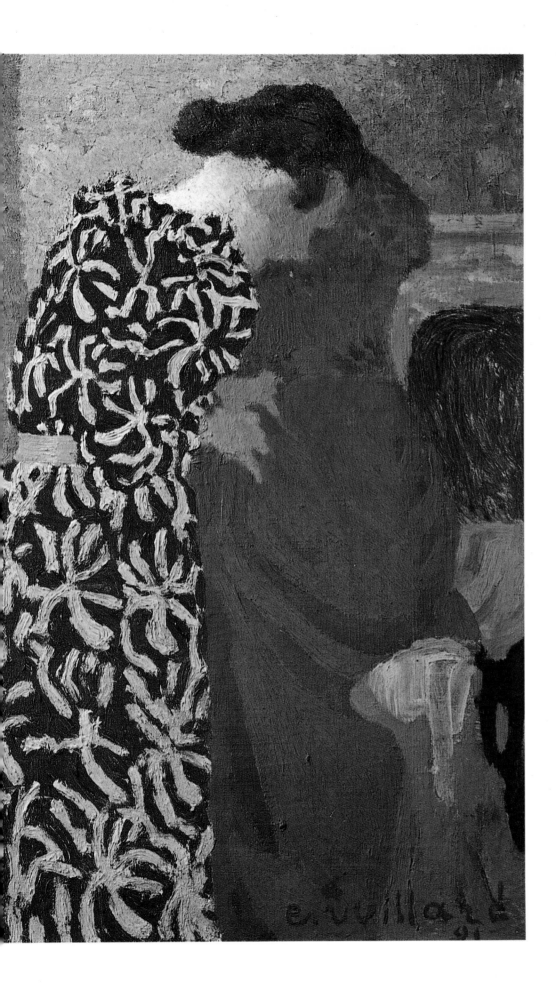

JEAN-EDOUARD VUILLARD

The Embroidered Dress

1891, oil on canvas,

São Paulo, Museum of Art.

JEAN-EDOUARD VUILLARD

Three Women in an Interior

1895, oil on cardboard,

32.5 x 52.5 cm. (13 x 20 in.),

Josefowitz Collection.

JEAN-EDOUARD VUILLARD

Women Sewing

1892, oil on canvas, 47.5 x 57.5 cm. (18 x 22 in.),

Josefowitz Collection.

JEAN-EDOUARD VUILLARD

Woman Looking under a Bed

Around 1895, oil on panel,

private collection.

JOSEF RIPPL-RONAI

Discussion of the Talmud

1895, oil on paper, 23 x 30 cm.

(9 x 12 in.), Josefowitz Collection.

The year 1890 was marked by a crisis in Vuillard's career, primarily because of Gauguin. He had been struck by the latter's work at the Volpini café, but was not one to modify his aesthetic position without long reflection.

A still-life from around 1890 entitled *The Lilacs* is a fitting example of the development that his work had undergone. It was handled not in subtle modulations of tone, but in flat colours with stark contrasts between the lit and the shaded areas; naturalism has given way to a synthetic expression. The same goes for the many small pictures he painted in the following three years. Of these we need mention only *Au divan japonais*, with its flat, bright yellow and orange lighting evoking one of Toulouse-Lautrec's favourite (and often represented) cabarets, and Two *Women under Lamplight* (1892), whose subject-matter, domestic life and chores, was often represented during the Nabi period. His *Portrait of Lugné-Poë* (1891), with its flat greys and beiges, and heavily outlined head, shoulders and arms, is reminiscent of Gauguin. Vuillard was by then sharing a studio with his model, who played an important role in his career by getting him (and other Nabis) work in the theatre.

THE NABI TEMPLE AND ITS FAITHFUL

Before discussing this and other aspects of Vuillard's work, we should mention a few of the other faithful of the Nabi Temple during Gauguin's stay in Paris. Henri-Gabriel Ibels, while still remaining close to his former classmates at the Lycée Condorcet, had already struck out on a quite different path. His landscapes and pastel drawings of wrestlers and soldiers had seemed promising enough to those who were in a good position to judge; yet he devoted himself more and more to humorous subjects. As a political cartoonist he countered the vehement anti-Dreyfus drawings published by Forain and Caran d'Ache in *Ps'tt!* with drawings of his own printed in the weekly magazine *Le Sifflet*. At the same time he taught history of art at the University, produced plays for the theatre, and still found the time to work on posters and lithographs. He was also actively involved in the campaign to obtain royalties for artists. All in all a very full and socially-committed life, far removed from the usual Nabi preoccupations with symbols and formal synthesis.

The so-called *Hungarian Nabi*, Josef Rippl-Ronaï (1861-1947), arrived in Paris in 1887. He began by working with the history and genre painter Munkacsy, whose successes at the Salon since he established himself in the French capital had spread as far afield as their common native land. Rippl-Ronaï's own very strong personality enabled him to resist his country-man's teaching, in the same way that he had resisted the teaching he had received in Munich. He was drawn to the Nabis and their precepts as early as

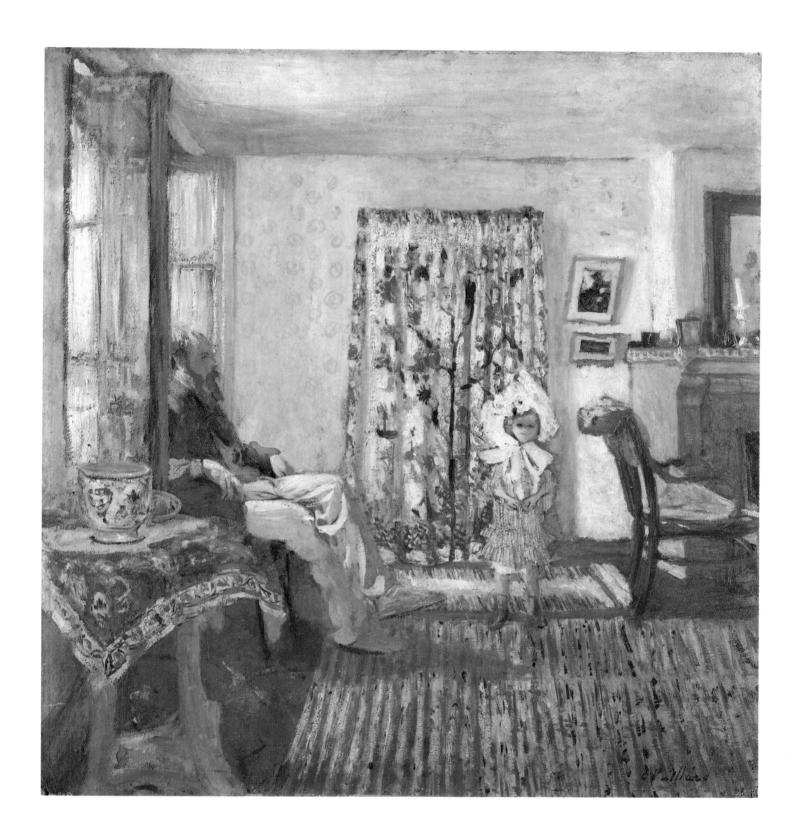

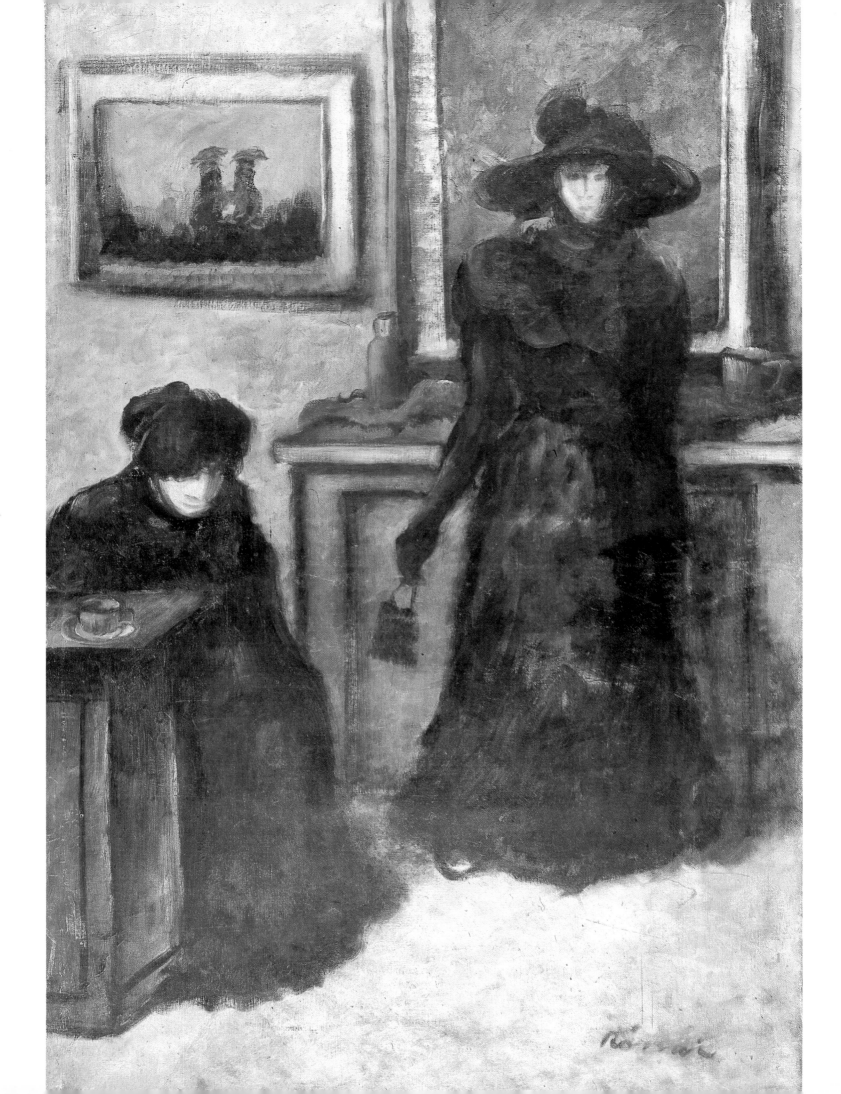

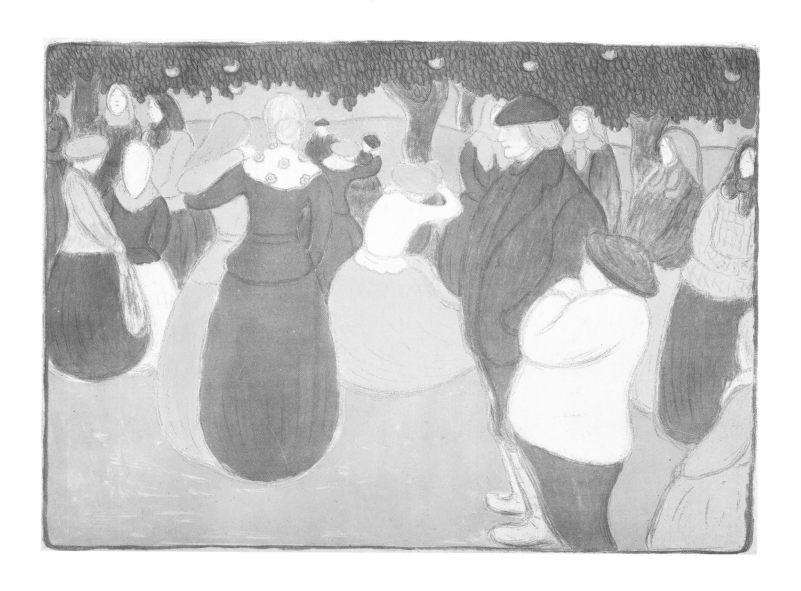

JOSEF RIPPL-RONAI

The Village Feast

1897, lithograph printed in five colours

by Clot, 43 x 57.3 cm. (17 x 22 in.),

Josefowitz Collection.

Opposite

JOSEF RIPPL-RONAI

Melancholic Sunday

1898, oil on canvas, 100 x 64.5 cm. (3 x 2 ft.),

Josefowitz Collection.

KER XAVIER ROUSSEL

Bathers

1892, oil on canvas,

24 x 39.5 cm. (10 x 15 in.),

Josefowitz Collection.

Overleaf

KER XAVIER ROUSSEL

Public Park. Les Tuileries

Around 1893, oil on panel,

27.8 x 17.5 cm. (11 x 7 in.),

private collection.

Opposite

KER XAVIER ROUSSEL

Composition with Forest

Undated, oil on canvas,

44.1 x 30.1 cm. (17 x 12 in.),

Saint-Germain-en-Laye,

Musée Départemental du Prieuré.

ARISTIDE MAILLOL

The Laundresses

1893, oil on canvas,

65 x 81 cm. (25 x 32 in.),

Josefowitz Collection.

1889 and for a long time made use of thick outlines; even the compositions of his late work bore the unmistakable mark of Nabi influence.

Until he left Paris in 1900, he was a very popular figure not only because of his talent but also his native cheerfulness and volubility. He was known for his dinner parties, at least one of which overstrained his Nabi brothers' capacity for vodka. In 1895, Siegfried Bing, the famous dealer in Japanese art, published *Les Vierges*, a text by Georges Rodenbach with four-colour lithograph illustrations by the Hungarian Nabi. Other notable works were the pastel portrait of Vuillard, a portrait of Thadée Natanson published in *La Revue Blanche*, one of Bonnard, and a superb likeness of his good friend Aristide Maillol from 1899. Maillol, in the process of dropping painting for sculpture, was enthusiastically involved in tapestry work, even dyeing his own thread. Under his influence, Rippl-Ronaï also developed a taste for this medium.

Ker Xavier Roussel (1867-1944), a fellow-explorer from the beginning, also became one of the first faithful of the Temple. His physician father, unlike most fathers, was not averse to his eldest son's artistic vocation. His unusual first name came not from his parents, but from his little brother, who had trouble pronouncing "Xavier," and so took to calling him "Ker," a name which stuck both in his artistic and personal life. Ker Xavier Roussel is known, among other things, for marrying Vuillard's sister, Marie, in 1893.

It is a noteworthy fact that the members of the Nabi movement maintained friendly relations throughout their lives, even long after the group had disbanded. Some, sharing common affinities, had even closer ties to one or more members. This was the case with K.X. Roussel, Bonnard and Vuillard. Less respectful of theoretical concerns and less prey to metaphysical anxiety than Sérusier, Maurice Denis and some others who were soon to join the group, the three men developed along a rather different trajectory from that of their companions.

Bonnard and Vuillard, benefiting from the example of Gauguin and Japanese art, both readily used their talents to portray scenes of everyday bourgeois life. Vuillard used this subject matter (often in outdoor settings) in his large decorative panels painted for private homes. Roussel was drawn very early on to subjects of vaster scope. Specifically, he was haunted by the imagery of classical Greek mythology, and embarked on a lifelong quest for harmony and sensuality in Antique settings of a less hieratic quality than those of Puvis de Chavannes.

The pace of events moved swiftly for the Nabis, and soon we shall see Roussel, along with many of his comrades, applying his talents to the graphic arts, the theatre and other fields.

First, though, we should mention Félix Vallotton (1865-1925), another of the Temple faithful of the first hour. Because he was the scion of an old French-Swiss family, he was given the appellation *Nabi étranger* (or

ARISTIDE MAILLOL
Dancer
1895, wood, 22 x 24 cm. (9 x 10 in.),
Paris, Musée d'Orsay.

ARISTIDE MAILLOL

Portrait of Mademoiselle Farrail

1893, oil on canvas,

46 x 55.5 cm. (18 x 21 in.),

Paris, Dina Vierny Collection.

ARISTIDE MAILLOL

Seated Woman with Parasol

1889, oil on canvas,

Paris, Dina Vierny Collection.

FELIX VALLOTTON

Interior

(from the "Intimités" series)

1898, oil on cardboard,

41 x 64 cm. (16 x 25 in.),

Josefowitz Collection.

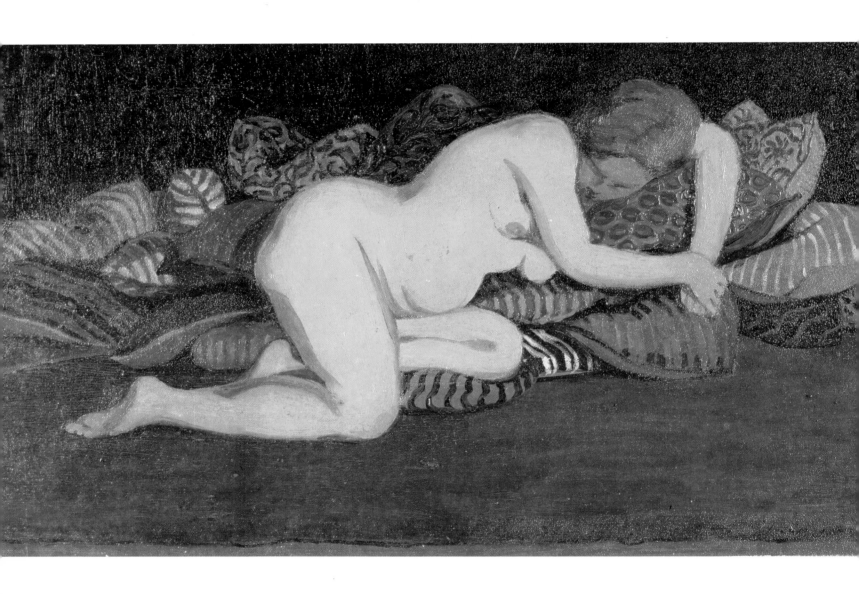

FELIX VALLOTTON

Woman with Cushion,

or *Nude on Cushions*

1897, oil on cardboard,

23 x 40 cm. (9 x 16 in.),

Josefowitz Collection.

FELIX VALLOTTON

Félix Fénéon in the Offices
of La Revue Blanche
1896, oil on cardboard,
52.5 x 65 cm. (20 x 25 in.),
Josefowitz Collection.

PAUL RANSON

Jesirah Briah

1891, pastel on canvas,

32 x 40 cm. (12 x 16 in.),

Saint-Germain-en-Laye,

Musée Départemental du Prieuré.

"foreign Nabi"). He went to Paris after finishing his secondary school at the age of seventeen. His father, not as open-minded as Roussel's, was not very pleased about the move and withdrew his financial support.

Although he was admitted to the Ecole des Beaux-Arts, Vallotton did not follow any courses there, preferring instead to study at the Académie Julian. In 1885, only three years after his arrival in Paris, one of his paintings was accepted for the Salon. This did little to modify his financial situation, however, and, after having worked at a variety of odd jobs, he accepted a position as restorer for an art dealer. This did not keep Vallotton from enlivening the meetings at the Temple with his wit, and biding his time until he could give the full measure of his considerable artistic talent.

What the Nabis in their convoluted jargon called the "Temple" was in fact Ranson's studio at 23, boulevard du Montparnasse. Paul Ranson (1861-1909) was the son of a mayor of Limoges who moved to Paris with his family in 1886, when he was elected as Member of Parliament. Soon after, Ranson entered the Académie Julian, where he met Sérusier, saw *The Talisman*, and became one of the first Nabis.

The Temple in which Ranson received his friends every Saturday starting in 1889, was situated in the area of Paris that was destined to become a mecca for artists from all over the world. Unlike the gatherings in the Passage Brady, feminine visitors were welcome. It was Ranson's wife, France, who was described by Sérusier as the "sublime incarnation of the eternal feminine," and, in the absence of documentary evidence, we have to take his word for it. We do know, however, from eyewitness accounts, that this woman who formed with her husband the "dreamed-of androgynate" was intelligent and good-humoured. For these qualities, she was given the title "Light of the Temple." And, while Maurice Denis' likeness of *Madame Ranson with a Cat* remains a valuable document of the feminine fashions of the times, the sitter's face does not seem to justify any superlatives.

In his *Theories*, published in 1912, the often verbose (but equally often useful) Maurice Denis gave a taste of the proceedings at these weekly reunions at the Temple: "The studio in the boulevard Montparnasse greeted us each Saturday with mugs of beer or cups of tea which the young mistress of the house served with impulsive grace and unflagging cheer." With his reputed expertise in beautiful women, Gauguin might have been able to furnish us valuable information on this point. But unfortunately we know next to nothing of his visits to the Temple. He seems not to have been present when a puppet performance was staged in one corner of the studio. Skits, often written by Ranson himself, were also performed. A staunch adversary of the Church, he created a character called Abbé Prout (a play on words roughly rendered as "Friar Fart"). This clergyman, the hero of a series of plays, was in the habit of making obscene statements designed to raise the

eyebrows of a Christian like Maurice Denis – but, as far as we know, he never let on. Jan Verkade, who arrived at a late stage in the game and eventually became a monk, was not shocked by these antics either, being still bent on enjoying the pleasures of secular life.

Other plays performed were such late medieval satirical pieces as *La Farce du pâté* and the young Maurice Maeterlinck's *Les sept princesses*. This last piece was written for marionettes, a type of figure that became an attribute of the Symbolist period. Most of the other Nabis contributed their talents to making heads for the marionettes, costumes and stage sets. In 1896, a number of them, Ranson included, collaborated on Alfred Jarry's *Ubu roi*.

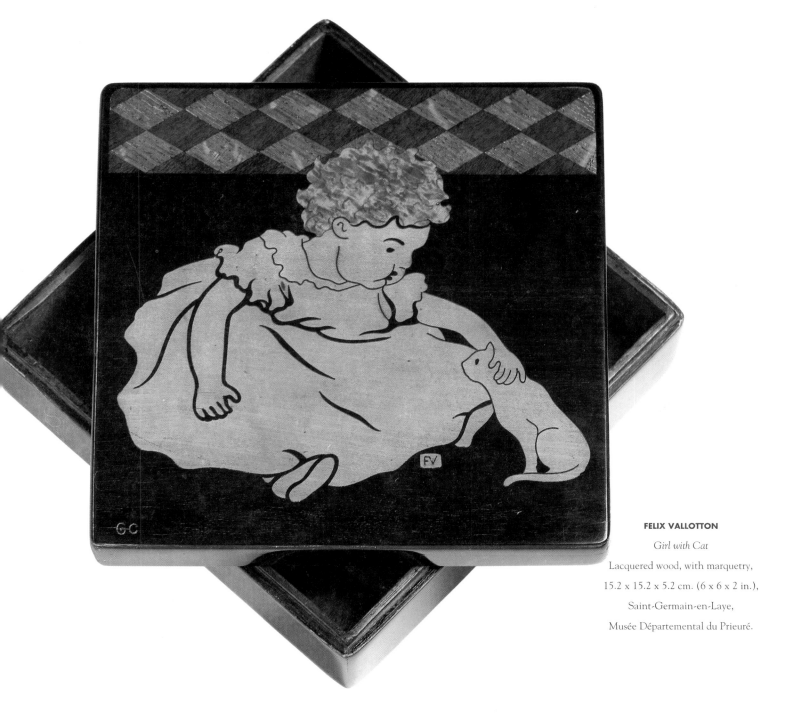

FELIX VALLOTTON

Girl with Cat

Lacquered wood, with marquetry,

15.2 x 15.2 x 5.2 cm. (6 x 6 x 2 in.),

Saint-Germain-en-Laye,

Musée Départemental du Prieuré.

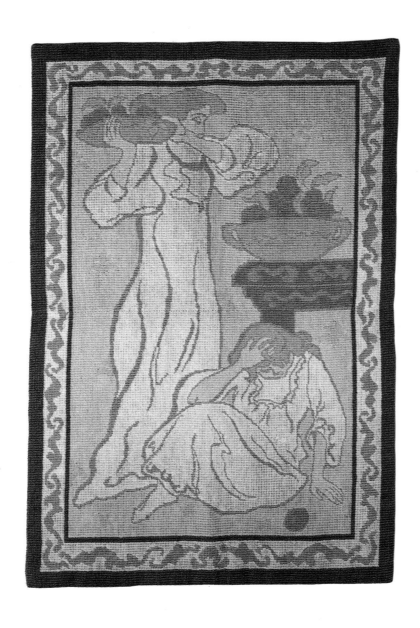

PAUL RANSON

Woman in White

1894, tapestry, wool on canvas,

150 x 98 cm. (5 x 3 ft.),

Paris, Musée d'Orsay.

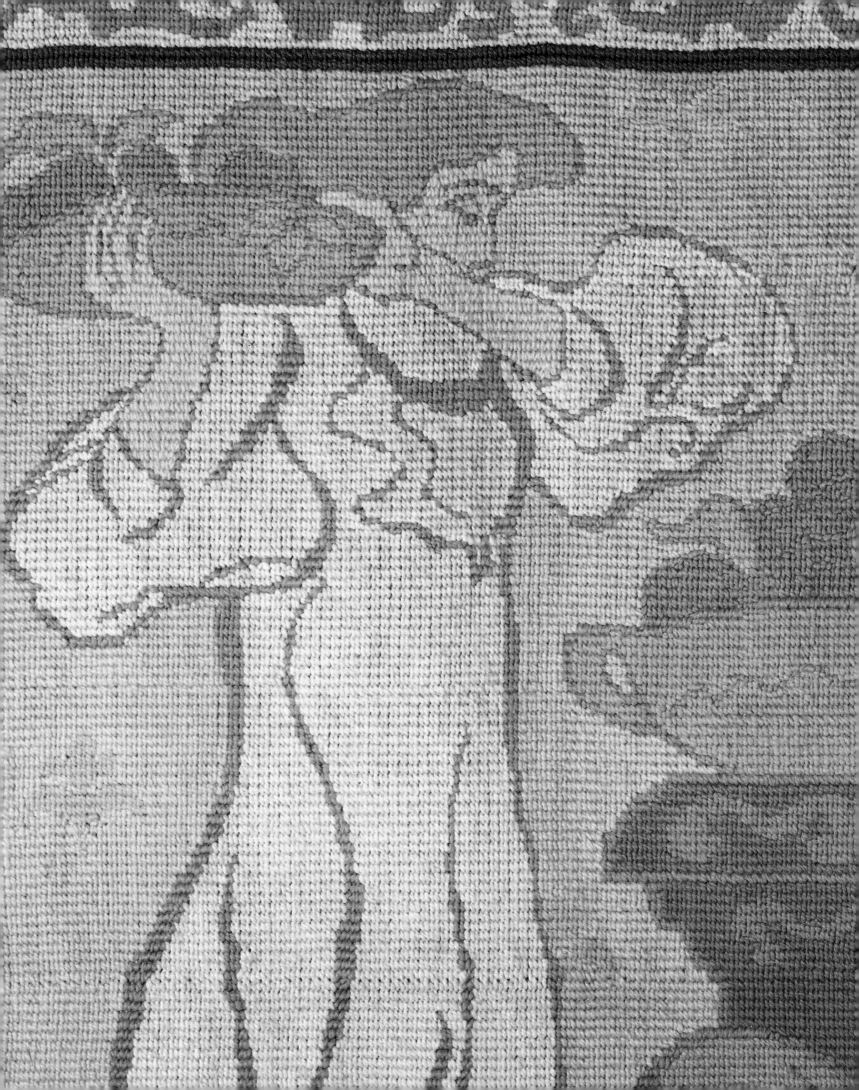

FIN DE SIECLE ART NOUVEAU

Events took on an ever swifter pace in the fin-de-siècle atmosphere of the French capital. Gauguin, who was about to leave for the South Pacific, was the acknowledged leader of Symbolism in painting. Mallarmé showed his respect and helped make his departure possible. The Nabis were joined by new followers and now enjoyed the support of "advanced" critics, dealers and collectors who had also gained a toehold in the Parisian cultural landscape. Several factors contributed to stirring and maintaining the great intellectual ferment of the period. There was, above all, a large number of high level individuals, some of whom were willing to use their financial means or practical talents in the service of their ideas.

We have already mentioned the debt owed by Van Gogh, Gauguin and then the Nabis to Japanese prints. They had previously been discovered by the Impressionists, whose revolutionary steps had been made possible precisely because of the advent of photography and the revelation of Japanese art. With the opening of trade relations with Japan in the days of the Second Empire, Japanese prints – a popular, "lowbrow" art form representing scenes from everyday life – began to appear on the Parisian art market. Because they were sold at low prices, they were within the means of even the poorer artists. At the same time, wealthy aesthetes like the

Goncourt brothers or the Count of Montesquiou could afford to buy works by first-rate artists from the Land of the Rising Sun.

The 1867 World Fair in Paris – following the one held in London in 1862 – sparked a veritable vogue for things Japanese, giving birth to a trend which became known as Japonism and considerably changed the course of Western aesthetics. Japonism introduced a sense of refinement, formal concision and invention at a time when academic art was foundering in its own triviality. In the visual arts, its influence was expressed by the simplification of forms, the use of large fields of flat colour and off-centre compositions. As the Goncourt brothers noted in their *Journal*, this deep and wide-ranging aesthetic revelation was analogous to the rediscovery of classical Greek and Roman sources that had nourished the Italian Renaissance.

Its repercussions were felt not only in the field of painting, but also in the fields of design, fashion, furniture, and even architecture. It is interesting to note that Van Gogh decided to settle in Provence to paint because he thought the region looked like Japan. He wrote in a letter to his brother Theo in the spring of 1888, "You know, I feel I am in Japan," and described Arles as a "little town full of flowers, all yellow and violet... so pretty, like a Japanese dream."

BING, JAPAN AND ART NOUVEAU

The one man who contributed the most to the spread of Japanese art was Siegfried Bing, a passionate admirer of the decorative arts who deserves to be mentioned here if only because he transformed his gallery into a *Maison de l'Art Nouveau* to champion the works that were directly derived from Gauguin's arabesques.

Siegfried Bing (1838-1909) began working as a ceramicist in his native Germany. He moved to Paris in the aftermath of the Franco-Prussian War and eventually became a French citizen. Upon his arrival, he opened a boutique specializing in Chinese and Japanese art. In 1875, he travelled extensively in the Far East.

He enjoyed a good reputation among art lovers, and began actively proselytizing for his cause in 1885. In 1888, he started publishing a superbly-illustrated monthly, *Le Japon Artistique*, which soon enjoyed a wide readership and contributed considerably to the dissemination of Japanese aesthetics. He also organized exhibitions of Japanese art in various places, and in particular a major show in his own gallery in that same year.

He was subsequently appointed to a research mission to the United States by the French director of Fine Arts and, in 1896, published a report entitled *Artistic Culture in America*, in which he made special mention of Louis Sullivan, the architect of the first skyscraper, and the stained-glassmaker Tiffany. It was around this time that he decided to devote himself

PIERRE BONNARD

Family Scene
1893, lithograph,
31 x 18 cm. (12 x 7 in.),
Josefowitz Collection.

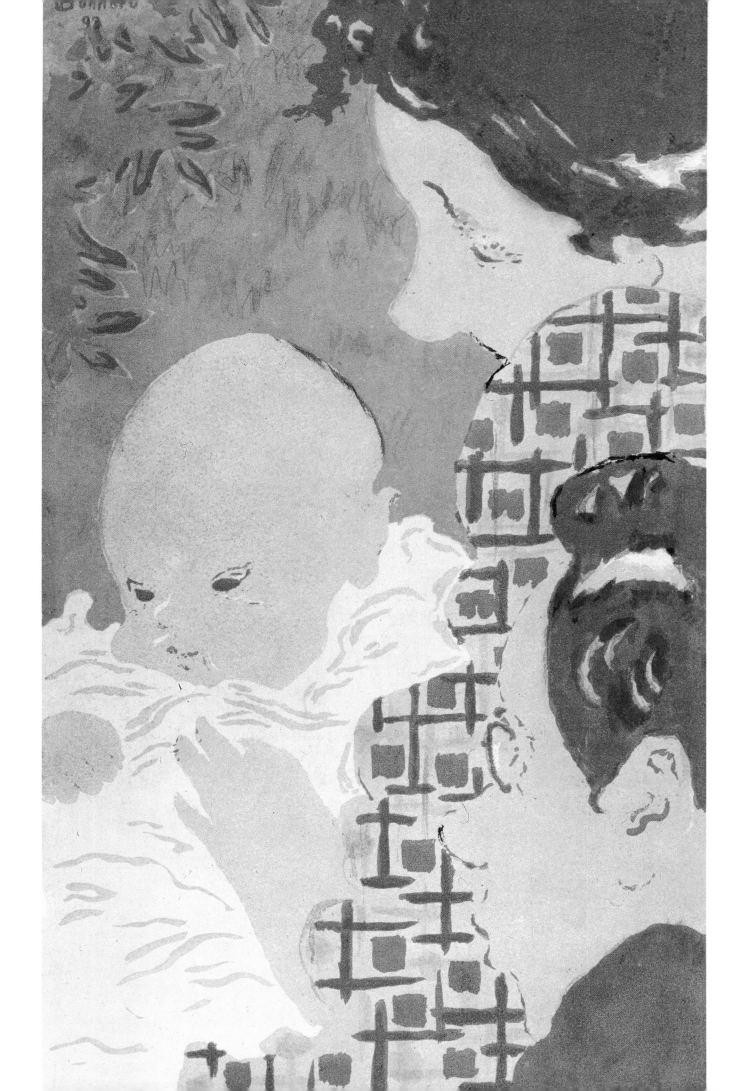

PAUL SERUSIER

Fishing Boats on the Breton Coast
Around 1892, charcoal, pastel and
pen and ink,
24 x 31.3 cm. (10 x 12 in.),
Josefowitz Collection.

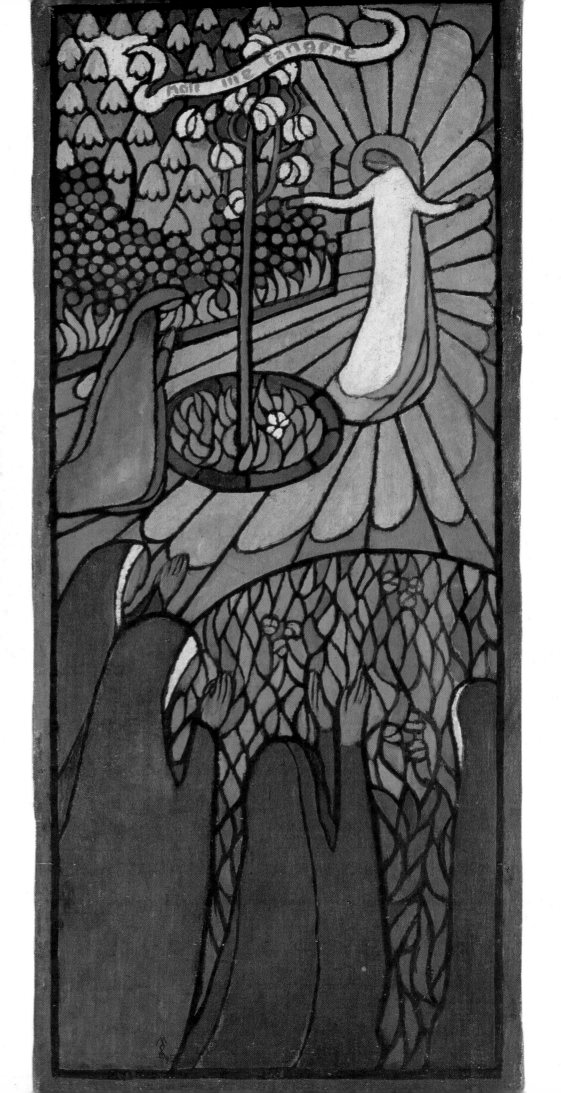

MAURICE DENIS

Noli me tangere

1895, sketch for stained-glass window,

oil on cardboard,

84 x 35 cm. (34 x 14 in.),

Saint-Germain-en-Laye,

Musée Départemental du Prieuré.

to his new passion for the decorative arts. His gallery in the rue Provence became known as the *Galerie de l'Art Nouveau*. For its inauguration, he commissioned the Belgian architect Van de Velde, whose work he had seen in Brussels, to design a smoking room, an office and a dining-room. He also asked Vuillard to design a small waiting room, and the Englishman Charles Conder (who had attended the Atelier Cormon and been influenced by Anquetin and Toulouse-Lautrec) to execute paintings on silk for a boudoir. The Nabis were superbly represented. Bing also commissioned Vuillard to decorate plates for the dining-room, which was decorated by Ranson and furnished by Van de Velde. Ranson painted four large canvases depicting women busy doing their every-day chores; with their typically Nabi serpentine line, his *Four Women at a Fountain* and *Three Women Harvesting* , were fully in keeping with the rising Art Nouveau sensibility.

For the bedroom, Maurice Denis painted a cycle of seven panels inspired by Schumann's *lieder*. He also designed the corresponding furniture, and, although Bing had already commissioned Gallé, brooked his patron's fury and insisted that his own pieces be installed.

NABI STAINED-GLASS WINDOWS

Just before going to the United States, Bing had become the representative for Louis Comfort Tiffany, a former painter who, in 1885, had founded the Tiffany Glass Company, specializing in coloured glassware and stained-glass windows. In 1894, Bing asked eleven artists to submit projects for stained-glass windows. All were members of the Nabi group, except for Toulouse-Lautrec, the society painter Albert Besnard (who looked askance at all this "advanced" art) and a certain P.A. Isaac. By some miracle, these windows were ready to be exhibited the following spring at the Salon of the *Société Nationale des Beaux-Arts*. In December, seven of them were displayed at the *Galerie de l'Art Nouveau*: K.X. Roussel's *The Garden*, Ranson's *Flowered House*, Ibels' *Summer*, Bonnard's *Motherhood*, Vallotton's *Parisiennes*, Vuillard's *Chestnut Trees* and Toulouse-Lautrec's *Papa Chrysanthème*.

Also exhibited on this occasion were eight small stained-glass windows designed by Sérusier and *Musique d'Automne* by the Swiss Eugène Grasset, who established himself in France and created posters in the grand style of the period. He also illustrated books and designed the remarkable type font that was named after him. Unfortunately, only two or three of the stained-glass windows have survived.

This Franco-American venture was in keeping with Bing's cosmopolitan convictions, which contributed much to introducing French artists abroad. A major concern of his had been to put the applied arts on the same footing as the fine arts. To this end, he showed works by the Nabis, Seurat, Signac, Toulouse-Lautrec and Rodin at the same time as glasswork by

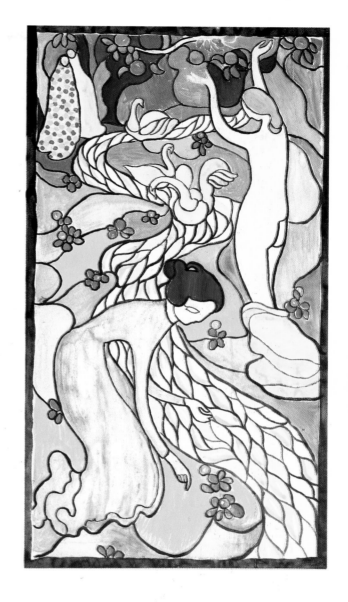

MAURICE DENIS

Women at a Stream

1894, gouache on paper,

143 x 71 cm. (4 ¹/₂ x 2 ft.),

Saint-Germain-en-Laye,

Musée Départemental du Prieuré.

PIERRE BONNARD

Design for furniture

1891, pen and ink with watercolour,

Paris, private collection.

Gallé and Tiffany, posters by Beardsley and Mackintosh, and jewelry by Lalique.

Public and critical response was not encouraging. But this did not deter Bing in the least; on the contrary, he thought that the best way to parry the reticence of the Parisians was by persisting in showing controversial art. What he needed now was an artist both highly original and little known. He thought of Edvard Munch. The Norwegian painter had received much attention at his exhibitions in Scandinavia and Germany but remained virtually unknown in France.

One prominent figure in artistic circles, Thadée Natanson (of whom more will be said later), had seen Munch's paintings during a recent trip to Norway and found them remarkable. The well-known German writer, Meyer Graef, had already taken the initiative of sending ten paintings by Munch to the *Salon des Indépendants* in April. Munch went to Paris with Graef for the occasion, met the Symbolists and painted a portrait of Mallarmé. The moment seemed ripe to hold a major exhibition of Munch's work in May at the *Galerie de l'Art Nouveau*. It was the subject of an important article by August Strindberg in *La Revue Blanche*. But, despite the Norwegian painter's growing popularity, the exhibition was not a great success.

Unabashed, the founder of the gallery went on to re-christen his establishment Art Nouveau Bing; by then it had its own workshops, in which the designs of Siegfried Bing's favourite collaborators were produced, in particular those of Gaillard and de Feure (who was also known for his very attractive posters). The two men designed furniture for him, not wholly devoid of taste, in a style best described as "fin-de-siècle-Rococo."

In the meantime, Bing had effected one of his characteristic about turns. The idea now was to "re-impregnate oneself with the old French tradition; to rediscover its elegance, its grace, its logic and its purity; to give it new forms, as if the thread had never been lost." So much for internationalism in art!

Siegfried Bing was not just another art dealer, but a man with ideas, perhaps the only one of his kind at the time. But here we must backtrack a few steps, for by the time Bing got around to commissioning from the Nabis, they had already taken part in several group shows. Their first support in the trade was Le Barc de Bouteville, an art dealer of Norman extraction whose name was matched only by his taste for elegant clothes, and who died all too soon, in 1896, at the age of fifty-nine – a sudden loss that deprived the Nabis of a valuable ally. It is true that they had already made their mark on the Parisian art scene: their first exhibition was held in 1891. In all the group had fifteen shows in which works by Gauguin, Anquetin, Toulouse-Lautrec and Maufra were also exhibited. There were also one-man shows: Van Gogh in 1892, Maufra in 1894 and Seguin in 1895.

When Durand-Ruel organized his first exhibition of Bonnard's works in 1896, the young painter's reputation had already been made. This was because his paintings had often been seen, but also thanks to the critical reviews that were being published in prestigious new magazines with a relatively wide circulation. The first issue of the *Mercure de France* appeared in January 1890, and this magazine soon became the official organ of the Symbolist movement, before continuing its long and distinguished career. The first issue featured an article by Albert Aurier on Vincent van Gogh. It was in also in the pages of the *Mercure de France* that Aurier published, a year before his death, his famous article entitled "Symbolism in Painting. Mr. Paul Gauguin."

La Revue Blanche was founded in 1889 as an obscure magazine for young readers before coming into its own three years later. Its founders, Alexandre and Thadée Natanson, the sons of a rich banker from Poland, decided to make the necessary investment for it to become an important journal.

Alexandre, the elder of the two and a businessman, played the role of administrator. His taste for luxury was manifested by a sumptuous apartment in the Avenue du Bois (Avenue Foche). He celebrated the unveiling of the panels he had commissioned from Vuillard for his dining-room with a gargantuan banquet that was the talk of the town long afterwards. Just one anecdote will suffice here: Toulouse-Lautrec, attired as a barman, served some two thousand cocktails that night, yet remained perfectly sober all the while.

The younger of the two, Thadée, was married at the time to the captivating Misia, a remarkable figure in her own right whose likeness is preserved in many an outstanding portrait. Thadée Natanson, who was already a friend of the Nabis in the Condorcet days, was endowed with a true artistic sensibility. The third and youngest Natanson brother, Alfred, an avid theatre-goer, wrote many perspicacious reviews of plays for the magazine. He was also a playwright himself, and co-produced (with Tristan Bernard) a long-running hit called *Le Costaud des Epinettes* (*The Strongman of the Spinets*).

The *éminence grise* of this concern was the admirable and enigmatic Félix Fénéon. Here is what he had to say about *La Revue Blanche* in a 1923 article published in the *Bulletin de la Vie Artistique* : "It may be that this review... is more famous today than in the days when, twice monthly, it sparked so much debate. What other magazine is still talked about twenty years after its disappearance? This one had the peculiarity of not courting its public, but of tendering with each issue some biting surprise, for it was completely free of moral and social superstition."

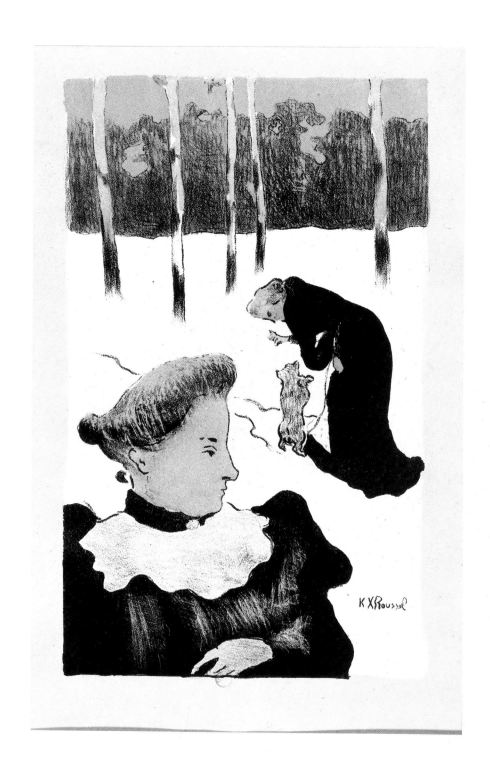

KER XAVIER ROUSSEL

Training the Dog

Lithograph, 32.7 x 19.6 cm. (12 x 8 in.),

Paris, Bibliothèque Nationale.

Then Fénéon went on to list the names of the authors whose articles had appeared in the pages of *La Revue Blanche*. Here are just fifteen names out of the fifty he cited: André Gide, Rémy de Goncourt, Léon Blum, Alfred Jarry, Jules Renard, Pierre Louÿs, Maeterlinck, Verlaine, Verhaeren, Claudel, Gorki, Péguy, Charles-Louis Philippe, Kipling and Apollinaire.

We have chosen those to whom these lines by Fénéon certainly do not apply: "It may be that some of these writers will fade with age, but at least *La Revue Blanche* had them at their prime and mordant best. The name of Stéphane Mallarmé is better still, and many of his *Divagations* appeared here. Jules de Gaultier was in charge of philosophy, Charles Henry and Félix Le Dantec of science, Claude Debussy of music and Thadée Natanson of art." It may be worth noting that Léon Blum, the future statesman, not only worked for a time as literary critic, but was also responsible for the racing pages.

Most of the names mentioned by Fénéon also appeared in the small, and generally more ephemeral, reviews like *L'Ermitage*, *Les Entretiens Politiques et Littéraires*, and *La Vogue*, all of which contributed to the feverish exchange of ideas among the various artistic groups. There were Rosicrucians as well as Anarchists, Theosophists, Atheists, Occultists and run-of-the-mill Christians, but Anarchism was still the most prevalent trend. Even Barrès sided with it and Mallarmé sent donations to support the "soup-lectures" given by the anarchist Roussel.

ANARCHISM, OCCULTISM AND THE ROSICRUCIANS

Anquetin, Ibels and Vuillard illustrated *L'Escarmouche*, which was published by their friend Georges Darien. Paul Adam, Gustave Kahn, Fénéon and Verhaeren, who had been the first defenders of Neo-Impressionism, were confirmed anarchists, as were the neo-Impressionists Signac and Luce. Seurat, who did not have long left to live, kept his opinions to himself. But Gustave Kahn was able to detect in his *Chahut* a hint of social criticism that seems to have been quite well camouflaged.

It was also in this period that a certain Péladan was called by Stanislas de Guaïta to serve on the Supreme Council of the Rosicrucian Order, and effectively brought a new impetus to the organization. Péladan, whose Christian name was Josephin, was the son of a devout Catholic and staunch Royalist father who dabbled in the occult. When he acceded to his new function, he took on the name of Mérodack, qualified by the title of Sâr, which he claimed to hold from a remote ancestor who had been a king of Babylon. He was born in Nîmes but moved to Paris and became a budding writer. A good friend of Barbey d'Aurevilly, Léon Bloy and Huysmans, he was also acquainted with Puvis de Chavannes and Gustave Moreau. Although he affected exotic costumes combining Italian Renaissance and ancient Chaldean

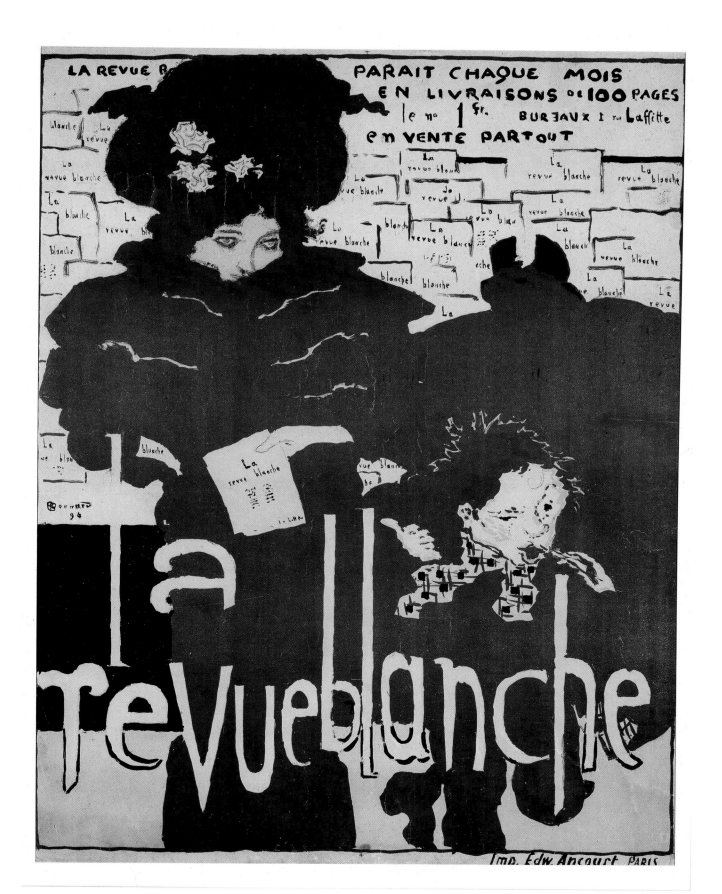

fashions, there was nothing shocking about this in a city where extravagance reigned more than ever supreme. His particular understanding of the myth of the Androgyne earned him a large following, and so it was not by chance that the Nabis often referred to it. The Sâr's first novel, *The Supreme Vice*, which appeared with a preface by Barbey, was not as bad as the ones that followed, of which the best that can be said is that they expressed in often simple and moving terms his devotion to beauty, love and art.

Painting and sculpture, for Péladan, were conceived as spiritual exercises in the all-important quest for the Ideal. With the help and financial support of his Archon of the Fine Arts, Antoine de la Rochefoucauld, himself a painter, he organized the first Rosicrucian Salon. It opened at Durand-Ruel's gallery in March 1892 and attracted so many enthusiasts (including ambasssadors) that buses had to be diverted from the rue Lepelletier.

Only works that fulfilled very precise requirements were deemed acceptable for this exhibition. The rules were dictated by the *Maccabée du Beau* (Péladan) and forbade, for example, "all landscape, except those painted à la Poussin" and "seascapes or sailors." These were rules six and seven out of a total of twenty! The best painters of Christian inspiration such as Puvis de Chavannes and Maurice Denis, or painters of the dream-world such as Odilon Redon and Gustave Moreau, were wise enough not to participate. The field was left to second-rate disciples, and Félix Fénéon sardonically whittled them down to size in *Le Chat Noir*, another of the brilliant small magazines.

But Emile Bernard, who was soon to benefit from the resources of La Rochefoucauld's well-balanced cheque book, did take part in the show. Vallotton, who made no secret of his anarchistic leanings, also played along; he was the only Nabi to do so. The presence of the latter speaks for the prevailing ecumenical spirit that was a specific sign of these times. Although the Sâr and his Archon held more such Salons, interest soon faded, and the last one came and went in 1898.

It has rightly been said that this fascinating period, which can be outlined only briefly here, was "one of the most fertile artistic periods in the history of humankind." Gauguin's own involvement was to be very short-lived. On 1st April, 1891, he left the port of Marseilles for Tahiti, arriving there in June. How had he finally made his dream come true, and how had he fared during the months that preceded his departure? In his book, *Le Sot du Tremplin* , Lugné-Poë tells of the Master of Pont-Aven's visits to the studio that he shared with Bonnard, Vuillard and Denis. His account reveals how a contemporary viewed the mystical tendencies shared by the Nabis and their immediate precursors: "Sérusier, Percheron (a Nabi who quickly became a businessman), Gauguin, Coquelin, Cadet, Ibels, Ranson, Le Barc de Bouteville and many others... would sit in this studio, which was the size of a

PIERRE BONNARD
Woman with an Umbrella
Lithograph, Paris,
Bibliothèque Nationale.

Opposite

PIERRE BONNARD
The Salon of the One Hundred.
Study for the poster
1896, lithograph,
Paris, Bibliothèque Nationale.

pocket handkerchief and had a stained-glass window overlooking the rue Pigalle....

Our friends were momentarily affected by the mystical emotion of the exalted few. There was a sort of mystic virus going around at the time. Some even ended up in a monastery.... Artists and poets of the previous generation had paved the way, and not too many steps separated a Gauguin from a Le Cardonnel. In the symbolic phalanx of the Voice of God, one could meet angels – and why not? Perhaps Maeterlinck played a mischievous, or even malevolent, role in egging the others on."

Gauguin, whose entire life was motivated by the ideal of the revolt of the individual, would never have dreamed of going the way finally chosen by the minor – but authentic – Symbolist poet Louis Le Cardonnel, who was ordained as a priest in 1896. But it is tempting to believe what Lugné-Poë insinuated about Maeterlinck; that his work was too angelic to be honest.

Whatever the truth, it is remarkable that one of the Nabis, Jan Verkade, became a monk, and that another, Mögens Ballin, who chose to keep his lay status, was nominated for beatification. What is even more remarkable is that neither was born of Catholic parents.

Before becoming a member of the clergy, Jan Verkade (1868-1946) was known as the obelisk Nabi because of his tall stature and extremely slender girth. In his autobiography, *Les Tourments de Dieu* (1923), he told how he made the transition from artist to monk in 1902. His book is an interesting record of the artist's life in Paris, Brittany and Italy, and contains telling descriptions of his fellow-painters.

Verkade was born in the Netherlands, at Zaandam, in a Mennonite family (the same Protestant sect to which Rembrandt had belonged). But his parents were indifferent to religion and raised their children in an atmosphere of open-mindedness. Jan went to secondary school in Amsterdam, where his father owned a biscuit factory, and went on to study at the Academy of Fine Arts. He soon dropped out, however, and joined forces with his brother-in-law, Jan Voeman, a painter in the Impressionist style.

The next step was to make the move to Paris; along the way, in Brussels, at the Salon des XX, he discovered the works not only of Gauguin and Van Gogh but also of Pissarro, Seurat and Signac. He arrived in Paris in 1891, armed with a letter of introduction to his compatriot Meyer de Haan. The latter introduced him to Sérusier, the painter of *The Talisman*, calling him the "principal apostle of the painter Gauguin." Sérusier took an immediate liking to the newcomer, offered to share his studio with him and kept a close eye on the development of his promising work.

With his lust for life, Verkade adapted well to Parisian social life and became a regular at the Café Voltaire, on the Place de l'Odéon, the

favourite meeting-place of the Symbolists. His Nabi friends introduced him to Theo van Gogh, who took him to Boussod Valadon's to see works by his brother and the Impressionists. Another obligatory Nabi pilgrimage took him to the Montmartre boutique of Tanguy, the now legendary curio-dealer who had the best stock of Van Goghs, Gauguins and especially Cézannes, to be seen anywhere in Paris.

Several years later, in 1900, Maurice Denis exhibited his *Homage to Cézanne*, a group portrait composed around a still-life by the master from Aix and showing most of the Nabis, in addition to Odilon Redon and André Mellerio, whose book, *The Idealist Movement in Painting* (1896), led to a better understanding of the works of the Nabis and their masters.

THE MASTER DEPARTS

At the Café Voltaire, Verkade met Gauguin, who was spending his last months in Paris working hard. An exhibition of his works, including paintings, sculpture and ceramics, was held at the Boussod Valadon gallery in January. The Groupe des XX organized an equally comprehensive exhibition in Brussels in February. Rachilde, the wife of the founder of the *Mercure de France*, Alfred Valette, asked Gauguin to make two drawings to illustrate the programme notes of a play she had written called *Madame la Mort*. The resulting charcoal drawings gave a striking vision of the play's main character.

Charles Morice then had the idea of holding a public sale of Gauguin's works at the Hôtel Drouot auction house to finance his journey to Tahiti. The two men did an admirable job of preparing the event. Morice sought help from Mallarmé, who turned to Octave Mirbeau in the belief that no one was better equipped than he to inform the public by an article in a major daily. Gauguin and Morice paid the writer a visit in his country house, and he responded by going to Paris to find out more about his new friend's work. A week before the auction, in the February 16 issue of *L'Echo de Paris*, Mirbeau published a very engaging front-page article, writing among other things: "Mr. Paul Gauguin is a very exceptional and troubling artist who rarely shows his work, and is thus not well known by the public...." Two days later he published another article announcing the sale and guaranteed to publicize it.

The article in *L'Echo de Paris* also served as the preface to the sales catalogue. Thanks to the well-orchestrated publicity, the auction was a success, with thirty pictures being sold for a total of over nine thousand francs. The next day, the great journalist Jules Huret published an article headed "Paul Gauguin in front of his Paintings." Not long afterward, the *Mercure de France* featured an article by Aurier, "Symbolism in Painting. Mr. Paul Gauguin." Yet in spite of so many efforts in the print media, four years later Gauguin could still be declared a dangerous eccentric and taken to task for "inventing" the colours of his shadows.

With the rather considerable proceeds generated by the auction, Gauguin was able to make the trip to Copenhagen to visit Mette and his children. But the family reunion was not a long one. By 23rd March, Gauguin was back at the Voltaire to attend the banquet celebrating his departure for the South Seas. Mallarmé, who presided over the festivities, proposed the first toast to the painter, delivering the kind of subtle and moving speech in which he excelled. More toasts followed, proposed by some of the forty guests, among whom were several Nabis. In his autobiography, Verkade wrote a brief and touching account of Gauguin's farewell on the platform of the Gare de Lyon where Sérusier and Charles Morice were also present. Gauguin, who could scarcely hold back his tears, hugged each of them.

At the banquet at the Café Voltaire, Verkade met Mögens Ballin (1871-1914). Ballin was born in Copenhagen but went to Paris at the tender age of seventeen, with the anxious blessing of his pious Jewish parents. There, he met Sérusier, and through him, Verkade. The two men became fast friends, going off together on merry nocturnal escapades through the streets of the French capital. Verkade loved nothing more than having a good time. He once wrote to Sérusier asking him about cotillon dance steps and received this stern reply: "I don't have it in me to talk to you about such foolishness. Ask one of your socialite friends, or buy yourself a book that describes such things." The letter naturally ended with, "In your palm, my words and my thoughts."

Sérusier had other titles in mind for Verkade than treatises on the cotillon. He introduced him to Edouard Schuré's *Les grands initiés*, and suggested that he read the Bible and Balzac's *Seraphita*. This novel, which tells the story of the androgynous Seraphita-Seraphitus, was widely read at the time. It was more than just a novel, but also a philosophical text heavily influenced by Balzac's early reading of Swedenborg and his own mystical leanings.

One wonders if Verkade had this book with him when he left with Ballin in the spring of 1891 for Pont-Aven, literally, it seems, to follow in Gauguin's footsteps. They were later joined by Sérusier, who then moved on to Huelgoat, which had the advantage of being practically empty of tourists. In a letter written to Verkade, he described his room that he had converted into a studio, covering the walls with his paintings, Japanese prints and "a copy of *Louis Lambert* on the table, of which I read one page before getting down to work." His choice of reading matter comes as no surprise, for it was another of Balzac's novels in the Swedenborgian vein.

THE NABIS IN THE CHURCH

As Verkade reminisced in *Le Tourment de Dieu*, he and Ballin went from Schuré's classic to the *Little Catechism of the Paris Diocese*. This pious handbook had been supplied to them by Percheron, who had

Above and next page (detail)

JAN VERKADE

Two Women in a Field

Around 1892, monotype touched up with

watercolour and gouache,

28.9 x 23 cm. (11 x 9 in.),

Josefowitz Collection.

JAN VERKADE

Farm at Le Pouldu

1891, oil on canvas,

61 x 78 cm. (24 x 31 in.),

Josefowitz Collection.

JAN VERKADE

Saint Sebastian

1892, tempera on cardboard,

46.5 x 23 cm. (18 x 9 in.),

Saint-Germain-en-Laye,

Musée Départemental du Prieuré.

Opposite

PAUL RANSON

Christ and Buddha

Arthur G. Altshul Collection.

experienced a variety of religious crises before finally settling into a career in business. Interestingly enough, the two companions had reached this point independently of each other. By the time they decided to take a trip to Florence, Verkade had already been baptised and Ballin was well on his way. When they reached the Tuscan capital, they were warmly received by the high clergy and given permission to stay at the Franciscan Convent in nearby Fiesole. It was there that Ballin was baptised by the Archbishop of Florence.

A letter from this period, however, shows that although the two friends had been converted to the Faith of the Apostles, they still indulged in the purple prose of the Nabis.

"Most Venerable Nebiim!

Most Dear Comrades!

A sweet duty it is to send you greetings at this time, as we await the coming of the Light in the world, the coming of the eternal Word.

Let the Budphas (sic), the Osirises, the statues of the terrible Jupiter crumble before the countenance of Jehovah, before the Holy Trinity, before the Justice, Love and Beauty which are the Father, the Son and the Holy Spirit. The impassive Budphas themselves appear as inchoate harmonies in comparison with scenes from the Passion of Our Sweet Lord...."

The highly venerable *Nebiim* – the pious Maurice Denis included – had quite other concerns at the time: they were busily designing theatre sets and posters, and painting wall-panels for interior schemes. In his book, Verkade explained how things had come to that: "At the beginning of the nineties, a war cry resounded in all the studios: No more easel painting!... The painter should not indulge in a freedom which isolates him from the other arts. The painter's work begins where the architect considers his work to be done. The wall must remain a surface and not be hollowed out with depictions of infinite horizons. There is no painting, there is only decoration!"[1]

Verkade had sensed the general drift of things and rightly perceived the aspirations of his "very dear comrades," who, although fond enough of intimist paintings, had seized the gist of Gauguin's efforts and proclaimed that all art was decoration. For his part, the Dutch painter was to devote the rest of his career to religious painting. During their visit to Rome, Ballin and he had noticed the frescoes painted by monks from the Abbey of Beuron, in the south of Germany. On his way to Amsterdam to see his parents, Verkade made a side-trip to Beuron, which was the active centre of a renewal of religious art led by Father Desiderius Lenz. In his autobiography, he reminisced how impressed he had been by the Father's exposition of his teaching, the general purpose of which was to "liberate art from the slavery

1. Verkade, *Le Tourment de Dieu*, Paris, 1926.

CHARLES FILIGER

Heads of Angels

1889, watercolour on tracing paper,

19 x 28 cm. (8 x 11 in.),

Josefowitz Collection.

of individualism and bring it back to classical beauty through number and proportion." Feeling strongly the call to join this religious community, Verkade finally took the step and entered the monastery as artist-oblate. He was admitted as a novice in 1897 and finally ordained as a priest in 1902.

His capacity for submission was often put to the test. During his noviciate, he was involved in a collective project to decorate the façade of the church at Beuron. Only afterwards was he permitted to work on an individual picture intended for a chapel; but it was judged unsuitable and contrary to dogma, and he was ordered to destroy it himself. Ever obedient and respectful, he worked from then on in places as different and far-flung as Monte Cassino, Vienna (twice), Jerusalem and Prague. He kept in touch with his former colleagues: with Maurice Denis, naturally, but especially with Sérusier who, always thirsting for theoretical discourse, was in a perfect position to appreciate the new vocation of a friend he still considered as his disciple.

During a sentimental journey through Central Europe, Sérusier stopped by at Beuron to visit Verkade. He also met Father Lenz and was duly impressed by the monk's own ideas about measure and proportion. He wrote a letter to Verkade after this visit, saying: "I have spoken much about your proportions... but Vuillard, Bonnard and Roussel remained indifferent." He may already have sensed that, if the various Nabis, whether *zouave* or *très japonard*, were interested in numbers and synthesis, it was thanks mostly to the bonds of friendship.

Before leaving Verkade, it is interesting to note that at the end of his worldly career, in 1892, he gave Rémy de Gourmont a drawing for Lautréamont's *Chants de Maldoror* that were to be printed in the review directed by Gourmont and Paul Fort, *Le Livre d'Art*. This is all the more interesting as Rémy de Gourmont was one of the few people to know of Lautréamont's work at the time.

In any event, the quest for the Absolute was not a major preoccupation of those Nabis whose names passed into history. Nor were they overly concerned about the study of numbers and proportions, whose secrets Sérusier believed he had unravelled: "Man carries in his body all the measures he needs; these are the cubit (the distance from the elbow to the tip of the index finger), the foot and the span," etc., etc. He went on to explain the relationships between these measures and the Golden Number, and finally concluded that "these relationships are exact in all men, even the deformed."

THE NABIS IN THE PROFANE WORLD

The painters with whom this book is mainly concerned were worldly fellows, content to enjoy all the good things which their stimulating

lives and mutual company could bring. One of their favourite meeting-places was the offices of *La Revue Blanche*, where they could mix with such engaging figures as Mallarmé, Toulouse-Lautrec, Verlaine, Fénéon, Jarry, and many more. Thadée Natanson, writing many years later, noted, paradoxically enough, that the appellation *Nabi* was in fact difficult to justify in their case.

While acknowledging that he was ill-placed to do so, he suggested that they be called instead *the painters of La Revue Blanche*, as some already called them, "not so much because they illustrated its fascicles and magazines, but because that is where their spirit flowered, in the midst of the ideas discussed there and the many people they got to know there." It must be said that Thadée Natanson, although impressed by Gauguin the man, greatly under-estimated his influence as a painter. Bonnard, Vallotton, their friends, and even Vuillard, who was never really a Symbolist, did not make the same mistake. In one of Bonnard's posthumously published *Notebooks*, we read this characteristically Symbolist statement: "Through seduction or a central idea, the painter attains the universal."

For the time being, at any rate, glad of the business of wealthy and open-minded individuals, they were busily applying the tenet cited by Verkade to which Gauguin would also have subscribed: "There are no paintings, there is only decoration." Thus, Vuillard, for one, executed many private decorative ensembles, starting with the Desmarais, who were related to the Natansons by marriage. He went on to more ambitious projects, like the nine panels for Alexandre Natanson's avenue Foch apartment, the unveiling of which occasioned that memorable party. The panels, which have now been dispersed, formed a sentimental cycle of Parisian public parks. In 1898, he was commissioned by a now forgotten novelist, Claude Anet, to paint decorative panels depicting the gardens of the two houses successively rented by Thadée and Misia to be closer to Mallarmé in Valvins. (Vuillard's avowed love for Misia may not be unrelated to their superb quality). He applied the lessons learned from these first efforts to his final work in the genre: the four panels to decorate the library of his friend, Dr. Valquez. They are painted in a minor key, no longer in the happy colours of before, and feature women in domestic situations, reading, playing the piano or sewing, against backgrounds of very typical fin-de-siècle wallpaper designs.

DECORATIONS FOR THE WEALTHY, POSTERS FOR ALL, THE THEATRE FOR SOME

Given their ideas on the decorative function of painting, their fondness for lithography and their concern – influenced by the ideas of William Morris in England – to bring art closer to the people, the Nabis very naturally moved on to poster design. They were far from being the only ones; so many artists – we need cite only Willette, Chéret, Toulouse-Lautrec, Mucha

PAUL RANSON

La Farce du paté et de la tarte

15th-century satire

Lithograph on paper, dated 1892,

22.5 x 15 cm. (9 x 6 in.),

Saint-Germain-en-Laye,

Musée Départemental du Prieuré.

HENRI-GABRIEL IBELS

L'Affranchi et Legrapin

Programme for the Théâtre Libre,

1892-1893 season, lithograph,

24.3 x 21.7 cm. (10 x 9 in.),

Josefowitz Collection.

HENRI-GABRIEL IBELS

The Fossils

Progamme for the Théâtre Libre,

November 1892, lithograph,

Josefowitz Collection.

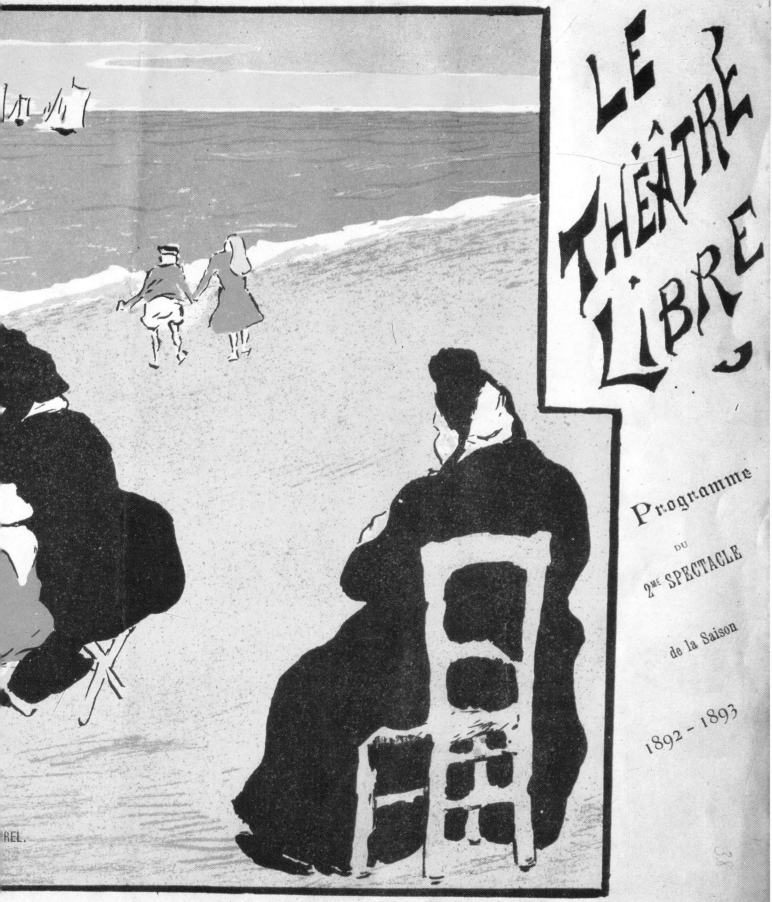

LE THÉÂTRE LIBRE

Programme

DU

2ME SPECTACLE

de la Saison

1892 — 1893

REL.

Paris, Imp. Eugène Verneau, 108, r. Folie-Méricourt.

and Steinlein – were drawn to this medium at the turn of the century that one could speak of a veritable "poster movement."

The Nabis cut a good figure in this movement, if not by their numbers, then by the quality of their work. A handsome example is Maurice Denis' design for the newspaper *La Dépêche de Toulouse*. Vallotton demonstrated the sureness of his line and his sense of composition in black and white in a poster for a pharmacy on the Champs-Elysées. He designed others, including one for the Galerie Sagot that shows his mastery of woodcut engraving and his peculiarly personal sense of observation. Henri-Gabriel Ibels' posters for the *Salon des Cent* and *L'Escarmouche* give an idea of what he could have contributed to this art-form had he not decided to devote his efforts elsewhere. Bonnard may not have been able to rival Toulouse-Lautrec in terms of quantity, but of their posters for *La Revue Blanche*, many preferred Bonnard's. Maurice Denis summarized the principles that guided his friends when they had to design a poster: "The main thing is to create an expressive silhouette, a symbol which, solely by its form and colour, will draw the attention of the crowd and appeal to the passerby."

The Nabis also did a lot of work for the theatre. Their taste for decoration found it a favourable medium, and the founder members of the group had been acquainted with Lugné-Poë at the Lycée Condorcet. The latter was not the only theatre director with an eye for innovation. The very eclectic André Antoine, a former employee of the gas company, founded the Théâtre Libre in 1887. Disenchanted with the facile unrealistic character of the standard fare in the boulevard theatres, he wanted to bring the stage closer to everyday life. His concern for realism was so extreme that if the script called for the actors to eat soup, then he would have steaming hot cabbage soup served on the stage. He also insisted that the actors stop using the ridiculous declamatory tone that was then in vogue.

It should be obvious that Antoine was no sympathizer of the Symbolists, for whom the theatre was synonymous with the world of dreams. He turned primarily to naturalistic writers producing Courteline's *Boubouroche*, and featuring plays by Tolstoy, Hauptmann and the Scandinavian authors in his repertory. He loved painting and called on the services of Toulouse-Lautrec and Signac, as well as those of Willette and Forain. Through Lugné-Poë he came into contact with the Nabis. Vuillard submitted several illustrations for programme notes, but only one was ever accepted: for a play entitled *Le Cuivre*, which has since fallen into oblivion along with its two authors.

As for Bonnard, he submitted two illustrations, neither of which was accepted. Sérusier designed the programme notes for Hauptmann's *L'Assomption d'Hannele Mattern*, "a sketch for one dream in two parts." The leading role was played by a Polish novelist who also happened to be Sérusier's mistress at the time and the model for his illustration. Henri-Gabriel Ibels, another Nabi painter – or at least one who was still

MIRAGES

Drame en cinq actes, en prose

Paul Hamelin	MM. ANTOINE
Louis Nattier.	GÉMIER
Madame V^ve Hamelin	M^mes BARNY
Marcelle Nattier	CLEM

De la part de M. Georges Lecomte

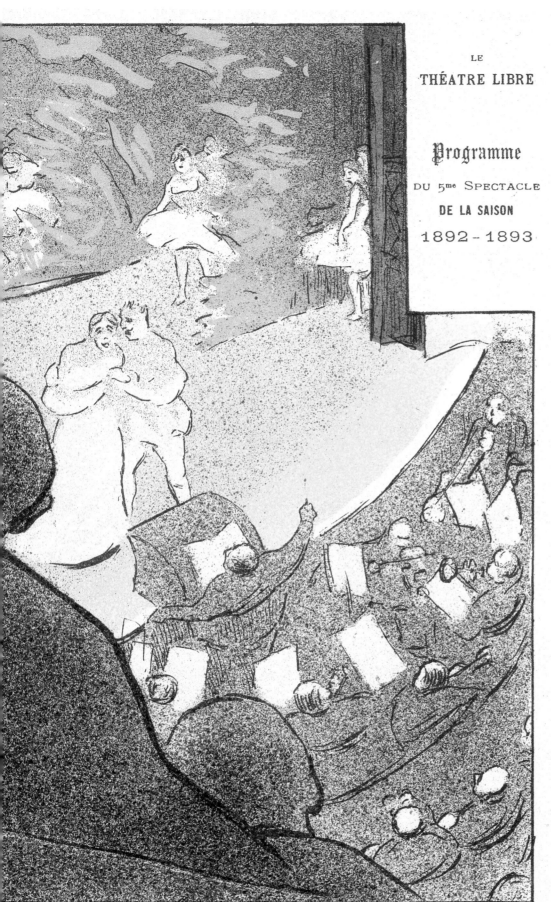

LE
THÉATRE LIBRE

Programme

DU 5me SPECTACLE
DE LA SAISON
1892 – 1893

D.03249 Paris. Imp. Eugène Verneau, 108, r. Folie-Méricourt.

HENRI-GABRIEL IBELS

Mirages

Programme for the Théâtre Libre,

1892-1893, lithograph,

24.3 x 21.7 cm. (9 x 8 in.),

Paris, Bibliothèque Nationale.

associated with the group – became Antoine's main artistic collaborator for many years; his jovial realism was much closer to Antoine than the Symbolism affected by his colleagues.

Another innovative director was Paul Fort who, while still an adolescent, created the *Théâtre d'Art* in 1890 with the intention of staging Symbolist plays. Naturally, he called on the Nabis for artistic contributions. Sérusier designed not only the programme, but also the costumes and sets for *La Fille aux mains coupées* by Pierre Quillard, an unjustly forgotten Symbolist author. He was equally active for Maeterlinck's *L'Intrus* and the Belgian Symbolist Charles van Lerberghe's *Les Flaireuses*. Before mentioning other contributions by the Nabis for the theatre, it must be said that none of these sets has been preserved, nor have any preparatory sketches or designs come down to us. They were simply done during the rehearsals and often pressed into service for several plays.

Lugné – who added "Poë" to his name out of admiration for the great American writer – started out as the director of the *Théâtre Libre*. It was he who directed the single performance of Debussy's *Pelléas et Mélisande* in 1893, which had been made possible by private sponsors, and which the composer attended.

Not long afterwards Lugné-Poë founded the *Théâtre de l'Oeuvre* and went through a difficult period. He recalled that, seven years after its foundation, in order to raise funds, he had to "take the best pictures given by Vuillard, Bonnard and others, and, blushing, offer them to collector friends who swore not to tell a soul." Lugné-Poë often went to great lengths to help his painter friends; it was thanks to his efforts that Vuillard made his first sale.

Once he had taken the decisive and liberating step of founding his own theatre, he was determined to put on as many Symbolist plays as possible. His former Condorcet classmates (with whom he shared a studio) and their fellow Nabi disciples were the best candidates to design sets, costumes and programmes. But he did not stop there and also enlisted the services of artists like Toulouse-Lautrec, Munch, Toorop, and many more.

In his previously mentioned memoirs, *Le Sot au Tremplin*, Lugné described the conditions under which the artists worked: "Once the *Bouffes du Nord* had been rented... Vuillard, with the help of several good friends – Pierre Bonnard, Ranson, Sérusier – agreed to paint in the scenery warehouse in the rue de la Chapelle.... It's a miracle that none of our good friends succumbed to bronchitis! Vuillard and his friends, working away at seven or eight o'clock in the morning, fixing all the stretchers we could find, really put their health and youth at risk. The scenery warehouse of the *Bouffes du Nord* was open to the four winds and had no heating whatsoever."

The most assiduous and enthusiastic of his collaborators was Vuillard. He often gave advice on stage direction and designed sets that were

ALFRED JARRY

Ubu roi

Programme for the Théâtre de l'Oeuvre,

reproduced in *La Critique*, 1896,

Josefowitz Collection.

completely non-realistic and created the perfect atmosphere for the Symbolist texts.

No one contributed more actively than Lugné-Poë to presenting Scandinavian theatre to the French public. With their dark and fiercely passionate casts of characters, the plays of Ibsen, Bjørnson and Strindberg were not only of a high literary quality but also steeped in Symbolist themes. They were the ideal fare for the habitués of the Café Voltaire and the readers of reviews like the *Mercure de France* and *La Revue Blanche*, who were the leaders of the cultural vanguard in Paris at the time. The Natanson brothers' review played a major part in this movement, and Thadée was even called Ibsen's "ambassador" in Paris.

Vuillard was particularly sensitive to the dramatic arts, hence his enthusiastic collaboration with Lugné-Poë. The latter told of the painter's innovative stage designs for *Solness le Constructeur*: "It was the first time in France that anyone had dared to set up a tilted trampoline on the stage, facing the public; it was supposed to represent the terrace in front of Solness's house." Lugné further wrote that the decor was "of matchless splendour" and that "the spectators were mesmerized like a bird by a snake." They must have been disconcerted by a set that was so far ahead of its time.

In addition to designing scenery and costumes, Vuillard and his friends executed many lithographs to illustrate the covers of the programme notes. The covers often featured advertisements for magazines or publishing houses. Vuillard designed those for Gerhart Hauptmann's *Ames solitaires* (1893), Maurice Beaubourg's *La Vie muette* (1894), Ibsen's *Rosmersholm* (1893), and, of course, for *Solness le Constructeur*. Vallotton drew the cover for Strindberg's *Père* (!894). Ranson displayed his masterly decorative sense in his remarkable cover for Hauptmann's *La Cloche engloutie* (1895). Maurice Denis was responsible for the programme of the 1893 performance of *Pelléas et Mélisande*, which Debussy later made into an opera (1902). He also designed the programme illustration for a series of short pieces which included Tristan Bernard's *Les Pieds nickelés* and Maeterlinck's *Intérieur*.

Jarry worked for some time as stage director for Lugné-Poë and did such a good job that Lugné agreed to present his *Ubu roi*, even though he feared the reaction – and he was right. There were two performances (which was the usual number at the *Théâtre de l'Oeuvre*), on 7th and 9th December 1896. The first created a scandal of such proportions that it was not equalled until fifteen years later, when Stravinsky's *Rites of Spring* was first played to the public. Jarry, who had set up the auditorium with great care, closely supervised the extremely simple sets designed by Bonnard and Sérusier.

We have already mentioned Jarry's interest in Gauguin; he was also an admirer of Bonnard and even dedicated a chapter of his *Gestes et opinions du docteur Faustrol* to him. This chapter is set in the national department store "*Au Luxe Bourgeois*" (a pun on the Luxembourg Museum,

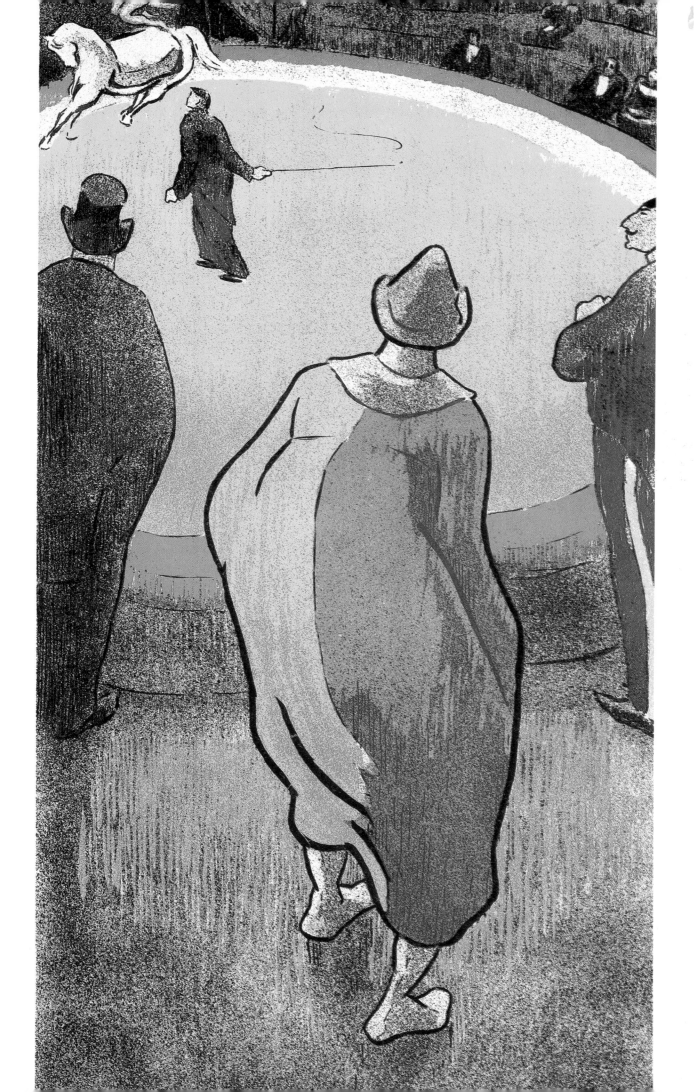

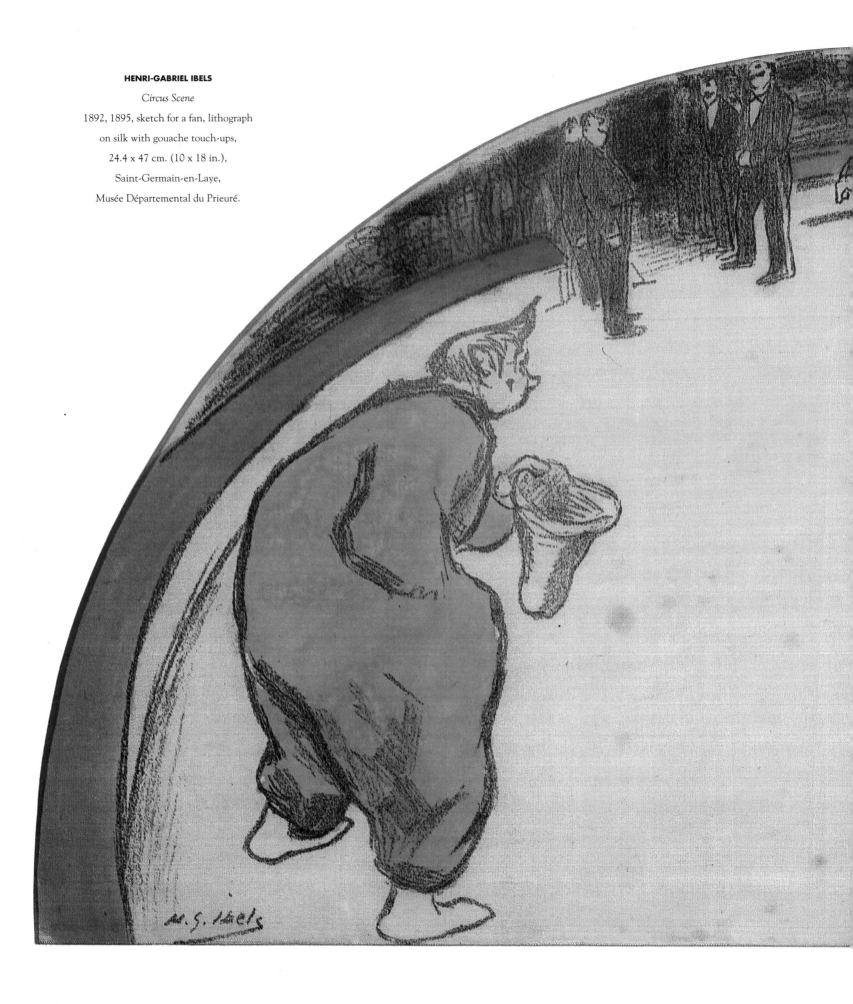

HENRI-GABRIEL IBELS

Circus Scene

1892, 1895, sketch for a fan, lithograph
on silk with gouache touch-ups,
24.4 x 47 cm. (10 x 18 in.),
Saint-Germain-en-Laye,
Musée Départemental du Prieuré.

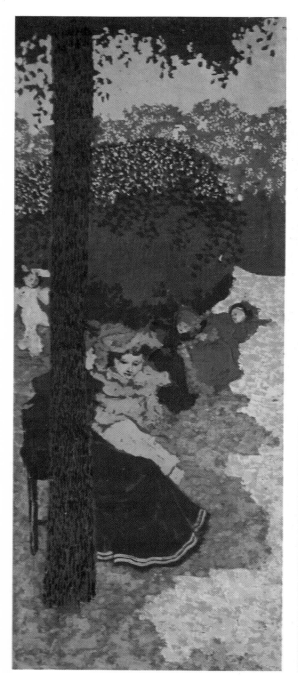
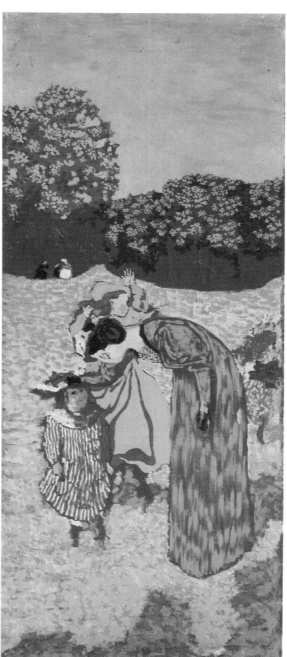
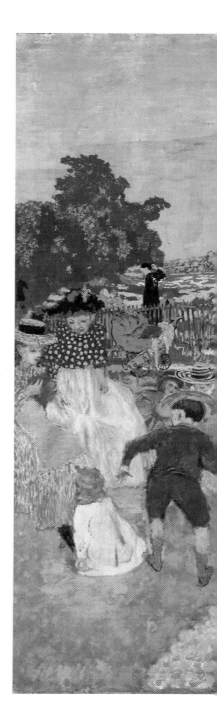

JEAN-EDOUARD VUILLARD

Public Parks

1894, panels for A. Natanson's

dining-room, paint on canvas,

Paris, Musée d'Orsay.

168

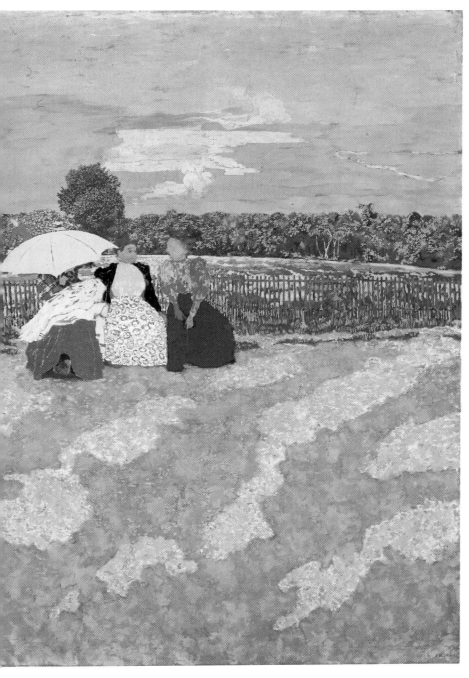
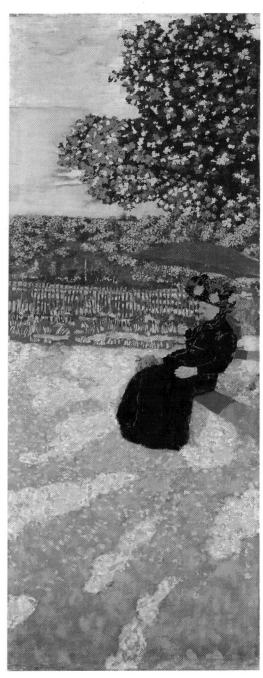

JEAN-EDOUARD VUILLARD

Girls Playing
215 x 88 cm. (7 x 3 ft).
The Interrogation
215 x 92 cm. (7 x 3 ft),
The Nurses
212 x 80 cm. (7 x 2 ¹/2 ft.),

Conversation
212 x 152 cm. (7 x 5 ft.),
The Red Parasol
212 x 80 cm. (7 x 2 ¹/2 ft.).

PIERRE BONNARD

Screen with Rabbits

Around 1902, oil on paper,

each panel: 161 x 45 cm. (5 x 1 ¹/2 ft.),

Saint-Germain-en-Laye,

Musée Départemental du Prieuré.

which was then dominated almost entirely by Salon painters). It would be difficult to summarize this extremely humorous text, but we can cite a few lines to show the author's singular sagacity: "...to clean the prognathism of your maxillary of the mercantile speeches, just step into the little room set aside for just this purpose. Inside it flash and flimmer the icons of the Saints... bow before the Monet, kneel before the Degas and Whistlers, crawl in the presence of Cézanne, prostrate yourself at the feet of the Renoirs and lick up the sawdust at the foot of *Olympia*."[2] Then Faustrol, who had begun by rendering homage to Puvis de Chavannes, celebrates the glory of Van Gogh, crying out "How beautiful yellow is," and concludes by giving Henri Rousseau his due.

Pierre Bonnard illustrated the various *Almanachs du Père Ubu*, including the very luxurious edition published by Ambroise Vollard in 1900. A year later, when Vollard published Verlaine's *Parallèlement*, illustrated with red chalk drawings by Bonnard, Jarry devoted a long article to it. He was quick to grasp the quality of this book, which has been hailed as one of the best bibliophile editions published this century.

Jarry was one of the figures through whom Gauguin, although far away in the South Pacific, was increasingly asserting his presence on the Parisian art scene. In 1894, when he met Filiger and Gauguin in Pont-Aven, he transcribed three poems under the title "After and for Gauguin" in the visitors' book at the Auberge Gloanec. He published one of them, *The Man with an Axe* in his *Minutes du sable mémorial*. He also dedicated a chapter of *Faustrol* to the painter. He remained one of Gauguin's staunchest defenders, and his voice certainly carried more weight than Daniel de Monfreid's. Vollard, who had his ears in the right places, heard enough good about the far-flung painter to sign a contract with him. But, as usual, he was very lax about respecting the modest financial stipulations.

Another connoisseur and Parisian socialist, Prince Bibesco, also offered Gauguin a contract, but was turned down.

2. Alfred Jarry, *Œuvres complètes*, tome I, Paris, 1972.

EACH HIS OWN WAY

As the years went by and as each of the Nabis followed his own way, the movement derived from Gauguin's teachings – as transmitted by Sérusier – ceased to exist. They continued to apply or not to apply its principles as they saw fit, and sometimes even fought against them outright. But thanks to these new principles, a major revolution had been achieved: painting had been freed from the stultifying rules of academicism.

SERUSIER THE INITIATOR

In the days when he was still supervisor of the "*petits ateliers*" at the Académie Julian, and even though each artist made his own particular contribution, Paul Sérusier was clearly the initiator of the Nabi group. It was he who gave the group its name and, more importantly, it was he who had painted *The Talisman* in the Bois d'Amour under Gauguin's direction at Pont-Aven. This was the seminal work that sparked the enthusiasm of his fellow students when he returned to Paris in October 1888.

Maurice Denis, who knew him during the Académie Julian period wrote: "In the rather primitive and vulgar atmosphere of the Julian ateliers, he seemed to be someone of superior culture, a leader, an intellectual and artistic guide. He was all of this and, at the same time, a good friend, a

PAUL SERUSIER

The Talisman (detail)

cheerful and lively companion, a defender of the weak; he was, besides, quite proud of his physical strength, his handsome bearing, his broad culture, and his tenor voice, which he exercised assiduously in the Euterpean Choir." He was, in short, a consummate artist, but one who did not fulfil his potential.

We may admire his better pictures for the spareness of the land-scapes and figures, the inventiveness of the colour schemes, the simplification of the drawing, all of which were in keeping with the rules of Synthetism. But the fact remains that he never managed to pull free from Gauguin's influence, nor did he achieve the pictorial force that characterized the works of the master of the Pont-Aven school.

This may be the reason why he became more and more preoccupied with theory and eventually turned – in vain – to the Golden Number for his elusive inspiration. He was completely won over by the ideas of Desiderius Lenz in his booklet titled *The Holy Measures*, and became absorbed almost exclusively in mathematics and the musical correspond-ences of colours, which he would formulate in a series of colour wheels. And so it happened that the prophet of a living, clear and free approach to paint-ing progressively became the champion of a pictorial ethic confidently derived from the "science of numbers."

Maurice Denis also recalled: "He seems to be a sort of Savonarola, always struggling against excessive sensibility, and against the temptations of instinct."

But the person who probably understood him best was the Polish novelist Gabrielle Zapolska, whose Parisian dining-room he decorated and for whose love he attempted suicide when she returned to live in Poland. She wrote letters in which she outlined his personality and manner of painting, stressing its relationship to Symbolism and his concern to create a decorative art in the grand style: "His works, which are brutal in appear-ance and seem unfinished, are in fact poems of harmony."

Later, as professor at Ranson's art school, he taught his students how to reduce the data of sensation to a small number of simple and intel-ligible elements, and summarized these principles in his book *The ABC of Painting*. He died in 1927 at the age of sixty, never having known the rewards of an advanced old age, which permitted Bonnard to progress ever closer to the heart of creation.

MAURICE DENIS, OR THE PERILS OF THEORY

Maurice Denis was both a prolific painter and author, setting down a valuable record of Symbolism and its times in his writings (*Théories. Du symbolisme et de Gauguin vers un nouvel ordre classique*, 1912; *Nouvelles théories sur l'art moderne et l'art sacré*, 1912). A devout Catholic since adolescence, he later founded the *Ateliers d'Art Sacré* with Rouault and

MAURICE DENIS

The Fitting

1900, oil on cardboard,

58 x 48 cm. (23 x 19 in.),

private collection.

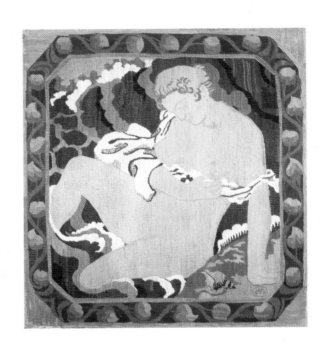

ARISTIDE MAILLOL

Bather, or *The Wave*

1896, cartoon for a tapestry,

oil on cardboard,

22 x 27 cm. (9 x 10 in.),

Paris, Dina Vierny Collection.

Desvallières (1919). He was the most cultivated of the Nabis and, with his deeply personal need for clarity, solidity and proportion (perhaps too much of it), was the one best equipped to express his ideas and convictions.

In 1908, he painted a series of five large panels illustrating the *Story of Psyche* for the music room of the Russian millionaire Ivan Morozov, a textile magnate and avid collector of Matisse and Picasso. Another great Russian collector of the day, Sergeï Shtshukin, was also drawn to these last two painters, as well as to Cézanne. It was he who commissioned Matisse to paint the allegories of *Music* and *The Dance* for his Moscow apartment in 1909. He was no less interested in Bonnard, Vuillard and Maurice Denis, but, significantly, only bought the latter's works from the Nabi period. His discernment was exemplary, to say the least: the highly simplified tonal composition entitled *Patches of Sunlight on the Terrace* (1890), with its broad fields of reds, oranges and greens, stands as one of the most powerful works of a painter who was all too often limited by his concern for transcendence.

In 1913, Maurice Denis decorated the cupola of the *Théâtre des Champs-Elysées*, built by the architect Auguste Perret and for which Vuillard later painted a drop-curtain, as well as murals and overdoor panels, while Bourdelle sculpted the famous bas-relief on the façade pediment. These artists, and a few others, including Bonnard and Maillol, were the leading representatives of modern art for the "advanced" art-lovers who comprised the majority of the public interested in avant-garde theatre. Ironically enough, it was on this same stage that Diaghilev's *Ballets Russes* often performed, contributing substantially to the rise of the Cubists, Matisse, and Abstractionists like Delaunay and Pevsner.

A great admirer of Fra Angelico and the Italian Primitives, whose works he often visited in the Louvre after discovering them in Italy, Maurice Denis once wrote: "At last, I am going to admire a work by my Angelico! It is *The Coronation of the Virgin*. What strikes one at first glance is the amazing clarity that envelops the figures: the light is diffuse, the sun veiled. What the painter represented are souls; out of mere matter, he distilled the religious essence." Unfortunately for him, although he strove to idealize his painting, even making his children pose for religious scenes, their "souls" generally proved elusive.

His last work was a Calvary and two panels for the basilica in Thonon, which he finished shortly before his death in an accident in 1943. Although widely appreciated during his own lifetime, his work has since fallen out of favour. At present, the judgement of posterity is unclear. While endeavouring to promote a new classicism, but overly bound to his theoretical and technical rules, Maurice Denis never quite managed to charge his painting with the daring that he praised in others and recommended in his writings.

What would have become of Paul Ranson's painting had he not died in 1909 at the fairly young age of forty-eight? What he left behind is a sedate and studious body of work, quite in keeping with his theosophical convictions, but at variance with his particularly lively imagination, which sometimes led him to dabble with sorcery and magic. His manner was characterized by an extreme simplification of line, sparse, flat colours, and symbols, all of which he had learned from Gauguin and medieval tapestry.

Perhaps this is why his tapestry cartoons constitute the most exciting part of his work. His wife would execute them without using a loom, but simply embroidering canvas with thick wool thread. The result imparted a sense of texture that, more often than not, was lacking in his own pictorial efforts.

Ranson, whom we have already seen in his crucial role as guardian of the Temple, was not above indulging in horseplay. One Saturday, a visitor to his boulevard du Montparnasse studio almost had to break the door down to gain admittance, so loud were the goings-on inside. When he was finally let in, he was greeted with the surprising spectacle of Ranson, his wife, Maurice Denis, Vuillard and Bonnard straddling their chairs like hobby-horses and racing along the newly-waxed floor!

As we have already mentioned, Ranson devoted a great deal of energy and enthusiasm to the marionette plays that he presented on Saturdays, writing sketches that featured a rather libidinous and sometimes philosophic character called Abbé Prout. He drew on the medieval tradition of satirical farces that targeted the dominant social classes and other stereo-types: nobles, the military, politicians, the rich bourgeoisie, clumsy servants, greedy wives, and so on. From the mouths of his wooden actors came the raw truth that his soft-spoken pictures all too often lacked.

MAILLOL AND THE SENSUAL VEIN

A characteristic feature of Maillol's person was his full beard, which covered his chest with its broad expanse, growing ever longer as it turned grey, and then white. Thadée Natanson interpreted it as the symbol of an artist who had never lost his sensual verve, even in the autumn of his life. This Nabi probably managed to keep his senses eternally young by steer-ing away very early on from the aesthetic and philosophical preoccupations of his friends from *La Revue Blanche*. The fact of it was that he was too sensual, while the others – Denis, Ranson, Sérusier, to name just three – were not sensual enough.

With the sunny and jovial disposition of a son of the Midi, Maillol traced his aesthetic roots back to Greece and, like Roussel, was

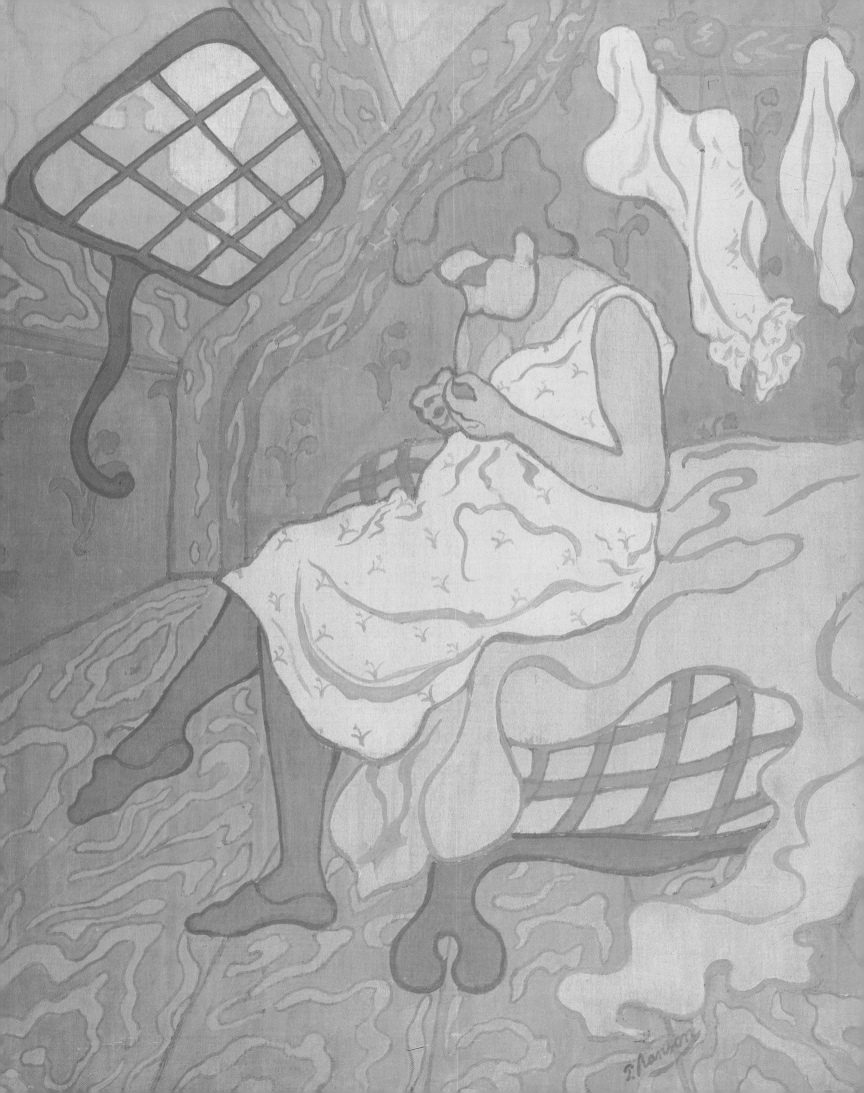

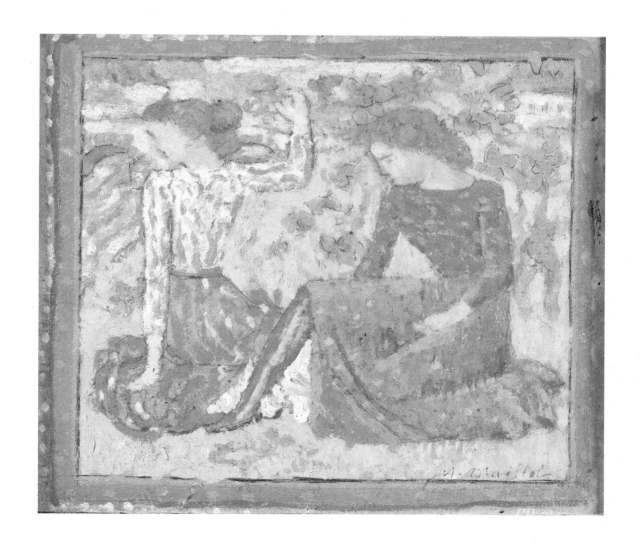

ARISTIDE MAILLOL

Two Young Girls

Around 1895-1900, sketch for a tapestry,

pencil, oil and gouache on cardboard,

20.7 x 33.9 cm. (9 x 13 in.),

Josefowitz Collection.

Opposite

PAUL RANSON

The Garret Room

1893, tempera on canvas,

61 x 50 cm. (24 x 20 in.),

Josefowitz Collection.

FELIX VALLOTTON

Street Demonstration

1893, woodcut,

20.3 x 32 cm. (9 x 12 in.),

Lausanne, Galerie Vallotton.

inclined to recite Virgil, whose works he knew by heart. Bonnard once said of him: "Between twenty and thirty one tends to meet like-minded artists, and so I got to know Maillol along with some other friends. He was making tapestries with very refined colour schemes. He was already one of those close-to-nature artists who would dye his own yarn and carve wood in imitation of Gauguin."[1]

His art, however, was closer to Renoir's caresses than to Gauguin's arabesques. And this applies not only to his paintings, but also to his sculptures, to which he devoted himself exclusively after an affliction of the eyes prevented him from engaging further in painting and tapestry.

He found his own style at an early stage in his career and evolved little during the course of his long life, which ended in 1944 at the age of eighty-three. Maillol's sculptures, whether he modelled the forms like a potter or carved them directly out of wood or marble, are characterized by placid volumes over which light seems to flow like water off a duck's back. As he was fond of saying: "One must be synthetic, like the African sculptors who reduced twenty forms into one." Nevertheless, while others around him were taking their cues from African statuary the better to develop an avant-garde art, Maillol was more concerned with ridding the Graeco-Roman tradition of the accretions of academic realism that were slowly stifling it. In this sense he was contributing more to a magnificent finale, rather than to a new beginning.

VALLOTTON THE CLAIRVOYANT

Félix Vallotton, one of the most appealing figures of the Nabi movement was also one of the first to achieve recognition, thanks to his efforts as an engraver. His stunning woodcuts were soon noticed and he was regularly asked to contribute to *La Revue Blanche*, for which he executed many portraits of notable writers, artists, philosophers and politicians, creating a gallery of true likenesses. He also contributed to such publications as *Le Rire* and *Le Cri de Paris*, which had a much larger circulation than the literary reviews, and so introduced his work to an even wider audience.

The ten plates that he published in 1898 as a series titled *Intimités* constitute a caustic critique of bourgeois marriage, with its typical hypocrisy, unkept promises and, of course, failures. In one plate, we see two lovers sitting with legs sensuously intertwined, their eyes closed, faces merging, but in an overall disquieting, ambiguous atmosphere. Is the man pretending to be in love only to seduce? And, is the woman's abandon the result of sincerity or of duplicity? In another plate, dinner has been interrupted by a scene: the wife turns away in tears, while the man rises anxiously from the

1. Claire Frèches-Thory and Antoine Terrasse, *Les Nabis*, Paris, 1990.

FELIX VALLOTTON
The Swans
1895, woodcut,
18 x 22.4 cm. (8 x 9 in.),
Lausanne, Galerie Vallotton.

FELIX VALLOTTON

Money

"Intimités" series

1898, woodcut,

17.9 x 22.5 cm. (7 x 9 in.),

Lausanne, Galerie Vallotton.

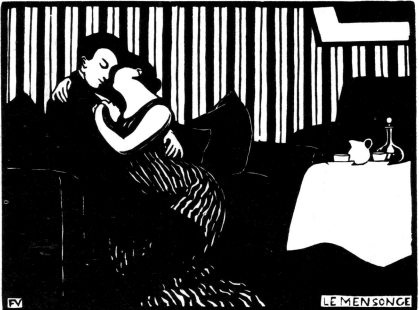

FELIX VALLOTTON

The Lie

"Intimités" series

1898, woodcut,

18 x 22.5 cm. (7 x 9 in.),

Lausanne, Galerie Vallotton.

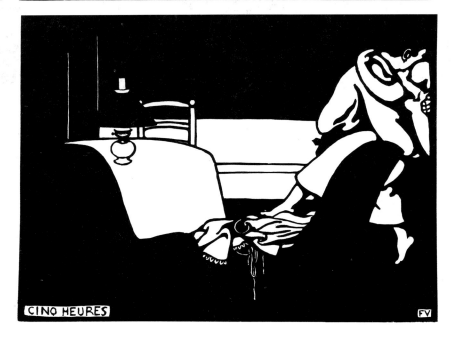

FELIX VALLOTTON

Five O'clock

"Intimités" series

1898, woodcut,

17.7 x 22.3 cm. (7 x 9 in.),

Lausanne, Galerie Vallotton.

FELIX VALLOTTON

Proofs of the destroyed woodblocks

"Intimités" series

1898, woodcut, printed from fragments of

the ten blocks,

Lausanne, Galerie Vallotton.

185

table, his napkin still in his hand. Although spare to the extreme, the line is evocative, and the large masses of black create a sense of drama.

In order to prove that the woodblocks had been destroyed, Vallotton would cut out ten more or less enigmatic details and put them together in a composition at the end of the album. The result is related to the aesthetics of the fragment and of the comic, which was beginning to gain popularity during this period.

His paintings present a similar world, situated somewhere between dream and reality. There are many pictures of great formal simplicity in which the same figures appear, seemingly trapped in their interiors, transfixed as in a nightmare. There, too, the eyes are shut and the faces more often than not averted. Vallotton's paintings show a cold, hard world filled with muted tensions and conflicts. Even more than his wood engravings, these disturbing images reveal the "scenes behind-the-scenes" of domestic relationships.

While he gave vent to clearly anarchist sympathies when he lambasted the bourgeoisie, this did not prevent him from joining its ranks in 1899 when he married Gabrielle Rodrigues-Henriques, a wealthy Jewish widow, the mother of three children, and the daughter of the great art dealer Alexandre Bernheim. Strangely, Vallotton thus embraced everything that he had claimed to hate – women, children, money – everything that had been fodder for his acerbic wit. In pairing up with Gabrielle, he gave up not only the independence that he had always jealously guarded, but also his mistress, Hélène Chatenay, a dress-maker with whom he had lived and who had given him much support during the lean years.

Feeling the need to justify himself, he wrote to her parents: "What touches me most is everything that concerns the little one. Ever since I have known her, I have had a complete and total affection for her, and I always will." How sensitive of him! Vallotton, in any case, was not the first, nor the last artist to deride the rich before settling for the comforts of a gilded cage.

And so he left his lodgings in the rue Jacob, on the Left Bank, and moved into a luxurious apartment in the rue de Milan, which he was often to depict in his paintings. Inexplicably, in the novels he wrote during his first years of marriage, he continued to express his aversion for the class whose ranks he had freely joined. One of these, entitled *La vie meurtrière* (or *A Deadly Life*), was a guilt-ridden, disturbing transposition of the sad fate of the unfortunate Hélène, who died an impoverished invalid in 1910.

Vallotton the engraver, novelist and painter of the fin-de-siècle bourgeoisie was also a remarkable portraitist. His *Portrait of Gertrude Stein*, for example, which he executed in 1907, is in no way inferior to the one painted by Picasso a year earlier.

In her *Autobiography of Alice B. Toklas*, Gertrude Stein described how the painter worked: "She often described the strange sensation she had as

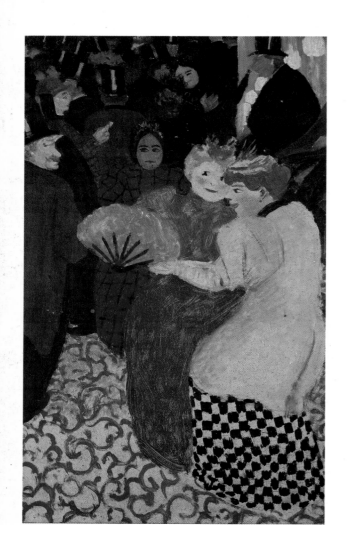

FELIX VALLOTTON

At the Music Hall,

or *The Promenade Gallery at the Folies-Bergères*

1895, oil on cardboard,

52.5 x 33 cm. (20 x 13 in.),

private collection.

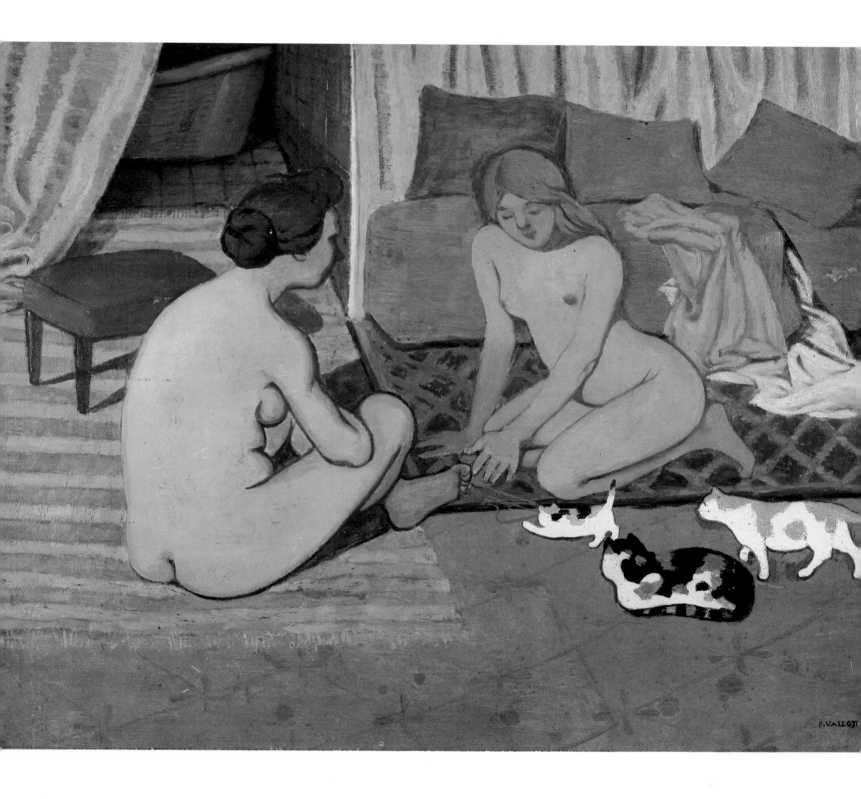

FELIX VALLOTTON

Two Nudes with Cats

1898, oil on cardboard,

41 x 52 cm. (16 x 20 in.),

Lausanne, Galerie Vallotton.

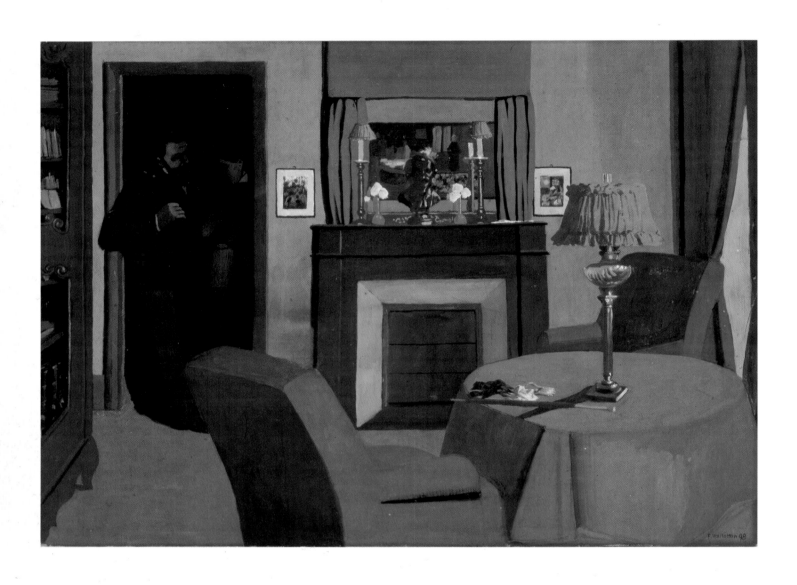

FELIX VALLOTTON

The Red Room

1898, tempera on cardboard,

79.5 x 58.5 cm. (31 x 23 in.),

Lausanne, Musée des Beaux-Arts.

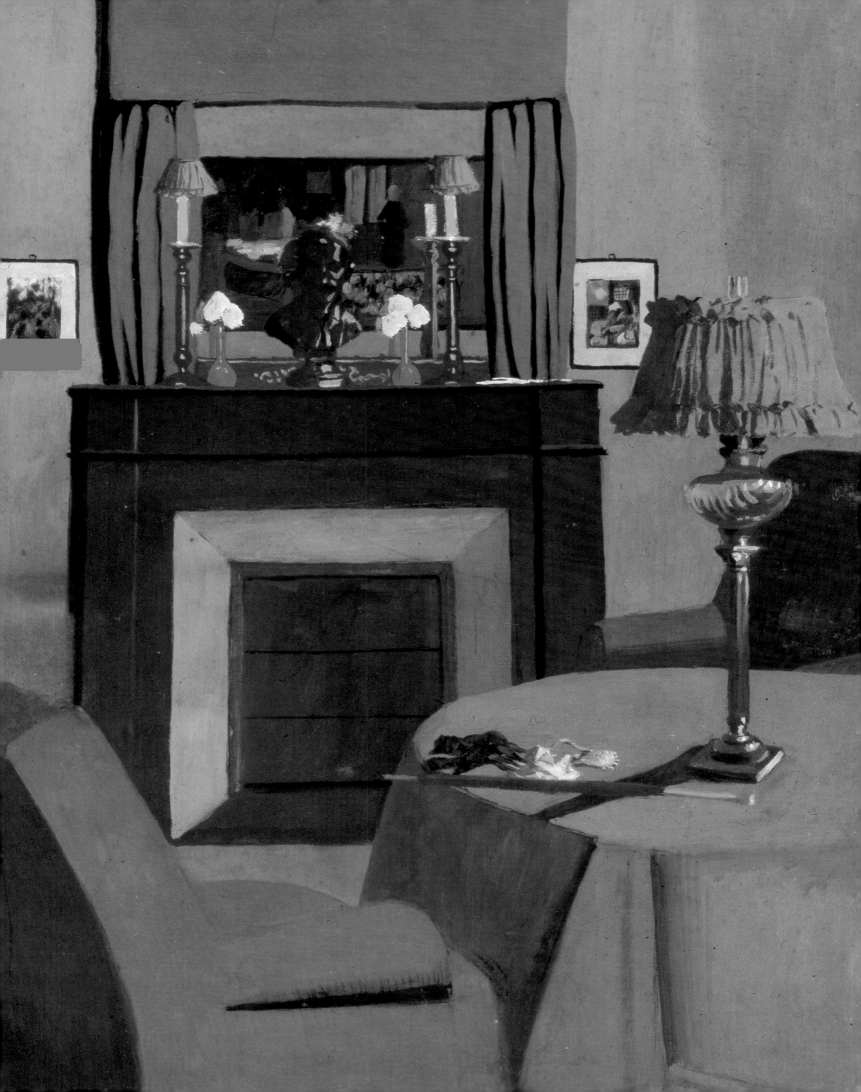

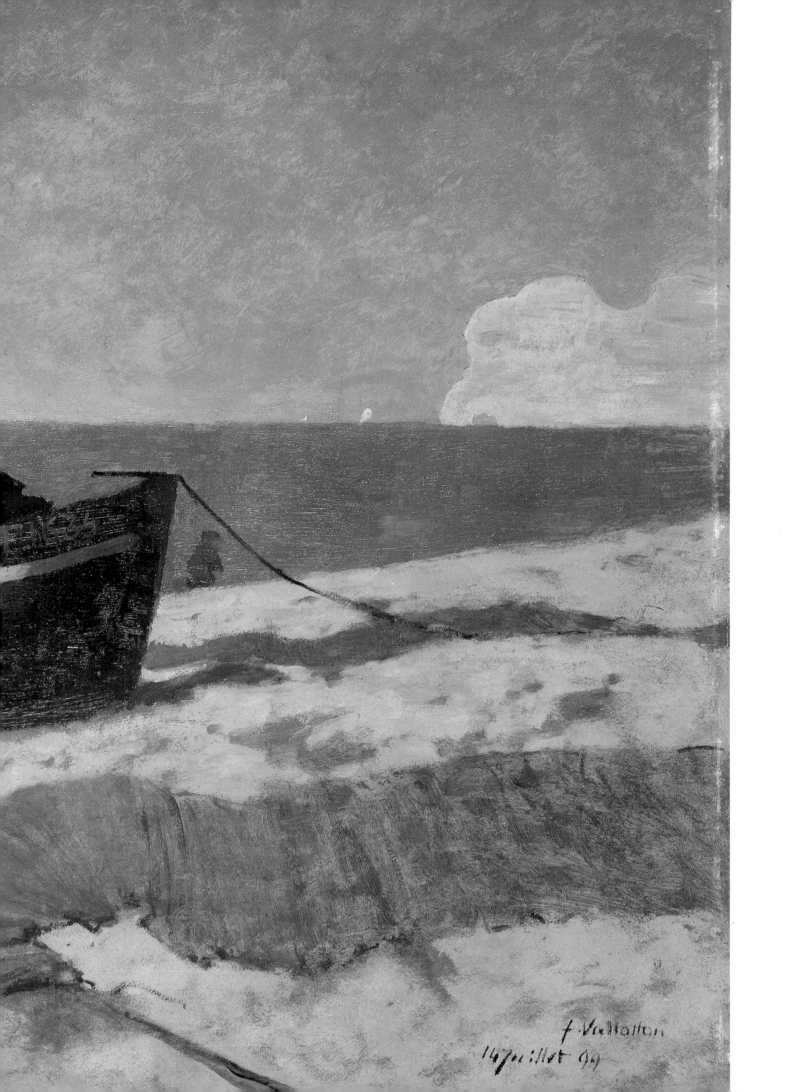

f. Vallotton
14 juillet 99

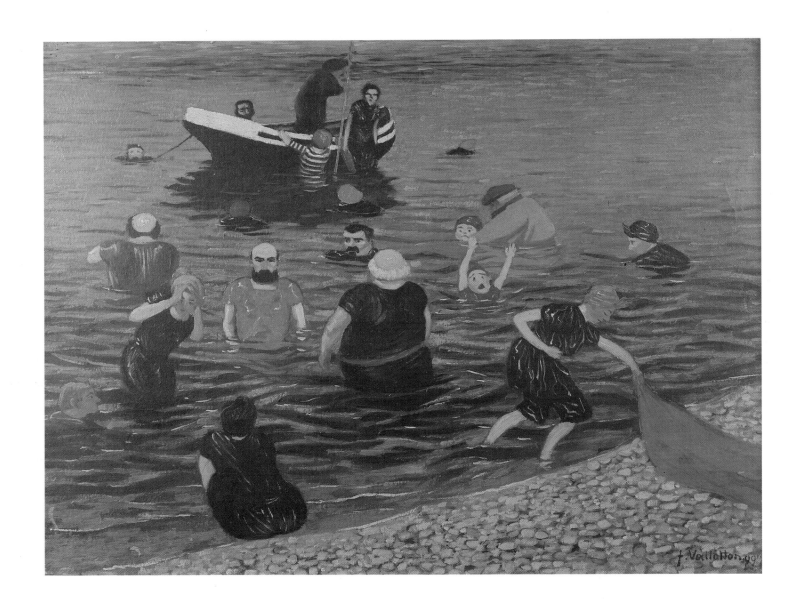

FELIX VALLOTTON

Bathers at Etretat, or *La Baignade*

1897, oil on wood-mounted cardboard,

49.5 x 65 cm. (19 x 26 in.),

private collection.

Overleaf

FELIX VALLOTTON

The 14th of July

1899, oil on cardboard,

47 x 60 cm. (18 x 24 in.),

private collection.

a result of the way in which Vallotton painted.... When he painted a portrait he started at the top and continued down. Gertrude Stein said it was like a curtain moving down as slowly as a Swiss glacier. Vallotton slowly took the curtain away and when he arrived at the bottom of the canvas, there was a portrait, not a curtain. The whole operation took about two weeks and then he gave the canvas to you. But first he exhibited it at the Autumn Salon where it received considerable attention; and so everybody was happy." In terms of the impression it makes, this work has analogies with Ingres' famous *Portrait of Monsieur Bertin*, so much so, in fact, that, when he saw it, Vuillard could not help exclaiming, "Why, it's Madame Bertin!," and unwittingly provoked the hilarity of less well-intentioned critics.

When the Great War broke out in 1914, Vallotton, a Swiss national by birth who was forty-nine years old at the time, immediately volunteered for active duty, but was rejected because of his age. After serving as a stretcher-bearer for several months, he put his talents to creating anti-German propaganda for various newspapers and published an edition of six woodcuts entitled *C'est la guerre!*. He also painted a number of compositions on the theme of war, including one titled *Verdun* (1917), that displayed a new manner closely related to Léger's Cubism and Severini's Futurism.

His engravings of the soldier's life at the front were fairly banal and did not elicit the expected acclaim. *Verdun*, on the other hand, put him back in the spotlight: with its clouds of green and yellow gas, criss-crossed beams of light scouring the sky, and all-devouring flames, it aptly expressed the dehumanization and mechanization of modern warfare. Officially dispatched to the front in Champagne with other artists to "capture the atmosphere," he caught on very fast: "A shell exploding on an embankment and scattering its death-dealing shrapnel does not present anything tragic to the eye. Except for the noise, one sees only a great upheaval of smoke and dirt, variously modulated in gracefully combined volutes, which develop and dissipate according to the usual laws. Afterwards, the sky is as blue as before, and if the terrain has suffered any modification, it is immediately integrated into the landscape, which may have changed in visual terms, but never disappears."[2]

His uncommon sensitivity to the new aesthetic directions being explored might have enabled Vallotton to renew his style, were it not for the deepening depression which gradually corroded his spirits: "Acute depression and melancholy; I feel more weary than ever before, just weary of everything. Painting leaves me cold, I am obsessed by people, and I avoid the one here, the other there, but without finding any consolation anywhere." He wrote these lines in 1920, and a year later was still mired in the same dismal vein: "Life is just a puff of smoke, we struggle, we delude ourselves, we clutch at phantoms that slip through our fingers, and death comes suddenly."

2. Sasha H. Newman, *Félix Vallotton*, Paris, 1992.

Vallotton died in 1925 at the age of sixty: a sad end for a clair-voyant man. In one of his occasional sallies into art criticism, in *La Gazette de Lausanne*, he published the first article recognizing Henri Rousseau's talent (1902).

LACOMBE: A BED FOR A MASTERPIECE

Georges Lacombe cut a superb and extravagant figure in his blue, brown or purple velvet suits and his flowing Liberty satin ties, which he would occasionally trade for the scarlet shirts, linen trousers and clogs that he sported at his country retreat. His work would be totally unknown today, were it not for the carved bed-panels that somehow miraculously survived. Doubly endowed by inheritance and a wealthy marriage, his Nabi convictions prohibited him from selling his paintings and sculptures, and so he would give them away as his fancy and friendships dictated.

GEORGES LACOMBE

Existence
Around 1894-1896, bas-relief,
four wooden bed panels,
Paris, Musée d'Orsay.

Above

Love, or *The Embrace*
Side panel, 195.2 x 49 cm.
(6 1/2 x 1 1/2 ft.).

Opposite

Birth
Foot panel, 68.2 x 142 cm.
(2 1/4 x 4 1/2 ft.).

He was born in Versailles in 1868, and from childhood had three servants to take care of him. His Nabi friends were impressed by the musical suppers – complete with orchid-garnished tables – to which his mother-in-law, Gabrielle Wengner, invited them.

Lacombe was educated in a Jesuit school but later displayed an absolute abhorrence of the Church. Religion, for him, amounted to "vulgar symbolism" and, speaking of baptism, he once declared: "I know of nothing more piteously grotesque and woefully insufficient for people who no longer live in caves with only bears to engage in philosophical discussion." One wonders how so critical a mind could have existed in the midst of a group with such mystically oriented members as Maurice Denis and Paul Ranson.

The famous four bas-relief panels that he carved for his own bed depict the three major events in human life: the sexual embrace, birth and death, together placed under the "heading" of the dream-world. They are fairly directly related to Gauguin's example and, as far as the panel of

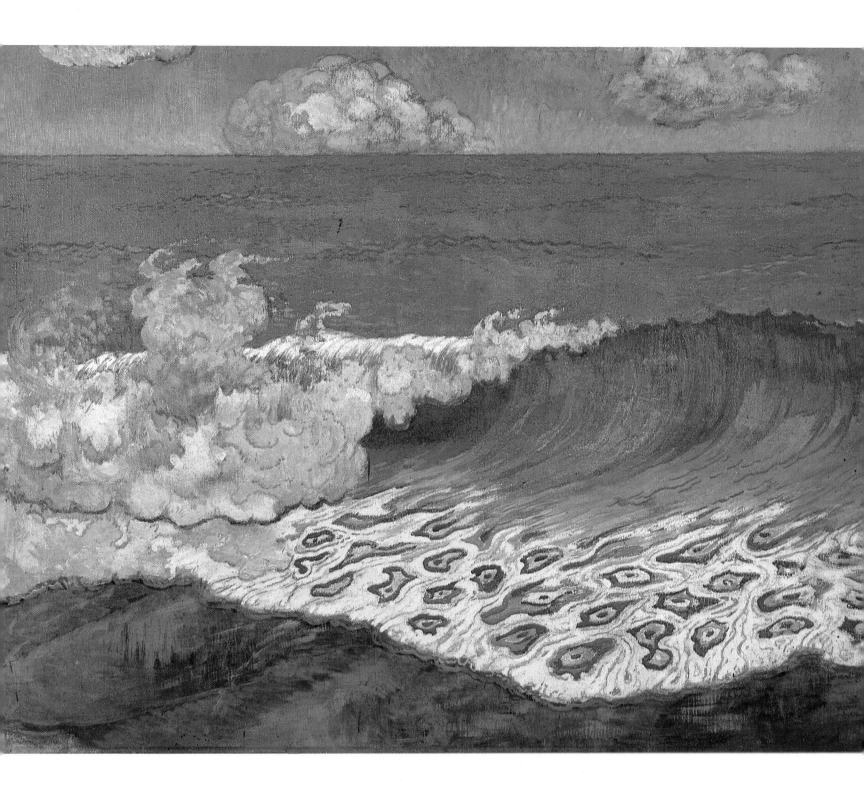

GEORGES LACOMBE

Isis

1895, bas-relief, painted wood,

111.5 x 107 cm. (3 ¹/₂ x 3 ¹/₂ ft.),

Paris, Musée d'Orsay.

GEORGES LACOMBE

Blue Seascape, or *Effets de Vague*

1892-1894, tempera on canvas,

49 x 65 cm. (19 x 25 in.),

Rennes, Musée des Beaux-Arts.

KER XAVIER ROUSSEL

Bathing at Villeneuve-sur-Yonne

1898, pastel and gouache,

21 x 36 cm. (9 x 14 in.),

formerly in the Vollard Collection.

Death is concerned, to Breton calvaries, which is not to detract from the particularly high quality of this work. The fantastic figure he invented for *The Dream* shows a snake biting its own tail and forming a composite human face with its curling body. He seems to have placed this image under the combined signs of Earth, Water and Air, for the panel presents a star in one corner, rippling water in another, and a leaf in the middle. Paul Klee would surely have been enthralled by this work which depicts so many of his own obsessions.

Lacombe's death in 1916 at the relatively early age of forty-eight – the same age as Ranson – and the low esteem which he himself had for his painting, impeded its development. He excelled at seascapes with patterned waves, flat colour fields and Japanese-style clouds, that were proof of real talent.

THE BUCOLIC ROUSSEL

Ker Xavier Roussel was the Nabi who had been the most durably affected by his encounters with fauns, nymphs, satyrs and dryads in the woods and clearings of the Ile-de-France.

He was a fervent admirer of Virgil, whose works he read during his long walks through the countryside. One author described him as follows: "He walked along paths and lanes, through orchards, copses, woods, everywhere. He walked as others harvested, without ever lapsing into idleness. He assimilated all the different things that he saw; bundled together the entire countryside like a sheaf of wheat. Then would come the moment to make a halt, like someone settling in the shade to compose a bouquet after an orgy of flower-picking. This was the moment to sit and paint, that is to make the drawings and pastels that decorate the sunny threshold of his art."[3]

Roussel's first pictorial efforts struck his friends by their kinship with the work of Puvis de Chavannes; and Albert Aurier thought that he would make a marvellous decorator. Like all the other Nabis, he was influenced by Gauguin's Synthetism and by Cézanne, whom he knew. Yet the decisive impulse came from his discovery of Monet and the Impressionists, because of their insistence on painting out of doors and depicting the shimmering quality of light. He was fond of saying that this encounter came "like a cool drink."

However, unlike the Impressionists who strove to seize the visual instant, Roussel had his eye set on the timeless. This quality is to be found in most of his works, and especially in his many murals: for Bernheim and Lugné-Poë in 1909, for the *Comédie des Champs-Elysées* (which he decorated with Vuillard in 1913), for the Palace of the League of Nations in Geneva in 1936, and for the Palais de Chaillot in Paris in 1937.

3. Claire Frèches-Thory and Antoine Terrasse, *op. cit.*

KER XAVIER ROUSSEL

The Red Parasol,
or *The Courtyard of the Louvre*
Around 1895, oil on canvas,
18 x 30 cm. (7 x 11 in.),
private collection.

Roussel rendered his pantheistic vision of nature in clear and muted tones, in imitation of Poussin, one of his constant sources of inspiration. In his preface to an edition of Roussel's lithographs, the philosopher Alain rightly noted: "Sometimes he mixed his colours, and, lo!, his painting would come alive and dance and sing." Until his death in 1944, he never stopped striving to capture life and celebrate it in his paintings.

VUILLARD THE INTIMIST

Vuillard, as we know, took his time before finally assimilating Gauguin's example. But he never went so far as to adopt the Platonic and Symbolist tenets of his fellow Nabis. As an artist, he was too enamoured of the act of painting itself, too busy transmitting his visual sensations to concern himself with the pursuit of the intangible and the ineffable. Nevertheless, the Nabi doctrine gave him just the ingredients he needed to achieve the mastery of these rich sensations. André Gide wrote of him: "I know of few works in which the dialogue with the author is so direct. I believe that this is due to the fact that his brush never loses contact with his guiding emotion, and that the outer world is there for him as a pretext and as a means of expression. It is due more especially to the fact that he speaks in a somewhat hushed voice, as befits talk of confidential matters, and one leans forward to listen."

Like Bonnard, he was fascinated by Japanese prints and adapted their compositional principles to his intimist pictures. Therein lies the best of his work, and this intimism became ever more pronounced, despite his taste for the elegant and worldly circles which he indulgently observed.

When his father died in 1883, his mother opened a dressmaking workshop, and so Vuillard spent his childhood years surrounded by fabrics of all kinds, from silk to wool. His maternal grandfather, a textile manufacturer, often designed patterns for his own fabrics. This explains to some extent Vuilliard's fondness for pictures of warm rooms and cosy boudoirs filled with small, precious objects, as well as the subtle charm, and the supple and demure simplicity of his forms bathed in muted colour schemes. Vuillard's technique was refined, too; he liked making mixtures with oil, tempera, gouache and pastel, producing tonal combinations that gave his works, often painted on cardboard, a soft atmosphere and a touching lyricism.

He was the painter of doors mysteriously closed in silent rooms or standing ajar at the top of a stair; or the plain curve of a table's edge. He painted the eeriness of corridors, of a spot of sunlight on a tiled floor at the foot of shadowed walls, and described the intricate relationships between the objects and people who occupied these interiors. The patterns – dots, checks, flowers – decorating a blouse, dress or apron were as important as those gracing the curtains and wallpapers: "Surprising pictures, in which the forms seem to be carved out of colour."

JEAN-EDOUARD VUILLARD

Félix Vallotton in His Studio
Around 1902, oil on canvas,
42.5 x 44.5 cm. (16 x 17 in.),
Nancy, Musée des Beaux-Arts.

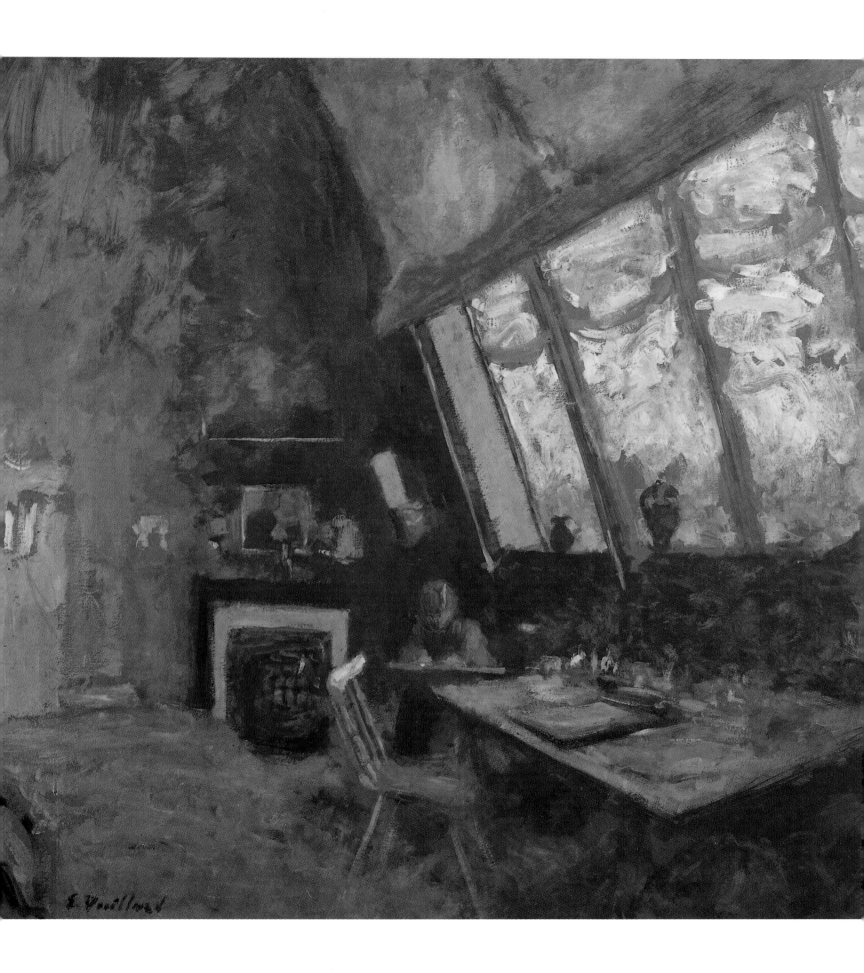

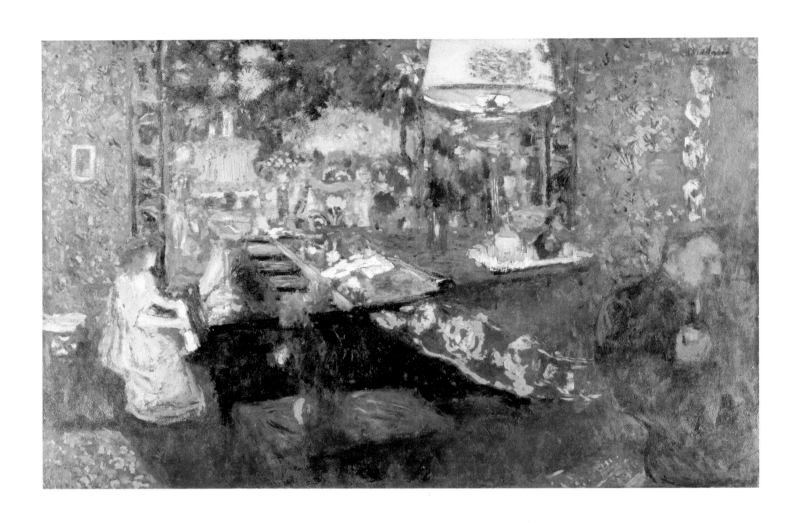

JEAN-EDOUARD VUILLARD

Interior with Three Lamps

Around 1894, oil on cardboard,

55 x 80 cm. (23 x 32 in.),

Josefowitz Collection.

This may be why this born intimist painter, a great admirer of Chardin and the still-life, did not shrink from changing registers and tackling mural projects, for which he was not as ideally suited.

In a previous chapter we mentioned the decorations that Vuillard executed for Thadée Natanson and his cousin, Paul Desmarais. These panels, characterized by his usual simplicity and refinement, and a pictorial space intelligently balancing the play of horizontals and verticals, showed scenes of everyday life and leisure among the *haute bourgeoisie* – governesses and children, badminton players, gardening – somewhat in the way that painters of former times immortalized the lives of the monarchs. His panels for Dr. Valquez's library, executed in 1896, depicted the confined world of figures absorbed in reading or playing the piano, projecting the intimacy of family life on a mural scale.

Towards the end of his life, in 1938, and despite his old age, he would still spend entire days on precarious scaffolding to execute the mural commissioned by the French Government for the Palace of the League of Nations in Geneva. He had worked in the previous year on a mural project at the Palais de Chaillot illustrating the theme of Comedy. The subject matter in Geneva was one of Puvis de Chavannes' favourites: *Peace Protecting the Muses*. Allegory never having been his *forte*, however, he represented his Muses in rather conventional poses, but as far as the floral decoration that frames their youthful procession was concerned, he was definitely in his element.

Vuillard devoted a considerable part of his activity to painting portraits. From the turn of the century until his death – during the French debacle in 1940 – he put his talents as portraitist at the service of the privileged and monied classes: great doctors of medicine, entrepreneurs, writers, fashion designers like Jeanne Lanvin, or musicians, like her daughter, the Princess of Polignac. His portraits were a valuable record of a fast vanishing world.

A single anecdote demonstrates better than a long discussion the important role he played for the bourgeoisie, before his work fell into oblivion for half a century. In 1942, when Louis Hautecoeur, the Secretary-General of Fine Arts, inaugurated the new *Musée d'Art Moderne* at the Palais de Tokyo, the pictures by Vallotton and the other Nabis were put on display, but the twenty pictures by Vuillard in the State collections were kept stored away in the reserves for fear of aerial bombardments.

BONNARD THE MAGNIFICENT

In an interview given in the thirties, Bonnard eloquently expressed the astonishment and frustration experienced by his friends and himself at the ever increasing pace of the history of art: "The march of

Next page

PIERRE BONNARD

Street Scene, Man Occupied with Two Dogs
Around 1895, oil on canvas,
30 x 40 cm. (11 x 16 in.),
private collection.

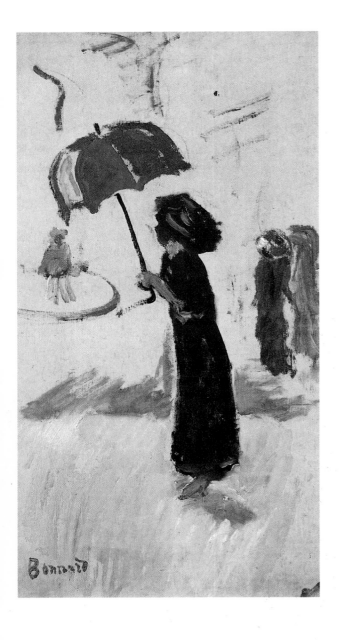

progress has accelerated. Society was ready to admit Cubism and Surrealism even before we had reached the goal we had set for ourselves. We were left suspended in mid-air, so to speak."

But Bonnard never lost his footing. During the *Salon d'Automne* of 1905, when the Fauves burst onto the art scene (in every sense of the word), he continued to paint according to his personal convictions. His taste and feeling for proportion permitted him to play with forms and achieve the most unexpected colour harmonies. "A painting is a series of spots that gradually come together to make an object, a form over which the eye can wander without effort." He was never totally satisfied with his work; there is the story of the time he was stopped by a museum guard who, thinking that he had a maniac on his hands, had to pull him away from one of his own canvases that he had wanted to "finish" with a small brush and a tube of paint.

A great admirer of the female form, he painted many nudes of Maria Boussin (who preferred to be called Marthe), a young woman he had met in 1893 and who later became his wife. With her graceful physique, her firm, shapely breasts, blue eyes and long hair, she was Bonnard's favourite model. She sat for the majority of his paintings of nudes, and in particular for his series of "Women Bathing," with those superb plays of water and light on flesh which rank them among the most powerful and delicate works painted in our time.

Indulging in his taste for sensual beauties, he liked to show them with their clothes strewn on an unmade bed, adding a dash of desire to the visual pleasure of his pictures. Nor did this exclude a sense of the seriousness of things: his justly famous *Nude in a Bathtub* (1936), which shows his wife lying like a corpse in a coffin, is closer in mood to Gustav Klimt than to the Impressionists. He felt in any case that Impressionism was too subservient to nature, and felt the need to develop it in unexpected directions.

Bonnard was also a marvellous observer and chronicler of the Paris of his day: the newspaper kiosk and flower boutiques on the Place de Clichy, the squadrons of nannies and children leaving for school, strollers in the rue Norvins at the foot of the Sacré-Coeur, young women crossing the Pont des Arts, the evening crowds going to the theatre, a woman in front of the wheel of a bus, a waiting horse and cab, no element of everyday life in *fin de siècle* Paris escaped him. His interior scenes are also superb: a woman sewing or reading at a window, cats happily basking in the warmth of a lamp, dogs prowling in an apartment or curled up on a chair, minor events of daily life to which only a great painter can impart the right degree of intimacy.

The four decorative panels entitled *Women in a Garden* (1891), which may be an allegory of the four seasons, and the *Croquet Players* (1892), are also a visual document of the times. But, with their flecks of fluffy white and reds, their mauve and blue checks, their flattened silhouettes on a flat background, they are above all superb examples of painting. As he liked to say, "the point is not to paint life, but to bring painting to life."

208

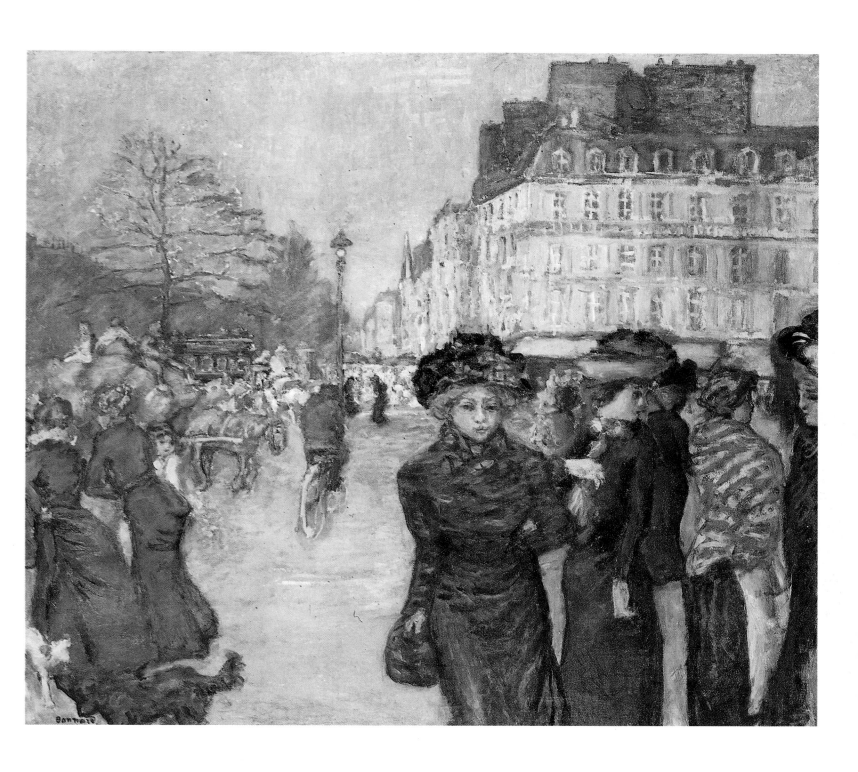

PIERRE BONNARD

Place Clichy

1906-1907, oil on canvas,

103 x 117 cm. (3 x 1 1/2 ft.),

Paris, Collection of Mr. & Mrs. Dumenil.

PIERRE BONNARD

Croquet Players
1892, oil on canvas,
130 x 162 cm. (4 x 5 ft.),
Paris, Musée d'Orsay.

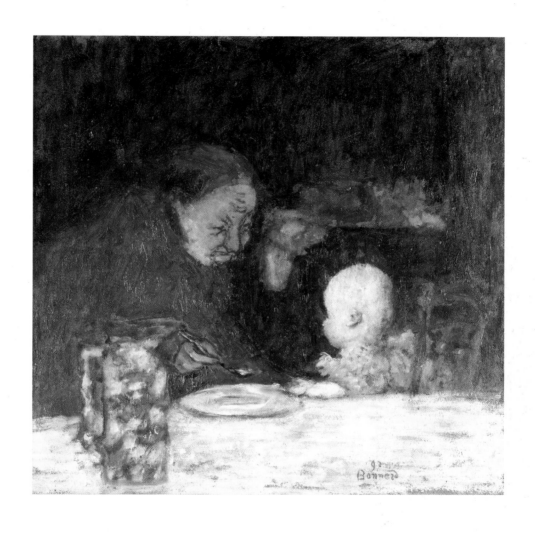

PIERRE BONNARD

Grandmother and Child

1897, oil on cardboard,

39.6 x 39 cm. (15 x 15 in.),

private collection.

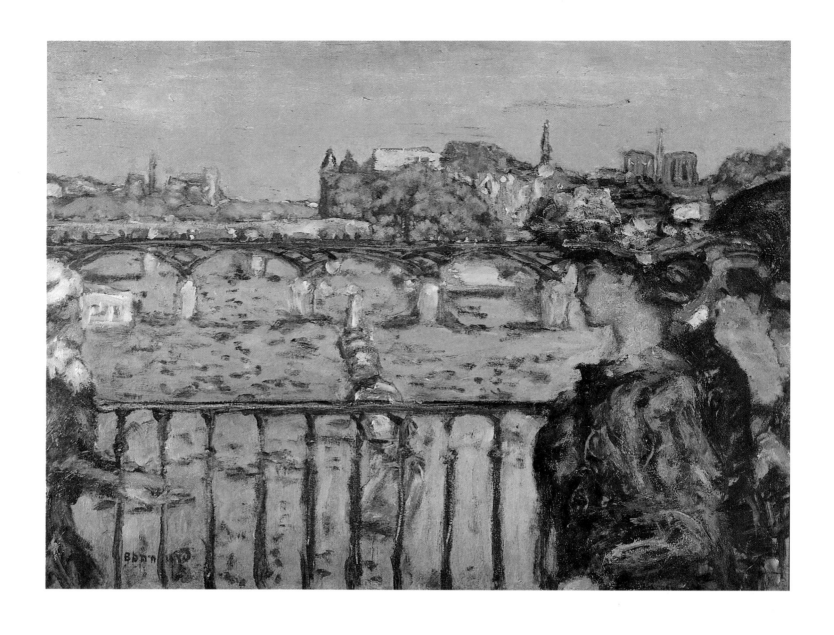

PIERRE BONNARD

The Pont des Arts

Around 1905, oil on cardboard

pasted on wood,

55 x 70 cm. (21 x 28 in.),

private collection.

If anything, however, Bonnard was an outstanding landscape painter and contributed much to renewing the genre. In 1902, he bought a house at Vernon, in the Seine Valley. He called it *Ma Roulotte* (my gipsy caravan) and often stayed there with Marthe. In addition to his pictures of her, he painted landscapes which gave him the chance to indulge in endless plays of form and colour. A trip to the South of France in 1909 brought him the revelation of the brilliance that colours could achieve and led him to change his palette. From then on, he regularly visited the Côte d'Azur, and finally purchased a house at Le Cannet in 1926. His Mediterranean landscapes display a seemingly endless joy in the play of colours that must have been as much a delight for his eyes then as it is for ours today.

He was so sensitive to the changes in atmospheric conditions that he would make daily notes on the weather in his diary. His sketches, whether of a face, an animal or a boat spotted in the distance off La Croisette, often contained such notations as "clear weather," "cloudy," "wind," "rain and sun" or "good weather with clouds." He would also make such precise observations of passing conditions as "when the weather is good, but cool, there is vermilion in the orangey shadows." For many years, such brief notations were the starting point for entire paintings.

Indeed, few artists have been as preoccupied as Bonnard with the slightest variations in light, the atmospheric changes that could affect the colour of a leaf or the lining of a cloud. The world transmitted by Bonnard in his paintings has something of the world at its origin, a world not yet subject to evil, not yet tainted by "civilization," the world as it may have appeared to the innocent and wondering gaze of the first human being.

Bonnard painted directly on rolls of canvas nailed onto the studio wall, and cut it down to the definitive format only when the picture was finished. In this way he could avoid any preconceived "framing" and extend his field of vision little by little, as necessary. He wanted to "show what one sees upon suddenly entering a room." This was his way of making us sit with him at his table or as he kept Marthe company in the intimacy of her bathroom.

Léon-Paul Fargue, who was a longtime friend, reminisced: "He painted with the deliberate, feigned but secretly seething indifference that had always been his way. He was bold, ingenious and reserved, all at the same time. He knew a great deal and wanted to know more. His memory of things seen and done was remarkable. He had a way of remembering museums, pictures by Velazquez, public squares, dogs and trees that was uniquely his own, and that would have been unsettling, if that glint in his eye had been less mischievous, less gentle, less sharp and less friendly."

Few painters have scrutinized the world around them with so little complacency; that much can be seen in his self-portraits. In his last ones, the brush which he usually wielded so briskly, lightly and turbulently,

became a precise and unrelenting scalpel. Like Delacroix, towards the end of his life, Bonnard liked to say: "You cannot paint violently enough."

He pursued his artistic activity until his death in 1947, at the age of eighty, and, like Titian or, closer to us, Matisse, was blessed with the rare privilege of enjoying the full use of his creativity. His last picture, *Almond Tree in Bloom*, pushed the powers of perception to the limits of hallucination. Self-conscious, he anxiously noted: "I hope that my paintings will hold without developing wrinkles. I would like to greet the young people of the year 2000 with butterfly wings." Now that his position in the history of art is no longer in question, each of his paintings and each of his retrospectives demonstrate that those who considered him merely a backward Impressionist were completely blind to his genius.

VERKADE, BALLIN, RIPPL-RONAI

The minor Nabis, all of foreign origin, played a less determinant role than their colleagues in the movement. Whether they returned to their native lands, like Ballin and Rippl-Ronaï, or withdrew from the secular world, like Verkade, they never experienced the great flowering of a Vuillard or a Bonnard, and so occupy a more modest position in the history of modern art.

Jan Verkade (1868-1946), a Dutchman of Mennonite background, believed that no worthwhile work of art could be created without deep religious conviction, even though, as we have seen, he enthusiastically participated in the pleasures of the bohemian life during his years in Paris. Yet even in the young Breton women that he painted then, he could already see the lineaments of female saints: "The pure and mystical features of a peasant girl of fifteen inspired my first painting of a Madonna." Not surprisingly, he eventually converted to Catholicism and was ordained in 1902 with the name Don Willibrod Verkade. As a monk subject to the discipline of collective life, he devoted his talent to religious painting.

His best friend, Mögens Ballin (1871-1914), a Dane, chose instead the vows of marriage. His parents, although strict followers of the Jewish faith, proved to be open-minded enough to offer hospitality to the newly-converted Verkade. They seem to have accepted the baptism of their own son with no less equanimity, as well as his marriage to a young Frenchwoman who bore him five children – all of whom entered the Church.

Ballin seems to have stopped painting fairly early on and left few works. Those which have come down to us bear out the esteem that Sérusier had for his artistic abilities. A modest work such as *Breton Landscape* may well reflect Sérusier's Synthetist precepts, but it displays a highly personal and very effective interpretation of nature .

MOGENS BALLIN

Breton Landscape

Around 1891, oil on paper,

38 x 32 cm. (15 x 12 in.),

Saint-Germain-en-Laye,

Musée Départemental du Prieuré.

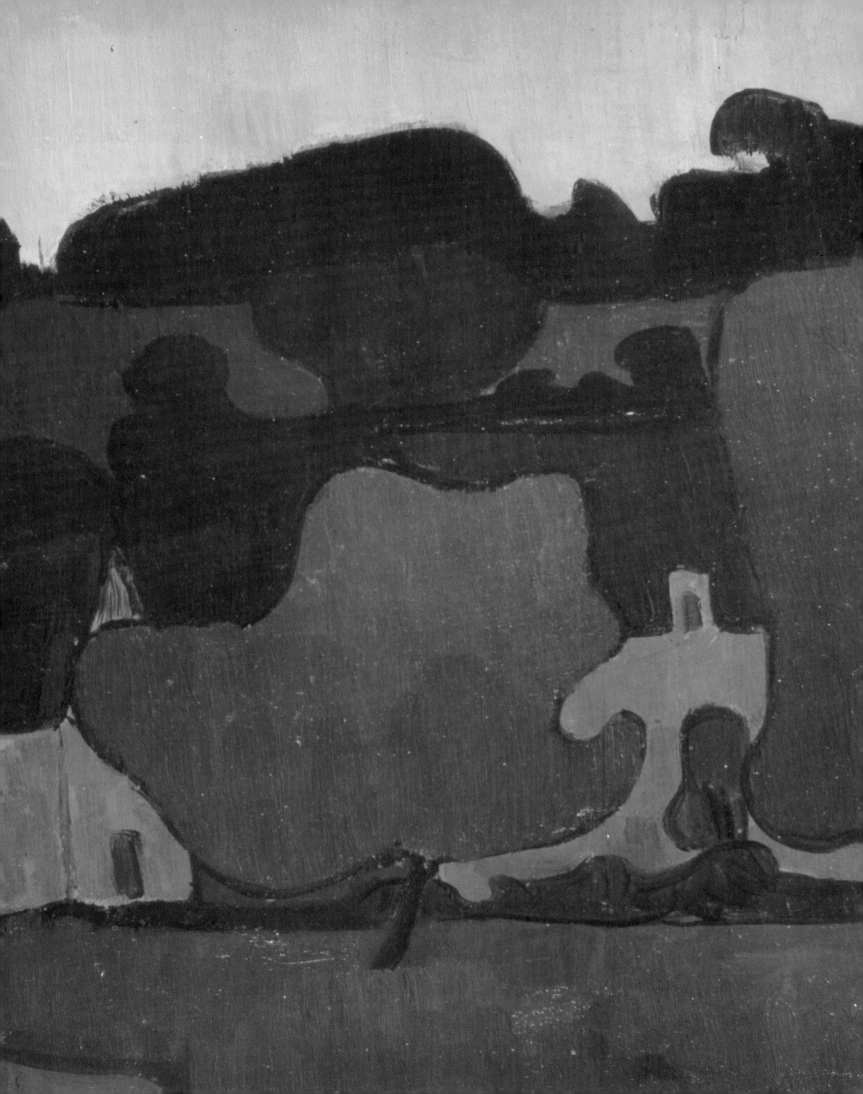

JOSEF RIPPL-RONAI

Scene in an Interior

Around 1900, pastel,

49 x 64.5 cm. (19 x 25 in.),

Josefowitz Collection.

He was barely thirty when he stopped painting and opened a bronze-casting workshop, which became so successful that he was able to retire and devote himself to the religious education of his children. As a sideline, he managed the interests of the Catholic Church in Denmark.

Far be it for us to think that this had anything to do with his nomination for beatification. This incident, however, gave Maurice Denis a chance to show where his sympathies lay. In his book on Sérusier, which was published in 1942, he wrote that his "old friend, the Jew Ballin with that handsome Assyrian face of his" was being put up for canonisation. It took some courage and not a little style to write such words during the Occupation.

Of these three foreign artists, Josef Rippl-Ronaï, who was born in Hungary in 1861, was the one who produced the most personal work, which he pursued until his death in 1947. His last self-portrait, painted in that year, shows an affable man with a Basque beret and broad moustache.

He was sensitive enough to eventually shake off the coolness and decorative exuberance of his early works. Back in Budapest in 1914, he continued a production which displays a great joy in the act of painting. In a long series of sketches, drawings and pastels, he noted the humblest sights and activities of everyday life. And so, despite his evident fondness for line and arabesques for their own sakes, he maintained a profoundly human dimension in his work, striving to capture the fleeting expression on a face no less than the purely formal qualities of a line.

After renovating many princely dwellings, including furniture, floors and ceilings, he introduced Hungary to the style that had gained currency in turn-of-the-century Paris as Art Nouveau.

CONCLUSION

THE FIRST POSTMODERNS

Because of its many different sources, the Nabi movement has often been taxed with eclecticism. But this was not so. To be sure, the Nabis were under the combined influence of Gauguin's Synthetism and Moréas' Symbolism, as well as of Impressionism, Japonism, scientific materialism and the Rosicrucians. But it is precisely in this diversity of influences that their richness lies. In this, they differed from many later avant-garde movements that subjected art to the perils of reductionism.

We observed in our introduction that the Nabis were the first Postmodern painters in the sense that they abolished the boundaries between the old and the new, the before and the after. To this we could now add another Postmodern trait: the great diversity of their productions and personal trajectories. For, in the end, Bonnard no longer had anything in common with Vallotton, nor Vuillard with Maurice Denis, nor Roussel with Sérusier. But what they did share, and what keeps them together is the enthusiasm, the doubts, the joys, the anguish, the ingenuity and the seriousness that they communicated in their works – in short, everything that makes up what we call life.

And this is why, after all the pictorial and intellectual terrorism to which we have been have subjected during this century, they remain so close to us.

BIBLIOGRAPHY

CACHIN Françoise, *Gauguin*, Hachette, Paris 1968.

CACHIN Françoise, *Gauguin, « et malgré moi sauvage »*, Gallimard, Paris 1989.

CHASSE Charles, *Les Nabis et leurs temps*, La Bibliothèque des Arts, Paris 1960.

DELEVOY Robert, *Journal du symbolisme*, Skira, Geneva 1877.

FRECHES-THORY Claire and Antoine TERRASSE, *Les Nabis*, Flammarion, Paris 1990.

HOOG Michel, *Gauguin: Life and Work*, New York 1987.

HUMBERT Agnès, *Les Nabis et leur époque*, Cailler, Geneva 1954.

LE PICHON Yan, *Sur les traces de Gauguin*, Laffont, Paris 1986.

NEWMAN Sasha H., *Félix Vallotton*, Flammarion, Paris 1992.

ROGER-MARX Claude, *Vuillard et son temps*, Paris 1945.

SALOMON Jacques, *Vuillard*, Albin Michel, Paris 1948.

TERRASSE Antoine, *Pierre Bonnard*, Gallimard, Paris 1967.

THOMSON Belinda, *Gauguin*, Thames and Hudson, London 1987.

PHOTO CREDITS

Imprimé en Italie
Printed in Italy
La Zincografica Fiorentina